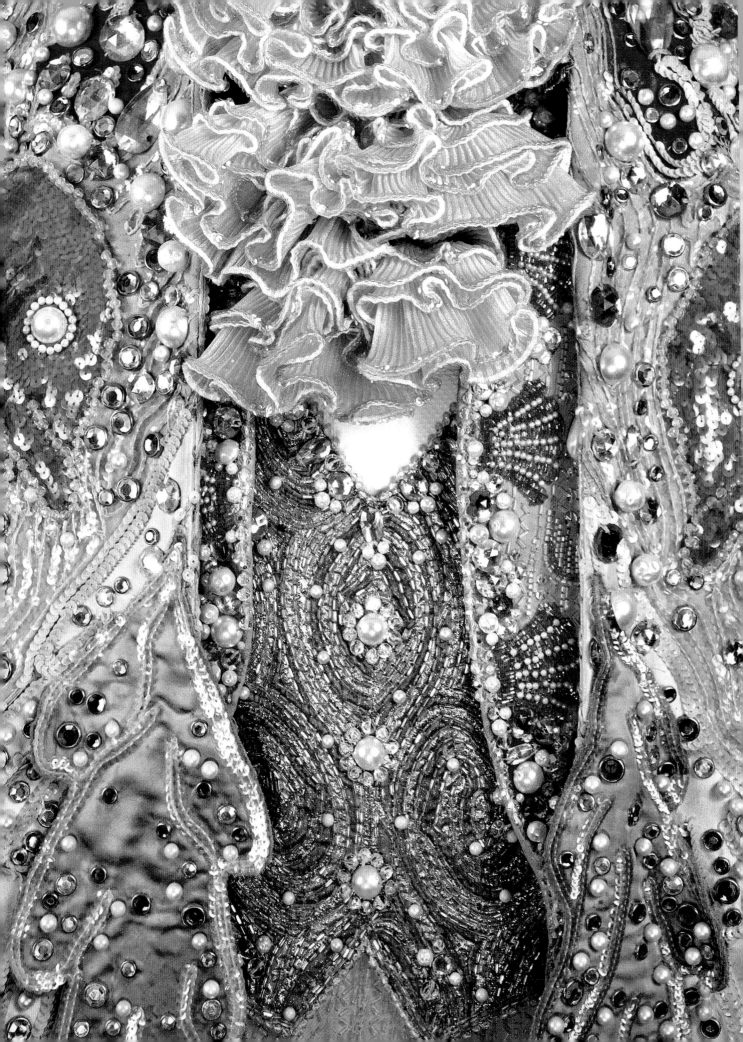

Liberace
Extravaganza!

Connie Furr Soloman and Jan Jewett

Foreword by Michael Travis

HARPER
DESIGN

An Imprint of HarperCollins Publishers

HarperCollins books may be purchased for educational,
business, or sales promotional use. For information please
write: Special Markets Department, HarperCollinsPublishers,
10 East 53rd Street, New York, NY 10022.

Published in 2013 by:
Harper Design
An Imprint of HarperCollins*Publishers*
10 East 53rd Street
New York, NY 10022
Tel (212) 207-7000
harperdesign@harpercollins.com
www.harpercollins.com

Distributed throughout the world by:
HarperCollinsPublishers
10 East 53rd Street
New York, NY 10022

Library of Congress Control Number: 2012951248

ISBN 978-0-06220255-0

Interior book design by Tanya Ross-Hughes

This book was published with the support of the Liberace
Foundation for the Creative and Performing Arts. Every
attempt has been made to give proper credit for quotations,
and to accurately give biographical information for and
attribution to the designer behind each costume, as well
as to accurately name the components of the costumes.
The authors apologize for any accidental missteps.

"Well, look me over!
I did wear it to be noticed."

Liberace

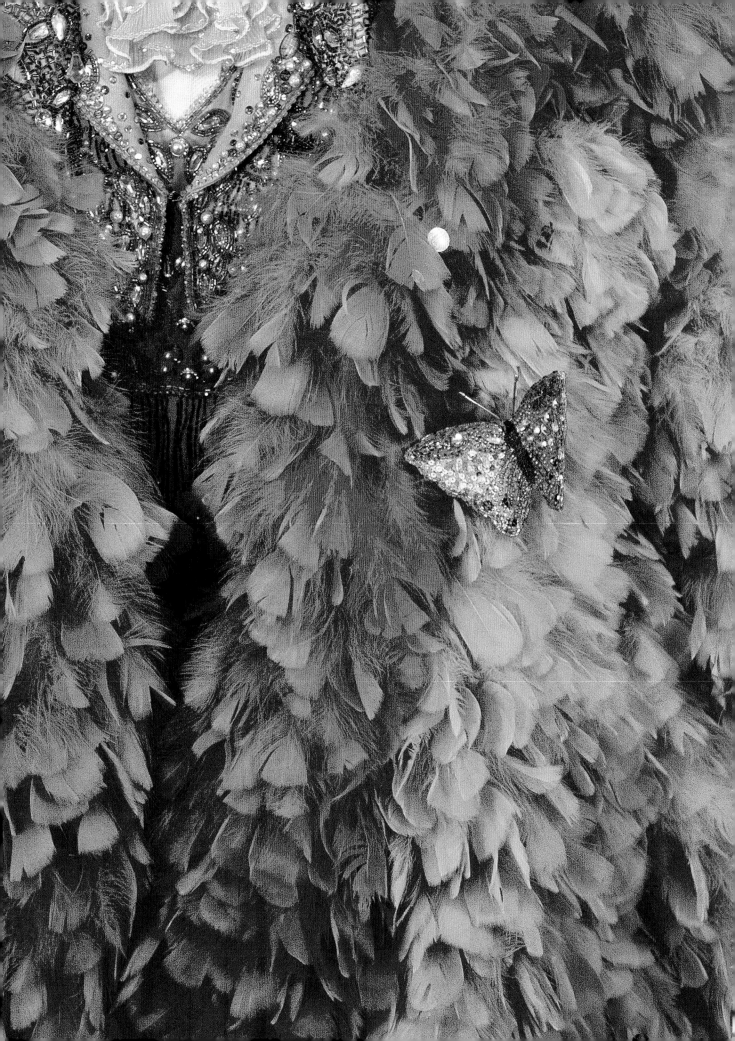

Contents

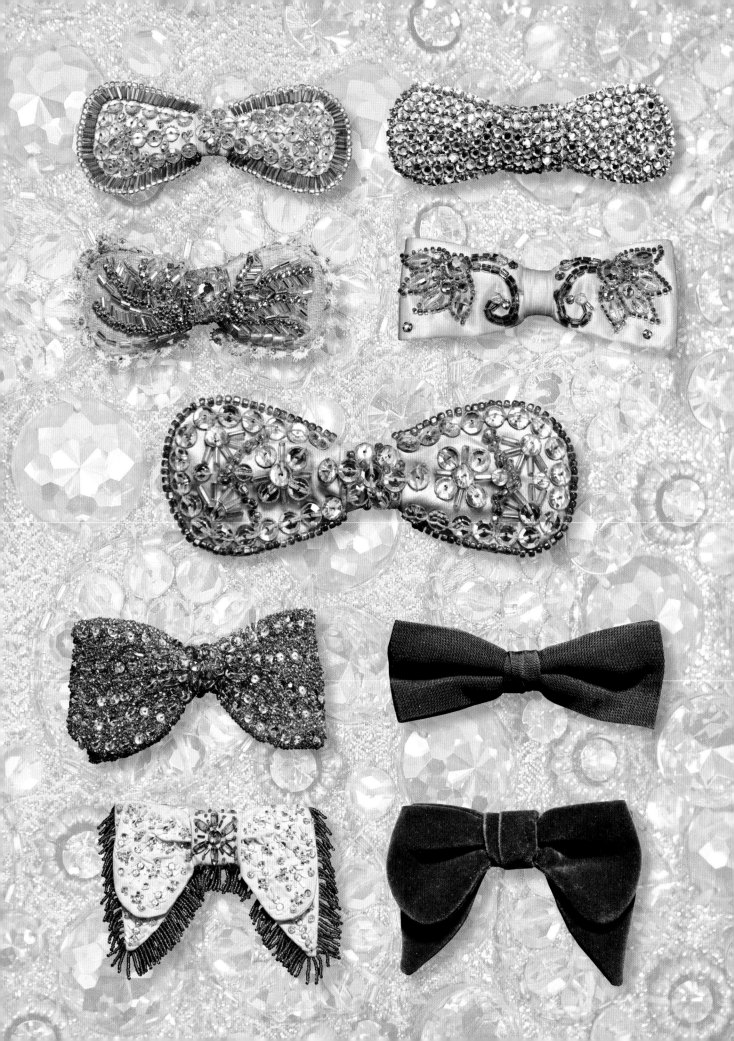

Foreword

Liberace was an incredible human being.

I was introduced to him in 1969 by Ray Arnett. Ray was his producer and choreographer, and he staged all of Liberace's shows. He briefed me that Lee [Liberace's nickname] was looking for a designer as his tailor, Frank Acuna, with whom he had worked for a number of years, creating his first "Glitter" costumes, was about to retire.

The costumes I made for him consisted of sequined and beaded jackets and suits. They were complemented with fur coats designed and executed by Anna Nateece. A signature candelabra, sparkling luxury cars, and original pianos were added to his performances. These were enough to make him more than a wonderful pianist; they earned him the title of "Mr. Showmanship," an image that was developed by Ray Arnett.

At my introduction to Liberace, in his Palm Springs home, he asked if I would create a chauffeur's costume for him to use on the stage in one of his limousines. I asked him how much he wanted to spend and he replied, "I hope you won't take advantage of me."

That first chauffeur's costume was blue. It was made of three-inch-by-six-inch patches of different shades of blue, each embroidered with different bugle beads, rhinestones, jewels, and sequins, as were the boots. The costume was further embellished with mink cuffs, collar, and boot tops.

He loved it.

Thus began a sixteen-year relationship, which ended at his death in the spring of 1987. Over the years, the costumes became more lavish, more detailed—and certainly not limited to sequins. Capes became extremely elaborate and furs became more grand. He was always satisfied, his motto being, "More is better, no matter what it cost."

But that was Liberace. He came from humble beginnings in Wisconsin, acquired a talent for the piano, and exploited it. To outperform other pianists, he added the first gaudy costumes. Fortunately, I was able to channel that taste into a more refined but always spectacular look.

I have always cherished the experience of working with him. He was unique. He was not a sophisticated man, yet he was comfortable with his peers and even with royalty, when he was presented to Queen Elizabeth. And he never forgot where he came from. He was just as happy eating a Greek dolma when he visited my mother in our family home in Detroit as he was when presented with foie gras at more formal occasions.

He was one in a million.

—Michael Travis

Preface

*V*isiting the Liberace Museum, in Las Vegas, Nevada, in 2009, we could not have imagined the journey we were about to take. As we entered the museum's magnificent costume gallery, Liberace's music was playing in the background and we were instantly mesmerized by the kaleidoscope of reflecting colors and lights. It was a magnificent spectacle. It reminded us of the magic of opening a most beautiful, ornate music box.

When we'd seen all of the fantastical costumes, we rushed to find the gift shop to take home a keepsake, so we could relive this glorious experience again and again. Much to our surprise, there was no book to be found. We stood there for a moment, stunned. Then we looked at each other. We knew we had found our next project.

Shortly after the visit, we approached the Liberace Foundation with a proposal. We asked permission to photograph all the costumes housed at the museum. The stars aligned for us. We were granted permission to take on what at times would be an overwhelming project—but also a consistently and extraordinarily inspirational one.

Neither of us knew much about Liberace at the outset. Who was this man who had entertained and delighted audiences for more than four decades? How had he remained relevant to the public for forty-six years? Who helped in creating Mr. Showmanship?

In our process of discovering the answers to these questions, we sieved through photographs of Liberace, fan letters, and cards that he had exchanged with other entertainment icons. We also went through his lavish collection of costumes and jewelry. We photographed everything, from every angle, and we painstakingly scribbled notes about what we saw, describing the little details about his costumes: the many kind of beads that were used and their colors, the threads, and the way each costume was created—all those things that only we costume geeks would notice. We also talked to those who had been closest to him: his producer, Ray Arnett; furrier Anna Nateece; designer Jim Lapidus; and designer Michael Travis (whom we are so blessed to have had contribute the foreword to this book).

Ultimately, we discovered a man whose life story is a tale of rags to riches, a man who had against all odds realized his wildest dreams. The world was forever changed by the great Liberace. His designers brought the razzle-dazzle that made him who he was.

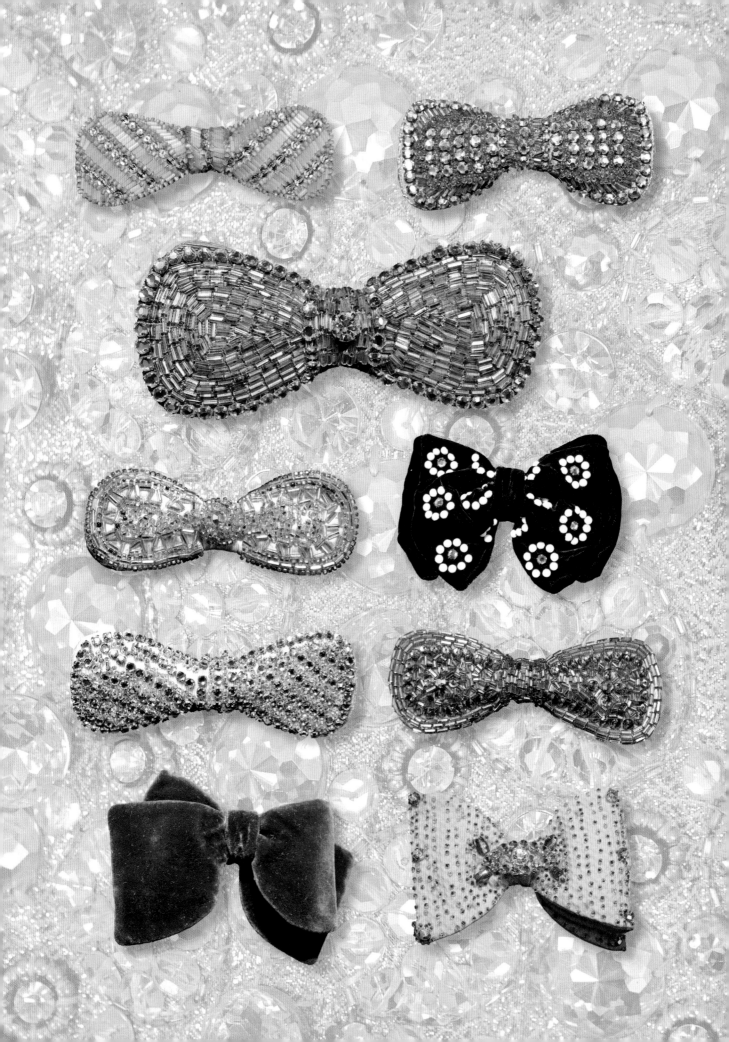

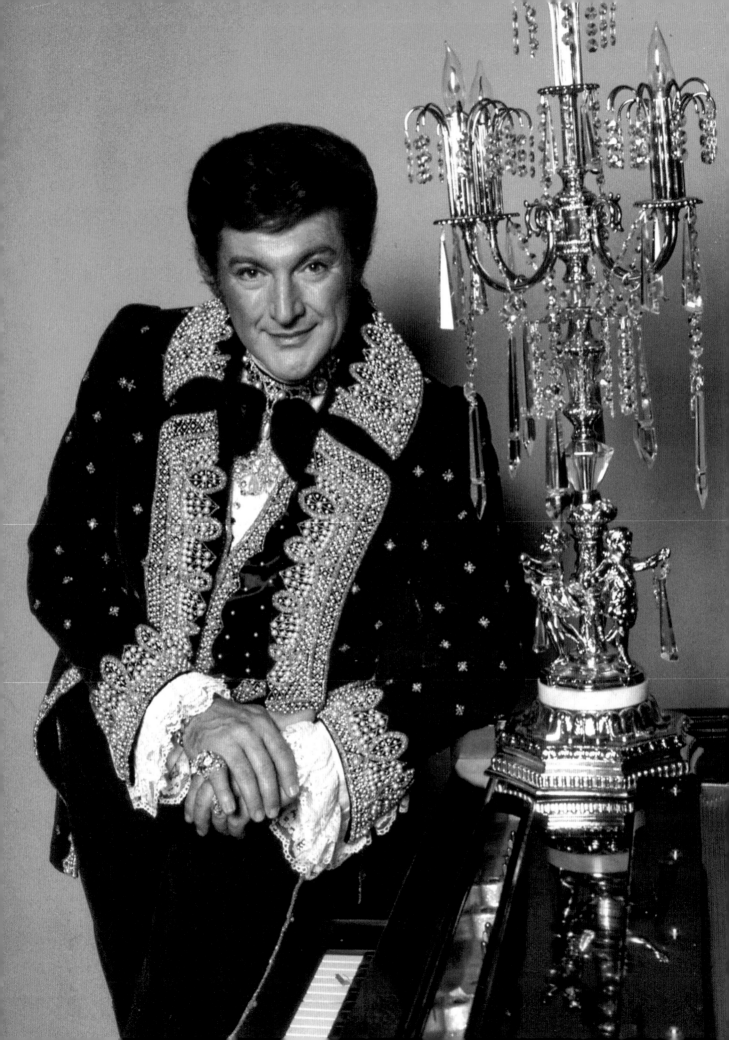

Introduction

At 2:05 in the afternoon of February 4, 1987, the world lost its most flamboyant and prolific performer: the great Władziu Valentino Liberace, known professionally as simply Liberace. His career lasted more than four decades, from the Big Band Era to the decadent 1980s. He earned two separate stars on the Hollywood Walk of Fame (one for music and one for TV), and he had six gold albums. His performances sold out Radio City Music Hall, Carnegie Hall, and the Hollywood Bowl—even today many of his attendance records have yet to be surpassed. He was an unparalleled TV personality, the magnetic star of *The Liberace Show,* which drew more than thirty million viewers at any one time, and received ten thousand fan letters per week. And he was the proud owner of his own museum, in which he showcased his dazzling possessions—his outrageous costumes, jewelry, cars, and pianos—for more than 450,000 museumgoers per year during peak years.

In 1955 *The Guinness Book of World Records* listed Liberace as the world's highest-paid musician and pianist in a single season after he earned two million dollars for a twenty-six-week stint the previous year. He made millions and he spent lavishly, happily enjoying the fine things in life—a glorious estate, ornate cars, and grand pianos. But above all else, Liberace's legendary wardrobe—his famous sequined, bejeweled, and rhinestone-studded

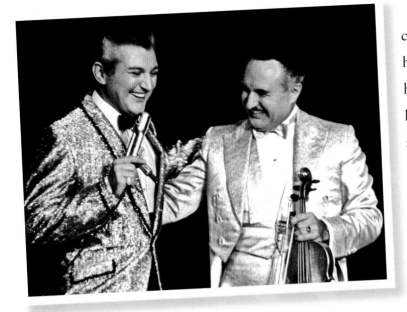

costumes; his feathered capes; and his fur collection—is what defined him. His wardrobe embedded him in the minds of his fans, and it is what people most associate with him. In glitter and glam regalia that only he could pull off, Liberace earned, among numerous other awards, the titles of "best-dressed man in show business" from the American Fashion Foundation, "best dressed" from *People* magazine, and "best-dressed entertainer" from the Las Vegas Chamber of Commerce.

Liberace's ensembles, created by brilliant designers and tailors—Sy Devore, Frank Ortiz, Frank Acuna, Jim Lapidus, Anna Nateece, and Michael Travis—inspired megastar performers such as Elton John, Cher, Freddie Mercury, and Madonna to bring eccentricity to their stage costumes. Indeed, today's young pop stars continue to follow his lead. One cannot help but consider Lady Gaga's entrance to the Grammy Awards enclosed in an egg—a reminder of Liberace's 1986 emergence from a Fabergé egg at Radio City Music Hall.

As Eric Felten wrote in the *Wall Street Journal*, "Though commentators have rushed to declare Ms. Gaga the new Madonna, the David Bowie of our day, or Elton John, Boy George, and Bette Midler all rolled into one, her real progenitor is the original purveyor of flamboyant rhinestone-studded excess, Liberace."[1] And as Adam Nagourney wrote in the *New York Times*, "Liberace was Lady Gaga before Stefani Germanotta was even born."[2]

Although ridiculed by some for his over-the-top numbers, Liberace was never one to apologize for who he was or to shy away from attention. "They have me crying all the way to the bank," he would say. It was one of his signature catchphrases.

Page 12: Liberace in a black and gold tuxedo with his signature candelabra. *Above*: Liberace and his brother, George Liberace. *Opposite, top*: Liberace in his red jumpsuit and black jacket costume. *Opposite, right*: Liberace in his silver knickers costume. *Opposite, left*: Liberace in his Hapsburg eagle costume.

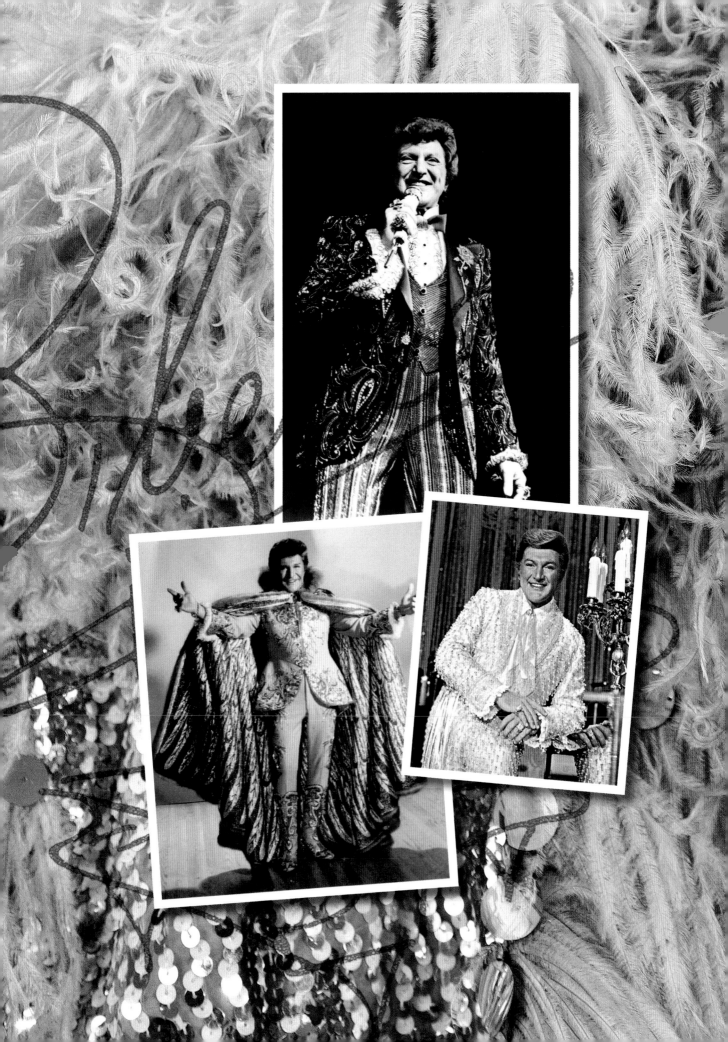

One

The Beginnings

Born to Frances Zuchowska, a Polish American, and Salvatore Liberace, an Italian immigrant, on May 16, 1919, Liberace, weighing thirteen pounds, was the sole survivor of twins delivered "under the veil"—encased in the delicate membrane of the amniotic sac. In medieval times, this was considered an omen that a child was destined for greatness.

Salvatore Liberace was a professional French horn player who once toured with John Philip Sousa's band, and he insisted his children be given musical training. Money was tight and Frances felt it was an expense they couldn't afford, but Salvatore's wishes prevailed. Liberace's older siblings, George and Angie, received music lessons, and in his crib Władziu would be lulled to sleep by the music created by his father, brother, and sister. Angie recalled, "At three, little

Walter was playing the battered family upright by ear. . . . You could never keep him off that piano bench. . . . He'd just brush you aside." [3]

Liberace relates in his autobiography that as he got older he would often play the piano in his sister's stead, fooling his mother, who was listening to make sure Angie was practicing. Angie would "skip out to play baseball or something with the kids and I'd carry on with her practicing." [4] Recognizing his son's musical potential, Salvatore began teaching him piano. Soon the family agreed that it was worth the money to enroll him with a professional piano teacher.

In 1927 seven-year-old Władziu had what he would later describe as a life-altering experience. Ignacy Jan Paderewski, a friend of Liberace's mother, visited the Liberaces at their home in West Milwaukee. Paderewski

was a Polish national who had achieved international fame and wealth as a pianist. His performance blended classical and popular forms. He had an onstage persona that drew adoring and loyal fans, attracting a new audience to the theater. He demonstrated how a musician could enter popular culture by developing marketing strategies—and this was not lost on the boy who would become the famous Mr. Showmanship.

At the end of Paderewski's visit, he paused and placed his hand on the young man's head, saying, "Someday this boy may take my place." It was a pivotal moment for Liberace: "Inspired and fired with ambition, I began to practice with a fervor that made my previous interest in the piano look like neglect."[5] Paderewski was to become a lifelong friend and mentor.

Władziu, or Walter as he became known, quickly outgrew the abilities of his first piano teacher. His father introduced him to Florence Bettray Kelly from the Wisconsin College of Music. Kelly was considered an outstanding teacher. The *Wisconsin College of Music Bulletin* listed her as woman whose "natural gifts combined with brilliant playing have made her remarkably successful in the development of pupils."[6] She was also a strict taskmaster, demanding discipline and perfection. Determined to help Walter, she secured him a scholarship at the college so he would be guaranteed access to music lessons. The scholarship ended up lasting more than fifteen years and was critical to his development as an artist. The United States was soon to enter the Great Depression, and without the financial assistance it is unlikely that Liberace would have been able to continue his training.

The 1930s

The thirties were desperate times for many families. The Stock Market Crash of 1929 threw the nation into the Great Depression. The arts survived due to the patronage of government and wealthy individuals, but their luster had dissipated and Salvatore had difficulty procuring employment. On occasion he was able to get work in the movie industry, performing in the orchestra while the movie played behind him. Once the talkie arrived, this was no longer an option.

In 1931 the birth of Walter's baby brother, Rudolph "Rudy" Liberace, stretched the family's sparse resources even more. To help support the family, Walter's mother converted the front of their house into a grocery store. At dinnertime, Liberace would be sent to the store to retrieve damaged produce to use in the family's meal.

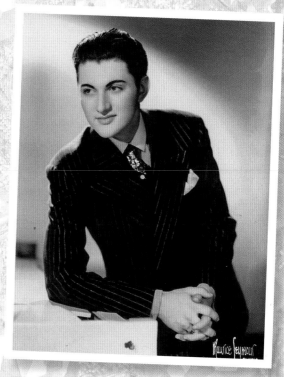

Above: Liberace as a teenager.

The Liberace children obtained jobs to assist with providing for the family. Walter was only ten or eleven when he procured his first paying gig. He'd badgered the manager of the Wisconsin Theater for the opportunity to perform in its "talent review." After a week, the manager relented. But it was a secret to his family. It was not until Florence Kelly contacted his father, "Do you know what Walter's doing? He's playing at the Wisconsin Theater. He's pretty good, too!" Angie later recalled that "he got seventy-five dollars for appearing in that show for a week. It seemed like a million at the time!"[7] But Salvatore was not pleased. As a proud Italian man, it was infuriating to him that his son was the breadwinner for the family. Liberace later said about his father, "I wasn't playing the kind of music he wanted me to learn or to perform, and he told me so with a lot of emphasis and muscle."[8]

Undeterred, Walter continued to seek employment. Performing felt right and he was good at it. He was fourteen when he found his next gig. One commodity that doesn't suffer during an economic depression is alcohol, and in 1933 Walter was able to aid his family by playing in the various beer joints around town. His mother was not pleased with the arrangement, and Walter, on occasion, would have to sneak out the window to meet up with his bandmates. But in time she came to accept it. The money was desperately needed.

In 1935 Salvatore was playing in a Works Progress Administration (WPA) orchestra. With the assistance of Florence Kelly, he convinced the conductor to allow the young Liberace an opportunity to appear as a soloist. Walter was over the moon with

excitement—as much about the music he would play as about the chance to perform in front of a large audience. His main concern: he wanted to look good. Against his father's wishes, he insisted that his brother's hand-me-downs were not appropriate for his performance, and he invested a whopping $27.50 to purchase a suit of tails. Just before the show, his brother George, a concert violinist, asked Walter if he'd learned to flip the tails before he sat down. He had not—it hadn't crossed his mind. As he reached for the first high note of the concert, his sleeves pulled toward his elbow. The moment he came to a musical rest he stood up and flung his tails over the piano bench; the audience laughed appreciatively. It proved an important lesson in engaging an audience, and one he would never forget.

For the young Liberace, style was increasingly important—it defined him, it made him memorable. A fellow musician remembered how the young Walter stood out from the rest of their circle: "He always wore a vest and suit for school. The rest of us were wearing sweaters. He was accepted, whatever he did or wore." A friend of Liberace's, Steve Denkinger, remembered that Walter once served as an emcee at their high school fashion show. "That night he came out on the stage in a beret, smock, and flowing artist's tie. He had a long pointer and an easel. He did a perfect job describing the clothes. It brought down the house—and I don't know one boy who resented it; everybody thought it was a big joke."[9]

Looking at Liberace's high school graduation photo, Joseph Schwei, assistant principal, at West Milwaukee High, recalled, "Look. That's a purple boutonniere. . . . That

was Walter for you. And see that double-breasted vest with the lapels. Nobody but Liberace would have dared to dress like that in those days—and the kids liked him for it."[10]

Toward the end of the era, technological advances proliferated. The period of the great shipping and railroad companies was coming to an end, and the age of air travel had begun. At this time an important advancement was made, and Americans saw the advent of a new form of entertainment: television. Young Liberace had no way of knowing how this would change his life. Financial security was in his future.

The 1940s

The forties marked both a turbulent and a prosperous time in the United States. The first five years were full of strife, with the country immersed in World War II. There was rationing, and people struggled to make ends meet. But fantasies created by the images on the silver screen helped to ease the mind, allowing an escape from the daily turmoil, and audiences attended movies in record numbers.

Many classics were produced in the forties—masterpieces such as *Casablanca*, *It's a Wonderful Life*, *Fantasia*, *Citizen Kane*, and *Rebecca*. The careers of Humphrey Bogart, Lauren Bacall, Jimmy Stewart, Bette Davis, and Cary Grant were propelled to the forefront. A young man by the name of Frank Sinatra, unable to serve in the military due to a punctured eardrum,

made his mark wooing millions of women with his silky voice.

For Walter, the early forties were full of conflict. Due to a spinal condition, he was also unable to serve in the military. The divorce of his parents in 1941 and his dissatisfaction with his performance opportunities caused him great distress. He was in a quandary about the direction his career should take—should he be a concert pianist or a nightclub entertainer? Florence Kelly advised him to combine the two: "Play some classics, then give them something popular. Make them think they're getting some uplift, then slide into something melodic and familiar. . . . I think it is time you move on. You've gone as far as you can go in Wisconsin. You've got to reach a more sophisticated audience. I think you should go to New York."[11]

Walter had always fantasized about performing in New York City and Kelly's

Above: Liberace with his brother George, sister Angie, and mother Frances Zuchowska.

words struck a chord. He knew of clubs such as The Rainbow Room and Central Park Casino. He had imagined himself performing at Carnegie Hall. With Kelly's encouragement, the twenty-one-year-old packed his belongings and headed east to the Big Apple. But life in New York wasn't easy, and Walter often went hungry in his one-room apartment. In later years he would recall this period as the time he saved ketchup packets to make soup.

Liberace's first gig in New York was as an intermission pianist at the Persian Room, a posh supper club in the Plaza Hotel. He would perform while patrons ate and drank between sets. It wasn't glamorous, but it was instrumental to the development of his act. The headliner was another Wisconsinite by the name of Hildegarde Loretta Sell, known professionally as Hildegarde. Liberace would study her performance. He noted the theatricality of her act, the way she used props, the flowers on her piano. Her entrance, he recalled, was marked with "a rousing fanfare, and spotlights shone on the stage. Six chorus girls emerged in maids' uniforms carrying dusters. As they dusted the piano, they sang of the coming of their mistress, the inimitable, the glamorous Hildegarde!" Walter noticed that she always left her audience asking for more. Hildegarde advised him that "he had to have a gimmick," and shortly after this conversation he saw the movie *A Song to Remember*, based on the life of Frédéric Chopin and starring Merle Oberon and Cornel Wilde. "It interested me to see that in the film whenever the great composer played, he had a candelabra on the piano," Liberace wrote in his autobiography. The ambience created by the candle-

light, the classical nature of the subject, as well as the association with Chopin, inspired him to adopt a candelabra in his act; he was looking for his gimmick. "So I went out to a little antique shop and bought a brass candelabra for fifteen dollars and a quarter's worth of candles and put it up on the piano that evening when I did my act. After that, whenever I opened somewhere, reviewers commented on the candelabra."[12] It became his trademark for the rest of his career.

Always good at being a publicist for himself, Walter decided to advertise his act. Liberace was not a name that many found easy to pronounce. To counteract this difficulty, he sent out penny postcards on which his name was spelled phonetically: "Liber-Ah-Chee." The effort paid off. One of the postcards reached Maxine Lewis, the entertainment director of the Frontier Hotel in Las Vegas. Having heard of Liberace's reputation as a performer she called and offered him a job. The salary he negotiated was higher than he had ever received, a whopping seven-hundred-fifty dollars per week. For Liberace, it was a thrill. But after a week Miss Lewis pulled him into her office to say, "We're not paying you enough." His act was so popular that she doubled his salary and extended the run six more weeks. His net profit was $9,750.[13] This was the beginning of the extremely profitable, lifelong relationship Liberace would come to have with casinos and the city of Las Vegas.

The primary fashion during the forties was a military silhouette—represented by women's straight skirts and coats with square, boxy shoulders. In 1942, the US War Production Board began severely restricting the amount of yardage that could be used

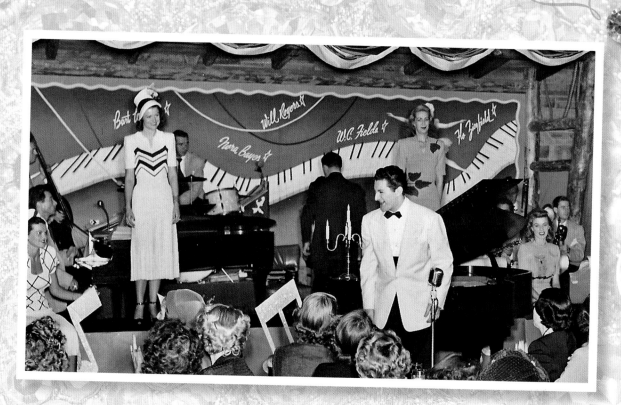

in garments. In an effort to save fabric, suits could not have cuffs or pocket flaps. Thankfully, the last five years of the decade marked a period of reconstruction. With the end of the war came the end of rationing in the United States, and this brought a dramatic change in fashion. Female fashion was recreated by the likes of Christian Dior's 1947 "New Look," which introduced the world to a new kind of style and beauty: the feminine silhouette, realized with wasp-waist dresses and petticoats. Men's style after the war favored long coats with pronounced shoulders, double-breasted jackets, and full-cut trousers. These were considered signs of opulence and luxury. In 1949 *Esquire* magazine promoted the New Look by labeling it "the bold look"—consumers wanted their clothing to make them stand out, not to simply fit in.

Liberace wore formal wear to casinos and supper clubs. Typically it consisted of either a black tailcoat and vest or a white dinner jacket with cummerbund and black trousers.

As he had done in high school, he would personalize his look by adding his own touches, a handkerchief in his breast pocket, a top hat, a watch chain in the style of the zoot-suiters.

Although television had been invented, the public still used radio to inform and entertain, and radio audiences numbered in the tens of millions. The careers of Jack Benny, Bing Crosby, and George Burns all flourished on radio during these years. Liberace alleged an aversion to the medium because he felt that his appearance was necessary to give an audience the full experience of his performance. But in 1945 he was offered the opportunity to be on the *Texaco Star Theatre* program. In the past he'd only been able to secure audiences the size his venues could hold, but with radio the possibilities were limitless. He couldn't pass up the offer.

The 1950s

Transitioning out of World War II, the fifties were a period of restoration and consumerism. Soldiers and their families needed housing, and suburban communities were born. Women had been invaluable members of the work force during the war, but now most returned to being housewives.

In the wonderful world of fifties entertainment, fans flocked to the theater to see performances of *My Fair Lady*, *The Music Man*, *West Side Story*, and *The Threepenny Opera*. The silver screen projected film classics such as *Singin' in the Rain*, *The African Queen*, *Harvey*, *Sunset Boulevard*, and *12 Angry Men*. James Dean, Marilyn Monroe, Jayne Mansfield, and Pat Boone were stars. A new performer, the likes of which had never been seen before, Elvis Presley, shook, rattled, and rolled.

Families of the 1950s embraced television, a new, life-changing form of entertainment, and watched together in the evenings. Soon Liberace had his chance to be a part of this phenomenon. George Liberace, seeking out a manager for his brother, bombarded the Hollywood management team of Gabbe, Lutz and Heller with notes and postcards: "Lee sold out all seven nights at the Baker Hotel in Dallas"; "Standing ovations every night at the CalNeva Lodge here at Lake Tahoe." [14]

Gabbe, Lutz and Heller represented an impressive stable of performers, including Lawrence Welk, Frankie Laine, Mel Tormé, and the Andrews Sisters. Initially, they felt that Liberace lacked the level of talent they were interested in representing; however, with George Liberace's insistence, they gave his brother a chance. Sam Lutz was persuaded to attend a Liberace performance

at the Hotel del Coronado in San Diego. Luckily for Liberace, Lutz attended the performance with Leo Robin, lyricist of "Thanks for the Memory," "Love in Bloom," and a variety of other popular songs. It was he who advised Lutz to sign Liberace. "This guy is amazing," the songwriter said. "He does some trick of modulation on the piano that I've never heard before. Sign him, Sam." [15] By the following Monday, the Liberace brothers had signed a seven-year management contract with the prestigious firm of Gabbe, Lutz and Heller.

Sam Lutz and Seymour Heller, in planning their strategy for Liberace's career, realized they needed a way to introduce him to a mass audience. They contacted Don Fedderson, general manager of KLAC-TV, Channel 13 in Los Angeles. Fedderson studied Liberace's performance and decided that he had television potential. One afternoon he picked up Liberace and drove him out to the suburbs. There he asked the performer what he saw. Liberace noticed a skyline full of television antennae, the majority in poor and middle-class districts. His face lit up. His future was clear. Television was the medium to reach a new audience, a bigger audience, that otherwise might never have known him.

Inspired by Paderewski and Hildegarde, Walter, in 1942, had decided to follow their example and began using only Liberace as his professional name. On September 20, 1950, he went to court to legally change his name to Liberace, with no last name and no initial.

The Liberace Show aired on August 7, 1951. Within a year, the show became a cult phenomenon, gaining more than thirty-five million viewers. It was also extremely profitable, having more than 178 advertisers. "For some reason," said personal manager Seymour Heller, "most of the sponsors are banks and biscuit companies. No matter which way he turns, he's in the dough." [16] It had more viewers than even *I Love Lucy* or *Dragnet*. Liberace had become a television idol and a household name.

As he did with his live performances, Liberace carefully calculated his appearance on the show. He not only had to entertain his audience, he also needed to win them—to make them loyal to him. Wearing immaculate tails, he would spray streaks of gray in his perfectly coifed hair to appeal to a wider audience. He also had his teeth filed and capped in preparation for camera close-ups— he'd never been able to afford this before. It worked. The thirty-two-year-old Liberace appeared dignified and mature. He was a matinee idol; older ladies adored him. His

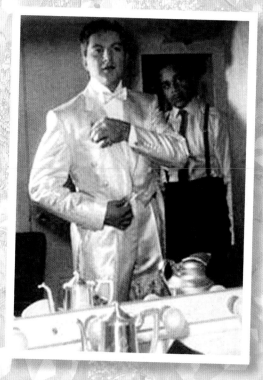

Above: Liberace and a stage assistant prepare for his performance.

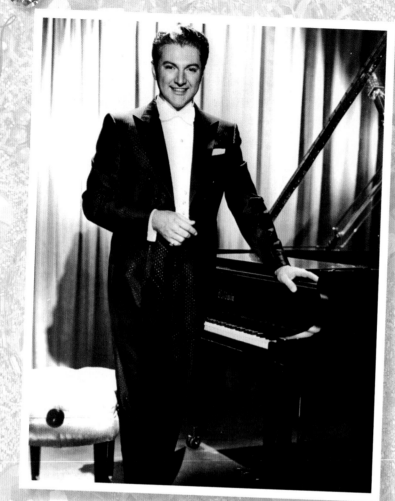

appeared in three films, *Sincerely Yours*, *Merry Mirthquakes*, and *South Sea Sinner*.

During this period, one fan wrote: "Dear Maestro: I am most appreciative of your delightful program and look forward to each Saturday night when for thirty minutes at least, the problems of the week seem minimized and humdrum existence unimportant whilst my living room is filled with your genius and overall softness and elegance is cast." [17]

In 1952 during a summer hiatus from the show, Liberace was booked to perform at the Hollywood Bowl. In preparation for his performance, he visited the venue to ascertain what the acoustics were like. The large amphitheater, which could hold more than twenty thousand people, was a concern. How would the audience be able to discern him in a sea of black tuxedos? To differentiate himself from the ensemble, he decided to don a white suit of tails. The result was met with resounding success. Even from a distance, the audience was able to clearly see the star. Asked by a reporter what he would do to top that appearance, Liberace looked at the gold lamé dress his sister, Angie, was wearing. "I will wear gold lamé," he said. [18] He was serious.

"I saw the showmanship there is in daring to do something different, in challenging the conventional," Liberace wrote in his autobiography. "I realized that just with the white suit I had lightning in a bottle . . . or, at least in one of the pockets." [19]

mailbox filled up with marriage proposals. His exposure on television catapulted him into concert halls and major nightclubs that had been previously unavailable to him.

This rapid rise to fame is what he would later refer to as his "white heat period." His wealth grew tremendously. Prior to his television show he reported earning fifty thousand dollars a year; afterward, his income soared into the millions. The first two years of his show alone earned him seven million dollars. It was as though his public could not get enough. His peers acknowledged his successes; in 1953 he was awarded two Emmys—one for "outstanding local television show" and the other for "outstanding male television performer." At the height of this "white heat" period, he

Liberace returned to the Hollywood Bowl in 1956. Always looking for ways to improve the performance, he implemented futuristic lighting effects. The press loved it. "A Liberace show puts a great strain on electrical equipment," read a review in the *Los Angeles Times*. "The lights go up and down and change color so often. . . . There were enough microphones to record an H-bomb explosion. . . . enough spotlights to forestall an air raid."[20] The *Hollywood-Citizen News* reported, "However one may classify him as an artist, one would have to say that the smiling pianist gave the people who attended the concert just what they WANTED . . . a full measure of Liberace."[21]

Liberace continued playing live shows even as he became a television star. In 1954 he played Madison Square Garden to a record-breaking crowd—18,456 people attended. Additional seats had to be added to accommodate the audience. He received a staggering payment of $138,000 for the concert. At the time, *The Guinness Book of World Records* listed this as the most money a pianist had ever received for one show. By today's worth, it would be in excess of one million dollars. Prior to this, his idol Paderewski was the only pianist able to fill the Garden, and that was not to capacity.

The opening at the Riviera Hotel & Casino in Las Vegas marked Liberace's leap beyond his black tuxedos and white suit of tails. The Clover Room, in which he was performing, was an opulent space that would accommodate twelve hundred audience members. Liberace made good use of his wardrobe for this—he had ten costume changes during the one-hour-and-

twenty-minute show. He'd commissioned a gorgeous white silk lamé tuxedo from Christian Dior to open the show. But his second costume, also by Dior, topped it—it had a hand-stitched tuxedo jacket with nearly 1.5 million shimmering sequins. This was the beginning of the spectacular costume changes that were to become an integral part of his performances. He also wore the gold lamé he'd promised reporters after the 1952 Hollywood Bowl appearance. "They crawled out of the woodwork when they saw it!" he said.[22]

In 1955 Liberace became the headliner at the Riviera in Las Vegas, earning fifty thousand dollars per week. This was the

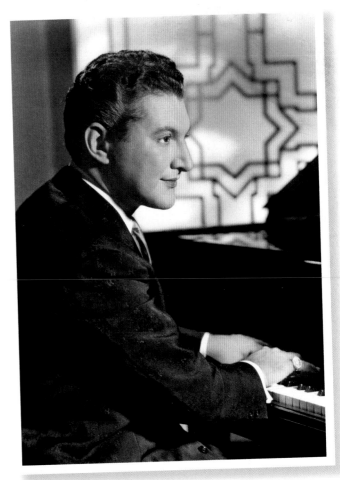

Opposite and above: Liberace in a black tailcoat at his performances.

highest fee a Las Vegas performer had ever earned; Marlene Dietrich previously held the record at thirty thousand dollars per week.

The Riviera was the hot spot to be seen and entertained when in Las Vegas, and its directors commissioned Liberace to be their headliner. He'd previously performed at the Frontier. Without him, the Frontier had been forced to revamp its image. It changed its name to the New Frontier, and in 1955 offered a contract as headliner to an up-and-coming performer by the name of Elvis Presley. The twenty-one-year-old pop star had previously made his famous waist-up appearance on the Ed Sullivan Show. However, his act at the New Frontier failed. He was no Liberace. But Liberace was willing to help him. Liberace recounted, "Elvis's manager, Colonel Parker, came to see me. He said, 'My boy'—as he used to call Elvis—'is appearing across the street. He's havin' some problems.' He told me what was happening and then added, 'He admires you so much. If I could bring him over for a picture, he'd really appreciate it.'"[23]

The performers got together for a publicity photo session, but it lacked chemistry. Later that season Elvis attended one of Liberace's performances at the Riviera. Liberace later described how he, wearing "showy white tails," serenaded Elvis. After the show, a second photo shoot ensued. It was November 15, 1956. This time, the entertainers exchanged jackets and instruments—Liberace wearing Elvis's striped blazer and Elvis wearing Liberace's gold lamé jacket. They hammed it up for the photographers. "Elvis and I may be characters—me with my gold jackets and him with his sideburns—but we can afford to be," Liberace joked. [24]

Elvis never forgot Liberace's generosity. He regularly sent Christmas cards, and when Liberace opened a new Vegas show, Elvis would send a guitar made of flowers to his dressing room. "I only send them to the people I love," Presley told him.[25]

The "white heat" period would not last. By the late fifties, overexposure on television and media speculation that Liberace was gay resulted in fewer bookings. To counteract the speculation, Liberace fired his manager, Seymour Heller, and, to replace him, hired John Jacobs, Liberace's former attorney. Liberace also sued two publications for slander: Hollywood's *Confidential* magazine and London's *Daily Mirror* newspaper. Both retracted their statements and Liberace was awarded a $24,000 libel settlement. Still, the seed had been planted.

In an attempt to have Liberace taken more seriously, Jacobs recommended that the performer "tame down his appearance."

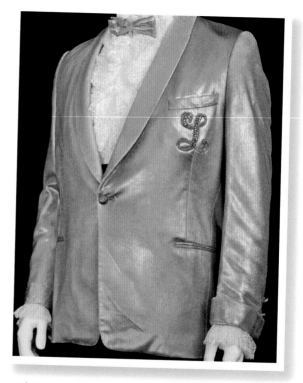

Above: Gold lamé jacket created by The House of Dior.

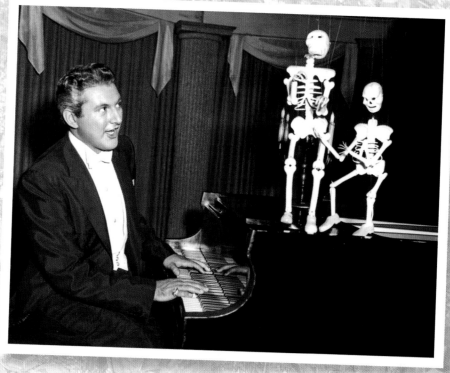

Above: Liberace in a 1950s performance of "The Dance of the Skeletons."

In a later television appearance, Liberace spoke about the changes he made at this time: "When you're starting out in show business, you need these things. Once I was established, I gave up the flamboyant clothes. Actually, I had to do it to find out if the audiences came to see me or all the fancy trappings. It became a matter of personal pride. To me, the image has been something I found amusing in a sense. I was caught in a gimmick I really hadn't planned. Then the pattern was established for me as a flamboyant performer. I was a curiosity who had to come up with fifty thousand dollars worth of sensation a week." [26]

In an attempt to stop the flow of accusations of homosexuality, Liberace's new advisors decided to give him a more conservative, "manly" appearance. They suggested he cut and straighten his hair, wear Brooks Brothers suits and traditional button-down shirts. There was to be no candelabra, and he would change his costumes only once per show—instead of a minimum of four times. The result was disastrous. A review in *Variety*

read, "There's still something nice about the man, but he seemed to be under the control of some outside force by talking a couple of octaves lower than he is famous for." [27]

The approach was met with abject failure. "I tried to revert back to what might be called sensible onstage clothes. That year my income dropped by eight-hundred-thousand dollars," Liberace remembered. He said his audience felt like it was being cheated: "Not to see Liberace 'done up' is like coming across Marlene Dietrich in a baggy old housedress." [28]

In the mid-1950s Liberace discovered Claude M. Bristol's self-help book *The Magic of Believing*. Bristol's philosophy—that if readers visualized themselves as successes, they would become successful—guided Liberace in these tough times. His challenge was how to reinvent himself in order to reconnect with his fans. He knew he needed a new look, a fresher look, but how could he make that happen? His first step: firing Jacobs and rehiring Heller. They would work together until his death.

Sy Devore

In 1955 actor William Holden suggested Liberace contact his designer, Sy Devore, "tailor to the stars." Devore understood Liberace immediately. He recognized how important his appearance was to his show and, accordingly, his self-esteem.

With Devore's eye and exceptional talent, Liberace's look was refreshed—his luster was renewed—and the public loved it. By 1957 the Brooks Brothers debacle was forgotten. The press loved him again. Liberace was back to being *Liberace*.

A new *Variety* review of him read: "The star's flamboyant style and dressing combined with his engaging humility and his strenuous application of the effort necessary for bistro production spell out his complete answer to a showman's ideal." [29]

Sy Devore was born Seymour Devoretsky in Brooklyn, in 1908, to Russian immigrant parents. His father, David Devore, was a tailor, and the children were trained in the family vocation.

The Devore family's original shop was located in New York's theater district in the 1930s and many of their clients were jazz musicians. In 1943 the family relocated to Los Angeles and again found themselves surrounded by a world of entertainers. Sy, known to be a fastidious dresser, had no acting or musical skills, but was captivated by LA's show business world. The same year he moved to LA, he broke into the entertainment industry by moonlighting as a road manager for a popular female singing group, the Andrews Sisters. He knew he wanted out of the family business, so he also opened a

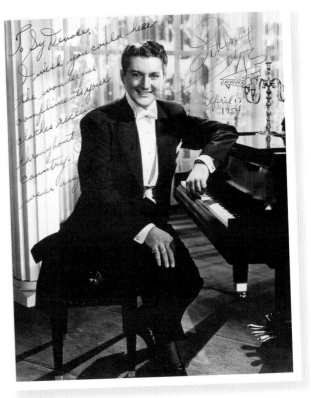

restaurant. But it was not successful; the restaurant world was not his calling.

In 1944, Devore opened Sy Devore Custom Tailors. He used the skills his father had taught him, but the business was his own. Sy began tailoring band costumes for Tommy and Jimmy Dorsey and Count Basie and his orchestra. It was not unusual to find the charismatic Devore at popular restaurants and nightclubs such as Cafe Trocadero, Ciro's, and Mocambo. His charm brought a wealth of new clients, and his star clientele grew to include John Wayne, Danny Thomas, Nat King Cole, Desi Arnaz, Bing Crosby, and members of the Rat Pack: Frank Sinatra, Sammy Davis Jr., and Dean Martin. Devore also created ensembles for Presidents John F. Kennedy and Lyndon B. Johnson.

Liberace once stated in a television interview with Phil Donahue, "Good grooming indicates an ordered mind, self-respect, and pride." [30] Thus it was no surprise that Devore's reputation for excellence attracted Liberace to his shop. Devore was known to

be a perfectionist, discarding garments that didn't meet his standards and having his tailors begin again. But perfection doesn't come cheap and his suits were not inexpensive. One of Devore's clients, Sammy Davis Jr., once placed a thirty-thousand-dollar order for eighty-four suits in various hues for his television variety show, one of the first in color. Typically, a custom-made Devore suit would be priced at $285 (a suit off the rack was approximately $25); a sports jacket, $200; a shirt, $25; and $85 for slacks. Bob Hope once joked, "In a very good year, I have my choice between a Rolls-Royce, a new house in Beverly Hills, or a suit from Sy Devore."

Devore remarked that of all his clients, he was proudest of how he transformed Liberace: "When Liberace came to me . . . I changed his style completely. He was wearing wide shoulders and droopy things. He wanted something a little different. In fact, he wanted a pink tuxedo, but I talked him out of that."[31] Instead Liberace received a set of white tails, a gold lamé tuxedo, and a gold-and-black tuxedo with a black satin lapel and cuffs. Now most of the suits that Liberace wore on his television show

were designed and tailored by Devore. Devore also tailored Liberace's wardrobe for *Sincerely Yours* (1955), which featured Liberace in his first major role in a movie. The costumes for *Sincerely Yours* were designed by Howard Shoup. Liberace's wardrobe included a gold lamé smoking jacket, gray silk suit, and black tuxedo peppered with gold polka dots, all marvelously tailored.

To Liberace, the wonderful world of colors and textures that Devore revealed to him symbolized all that had been beyond his reach as a child in a family of modest means. He was enchanted by lavish, costly cashmere and vicuna, and he had a proclivity for plaid sports coats, ties with pink in them, and big cuff links. He also favored hand-painted ties—often painting them himself. And Devore's artistic visions played well with Liberace's. Devore once said that while the star was one of his more meticulous and experimental customers, he was also among the most courteous and least temperamental.

Opposite: A Liberace promotional card with a note from him to Sy Devore. *Below, left*: Publicity for Liberace's style. *Below, right*: Designer Sy Devore

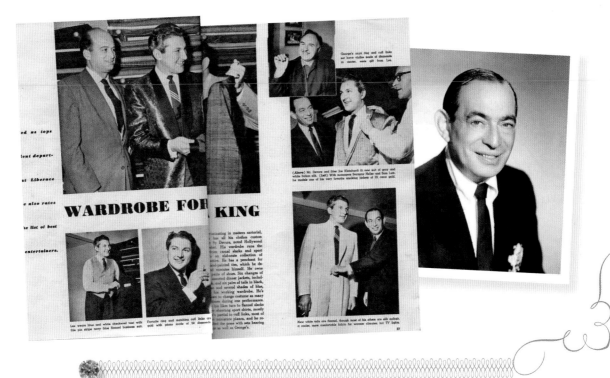

WARDROBE FOR KING

The 1960s and '70s

The sixties was an era of transition. Civil rights were at the forefront of American politics. The sexual revolution was in full swing and the gay rights movement took off. The West Coast saw the Summer of Love and the East Coast saw Woodstock. Entertainers such as Janis Joplin, the Rolling Stones, Jimi Hendrix, the Grateful Dead, and Bob Dylan rose to fame. On July 20, 1969, Neil Armstrong walked on the moon.

American fashion was also changing. Before the 1960s there was an accepted protocol for menswear. Suits were blue, brown, black, or gray, and sometimes a plaid might be used. Now, there was a freeing of the rules, and the same was true with women's wear. Mary Quant made the miniskirt popular. England's boutiques brought mod fashion, bright colors, large brocades, and pop art motifs. Young people were freed

from the staid colors and silhouettes of generations past.

By 1960 overexposure on television, low attendance at concerts, as well as several court cases and magazine headlines suggesting Liberace was gay, had sent Liberace's career in a downward spiral. Popular magazines were asking what had happened to Liberace. In 1961 he was called a has-been and a one-time TV idol. Back on board, Seymour Heller went into high gear to save Liberace's career. Liberace had bounced back once and he could do it again.

Heller, realizing Liberace's power in front of a live audience, began carefully selecting the venues Liberace would play, and Heller convinced the Las Vegas casinos to once again hire the performer. With the help of Devore and costumer Frank Acuna, whom Liberace had met in 1957, he once again revamped his image; this time making his costumes even

more over-the-top than before. Again, the costume update worked. Liberace was even more glitzy and glamorous than in the past. By 1963 he had recouped his standing as one of the most popular entertainers of all time, so much so, in fact, that he dubbed himself "Mr. Showmanship," a nickname that became inseparable from his public persona.

Liberace's new look featured commissioned jackets made of large brocades enhanced by beading and sequins. The collars were big and an abundance of ruffles, peeked out of his cuffs and burst out of the front of his jacket. Yet, as before, his clothing was perfectly tailored. One of his idols was Beau Brummel—a fashion connoisseur of the nineteenth century who was known for perfectly tailored clothing, and for not leaving the house without immaculately scrutinizing his appearance. While far less toned-down that Brummel, Liberace also embraced high collars, wide lapels, knee breeches with a claw-hammer tailcoat, and fashionably long locks of hair with sideburns. Brummel was synonymous with dandyism in the nineteenth century, and it would be the same for Liberace in the twentieth.

Liberace had not been on television since 1958. But now with his career firmly in place again, he decided to return. He told a reporter for the *NY Sunday News* he was going back because in this fashion-conscious world "it was a shame to waste mother-of-pearl trimmed suits only on tour audiences." It was an exciting time he said, and the "interest stimulated today over men's clothes adds a new dimension to my act." [32]

In 1969 *The Liberace Show* was the summer replacement for *The Red Skelton Show*. This was important because the show was filmed in color. The television audience could see his wardrobe in its full glory, and while it had once seemed outrageous, Liberace was now seen as a fashion icon.

Sy Devore passed away in 1967. Devore had served Liberace well in creating the tailored look that helped propel him to stardom. The man he selected as his next costumer was Texas tailor Frank Ortiz.

"Magnificently bedecked in an electric blue Edwardian suit, powder-blue shirt with ruffled cuffs, and neck set off by an oversized maroon velvet bow tie," read an article in the *NY Sunday News*, "showman Liberace no longer looks like an exaggeration. Once far-out, he's way-in and well aware of the change." [33]

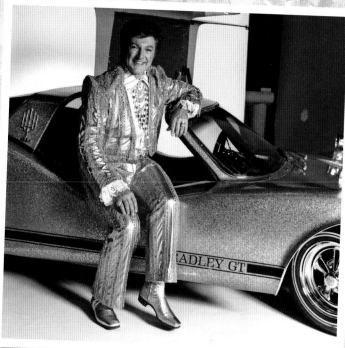

Above: Liberace in a gold lamé suit with a matching Bradley GT sports car with a candelabra on the side.

Frank Ortiz

Frank Ortiz, born in 1918, was eight years old when his father brought his family to the United States from Aguascalientes, Mexico. For the senior Ortiz, the dream of prosperity turned into a reality of hard labor, working for eighteen dollars per week. At age eleven Frank secured his first job as the sweeper at a textile mill. At fourteen he became a reliever, a position that could sub for any other in the plant. He later became a weaver.

Always one to think outside the box, Ortiz developed a system to change the thread on the machines without stopping the equipment. In manufacturing, this was an advancement that saved valuable time, and the factory awarded him a six-hundred-dollar bonus for this innovation. With this recognition from the textile industry, Ortiz went on to immerse himself in the field. His next job was as a tailor at National Tailor in Houston, Texas. He received only a salary of one dollar and fifty cents per week, plus commission. By that point, however, Ortiz had saved more than five thousand dollars, and he decided he could stand the pay cut because he would be learning something new. At twenty-one, Ortiz entered the military; on his return to Texas, he opened Ace Tailors in Galveston.

A one-room shop, Ace Tailors was upstairs from a law office and a photography studio. Ortiz's motto: "Walk the stairs and save the difference." He named his business Ace Tailors because he couldn't afford a sign and Ace was at the beginning of the alphabet in the phone book. After his business and reputation grew, he changed the name to Ortiz Tailors.[34]

It wasn't a posh studio but it sufficed, and word of Ortiz's custom, hand-tailored men's suits began spreading. A bandleader by the name of Chuck Cabot, the brother of jazz composer Johnny Richards, ordered a suit. The only problem was that he needed it for the next night's gig, and he weighed in at 625 pounds. Fabric had to be flown in from Chicago, but Ortiz made it work. At 7:00 a.m. the suit was delivered to the Balinese Room. Needless to say, Cabot was a return customer.

Ortiz's next big break was an order of ninety-six suits from the Gophers, a five-man band. From that point on, his career path was established. He would be a costumer for the stars. Disliking air travel, he would drive his Lincoln Town Car one-hundred-thousand miles annually—from Texas to New York, Las Vegas, and Hollywood—all to custom-fit costumes for his clients. His real success: designing and constructing wardrobes for Liberace, Jack Benny, Kenny Rogers, Bobby Vinton, and Wayne Newton.

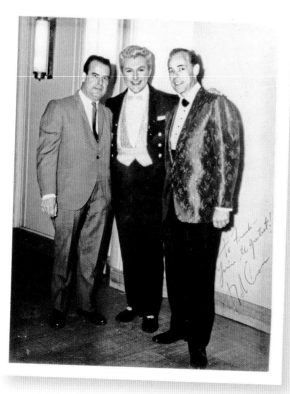

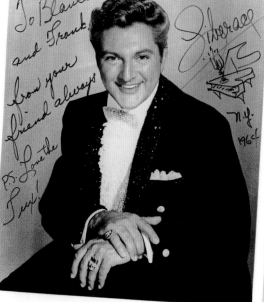

Opposite: Liberace with Frank Ortiz and another gentleman. *Above*: Designer Frank Ortiz. *Right*: A publicity photograph of Liberace with a note to Blanche and Frank Ortiz.

LIBERACE

DICK GABBE - SEYMOUR HELLER
Personal Management
Beverly Hills, Calif. - New York

In 1957 Ortiz was introduced to Liberace by the entertainment director of the New Frontier. The event turned into a jam session with Liberace on the piano, Bob Cross on the bass, and Gene Krupa on the drums. Liberace spent the time he wasn't playing talking to Ortiz's wife, Blanche. The two became fast friends. He was able to converse about cooking, fashion, and music; women loved him. The next day Frank showed him fabric swatches and Liberace ordered twelve silk suits. Shortly after, he sent a plane for Blanche Ortiz to take her to dinner at Maxim's restaurant in New York. Like most of his other relationships with women, there were no romantic overtones. "He told me to bring Frank along," Blanche related.[35]

Frank and Blanche treated their customers like family. To make their show business clients comfortable, they furnished the living room of their home to resemble the lounge at the Sands Hotel. In comfortable surroundings, Liberace and Wayne Newton brainstormed costume ideas and had their costumes fitted.

The Texas tailor introduced Liberace to sequins and rhinestones, but his most jaw-dropping designs were the electric costumes he created. Ortiz once described a silvery, metallic jacket woven with fine metal threads he made for Liberace. Attached to the vest pocket was a tiny candelabra with miniature candles. A hidden battery would light them. "Only one weaver in the nation makes this metallic material and it was ordered especially for Liberace,"[36] he said. This innovation of electrified costumes was thrilling to Liberace, and he continued to use them in his act until his death.

Liberace was exceedingly loyal to Ortiz, as he was to his other designers. He preferred to use only one costumer at a time, and he worked with Ortiz until 1965. "Liberace was priceless because everybody knew him," Ortiz said.[37] It was a powerful professional collaboration, and the two men became great friends over the years.

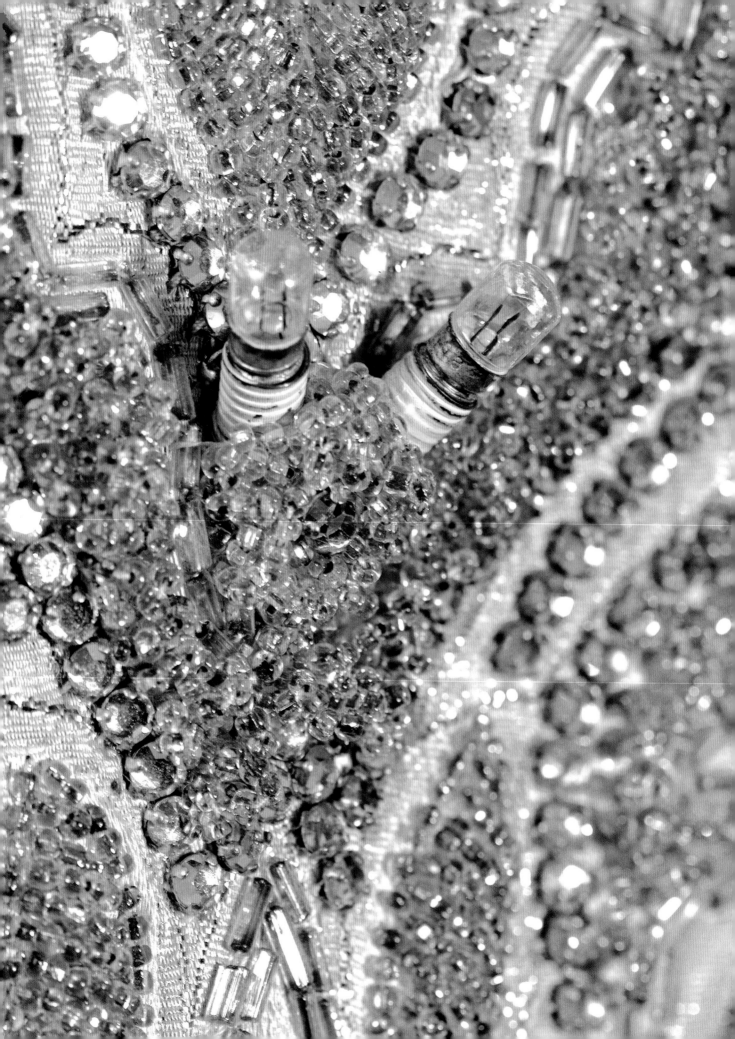

Silver-Beaded Jacket with Electric Candelabra · 1959

Costume design by Frank Ortiz

*T*his jacket is the first of Liberace's costumes to be decorated with his signature candelabra; it is also believed to be his first electrified costume. The jacket is of silver-gray damask embellished with silver and gold bugle beads, rhinestones, crystal-colored lochrosens, seed beads, rhinestones set in Tiffany mountings, and AB-finished rhinestones.

The candelabra on the left breast pocket is made of metallic gold cording enhanced with bugle beads, small crystal rhinestones, and two large AB crystal rhinestones. The three candles are incandescent bulbs. The battery-controlled switch for operating the candles is located in the left sleeve so that the audience could not see it, and it could slip easily into Liberace's hand.

The lapels and the gathered lace cuffs of the shirt (most of Liberace's cuffs were attached with Velcro) are worked solid with alternating rows of crystal rhinestones and crystal seed beads. The edges of the coat, cuffs, and lapels are outlined with self-fabric cording. The cording forms a frog closure that wraps around two fabric-covered buttons.

Completing the costume is a sleeveless white shirt with a ruffled front accented with rhinestone buttons and a wing-tip collar, a crystal bow tie, and black wool slacks.

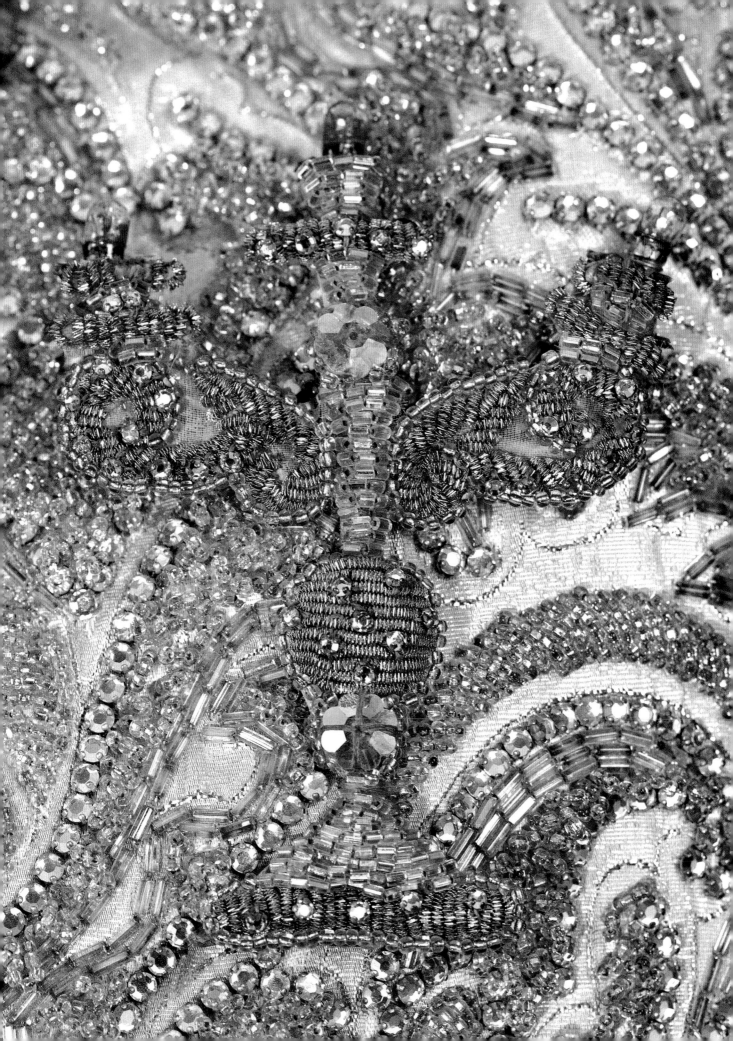

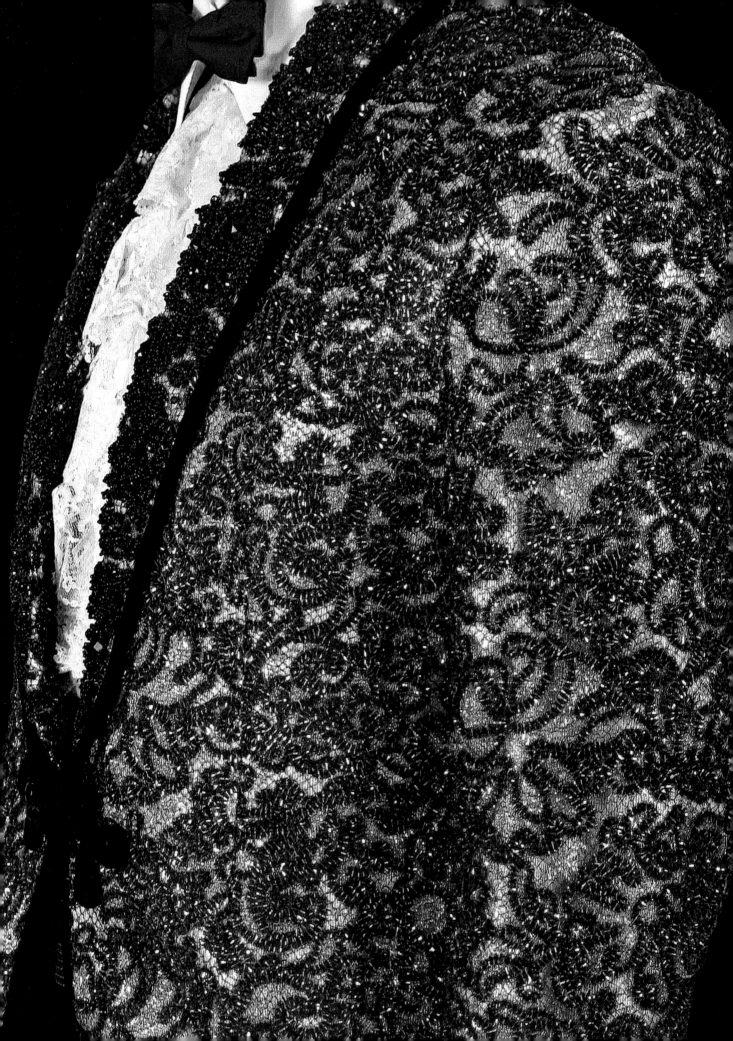

Black-Beaded Silver Dinner Jacket • 1960

Costume design by Frank Ortiz

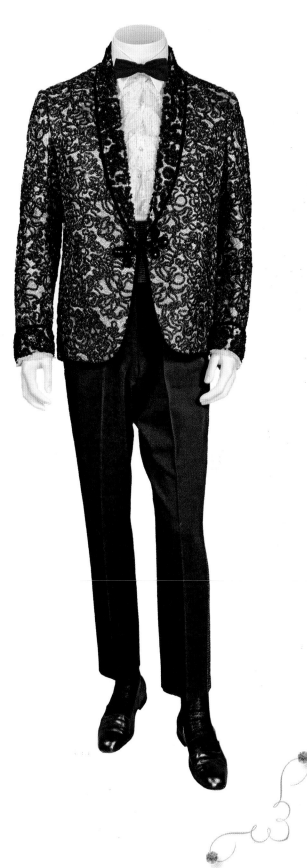

Ortiz was not only a master tailor, but he also had the ability to custom design fabric. This jacket is of silver-and-gold lamé worked with chenille yarn (chenille is French for "caterpillar"—thus the furry texture). The body is enhanced with black bugle, seed, and rocaille beads, and faceted black glass beads—all on black netting. The paisley-like pattern evokes flowers and leaves.

The cuffs and lapels are also thickly beaded with black bugle, seed, and rocaille beads and faceted black glass beads—again, on black netting. A black velvet band edges the cuffs, lapels, and bottom of the jacket. The frog closure is of black cording.

White Suit with Clef Notes • 1965

Costume design by Frank Ortiz

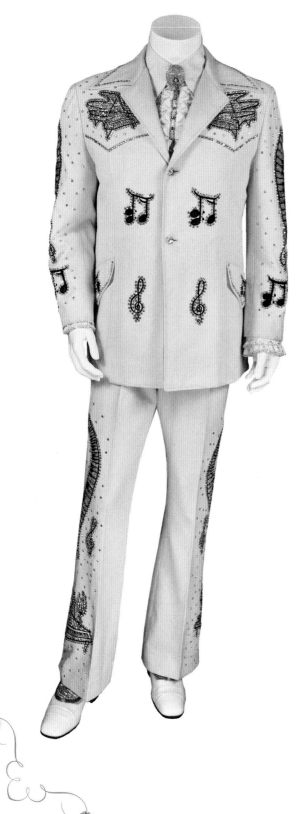

This ensemble consists of a jacket, matching pants, ruffled placket shirt, lace cuffs, rhinestone broach, and slip-on shoes. Running down the front placket of the white shirt is a silver thread trimmed ruffle centered with rim-set crystal rhinestones. The pieces are white polyester gabardine with multiple appliqués.

The Western-style jacket features Liberace's signature piano logo on each yoke. The pianos are filled and accented with rim-set crystal and AB crystal rhinestones and outlined with heavy black embroidery. On both sides of the jacket, below the pianos, are overlapping musical notes and a clef note. These are also worked in heavy black embroidery and accented with rhinestones.

On the back of the jacket, the yoke features another, larger piano logo, heavily detailed with black embroidery. Rim-set crystal and AB crystal rhinestones fill the logo and are scattered around the entire yoke. Light Siam rhinestones light up the candles in the candelabra.

The edges of the collar, pocket, and yoke are outlined in rim-set crystal and AB crystal rhinestones. The jacket pockets feature embroidered music notes with rhinestones.

The sleeves are decorated with piano keys worked in AB crystal rocaille beads and black bugle beads. Wider at the shoulder and narrowing toward the cuffs, the keys are outlined with rim-set crystal and AB crystal

rhinestones. The sleeves also feature the same note motifs as the front of the jacket. Rim-set rhinestones are scattered.

The ruffle of the white shirt is edged with a silver-thread ruffle running down the front placket and the center has rim-set crystal rhinestones. The ends of the shirtsleeves have a matching ruffle accented with rhine-stones. A tasseled round rhinestone broach sits at the neck.

Down the side of each pant leg are the same piano keys, notes, piano logo, and scattered crystal rhinestones. The suit is shown with white leather slip-on shoes with rhinestone clips.

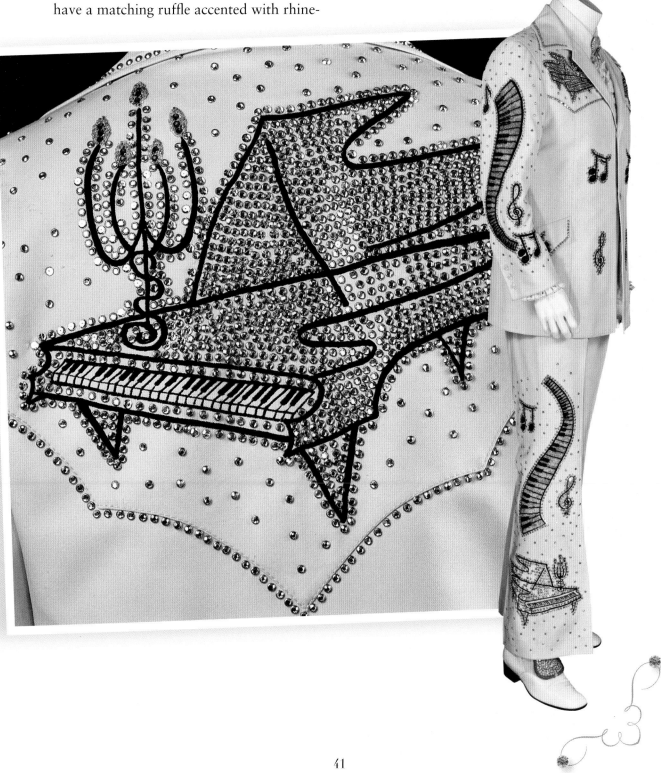

Frank Acuna

rank "Paco" Acuna, a native of Mexico, specialized in period costumes for screen stars such as Rudolph Valentino (for whom he was the exclusive designer), Douglas Fairbanks, Cary Grant, Eleanor Powell, and Clark Gable. Liberace loved the costumes he saw in swashbuckling historical movies because the designs reflected the theatricality he personified, and so he sought out Acuna. Both performer and designer brought their ideas to the table.

In an interview for the *Saturday Evening Post*, Liberace described his work with Acuna: "He has hundreds of pictures," Liberace said. "I look through them and I'll say 'Oh Frank, I love this outfit.' He'll say, 'That was worn by Valentino in such-and-such film.' I'll say, 'I want one just like it, but with some sparkle on it.'" [38] In a later interview for the *Washington Star*, Liberace continued, "Occasionally, I get an idea from some royal regalia. Not long ago I was inspired by the ermine cloak that King George wore to his coronation. But I tried to make it different. I used chinchilla instead of ermine. It has a twenty-foot train." [39]

Acuna's garments were heavily stoned and beaded and only the best materials were used for Liberace's costumes. The rhinestones were top-quality, Austrian-Swarovski lead crystal rhinestones. The finest sequins manufactured in Spain, traditionally used for bullfighting costumes, were used. An elaborate costume of sequins, extensive beading, and rhinestones could take up to a month to design and manufacture in Acuna's shop on Sunset Strip in West Hollywood—and the price tag wasn't cheap. One of Liberace's tours used forty elaborate jewel-encrusted outfits priced at an average of twenty-four thousand dollars per suit.

One of Acuna's most famous designs was an elegant black beaded tailcoat with diamond buttons spelling L-I-B-E-R-A-C-E. Six buttons attached on the front and two attached on the back. Each was made of fourteen-karat white gold and contained approximately fifty diamonds. "It's not the loudest one but it's the most expensive," Liberace would tell his audiences. "You know why? Because of the buttons. They are real diamond buttons. The buttons cost more than the suit, but I couldn't come out in just the buttons. Coax me—I'll make that centerfold yet! You know what the gimmick is with the buttons? They spell out my name. That makes it tax deductible!" [40]

Ray Arnett, Liberace's producer and friend, related a story of how the buttons

Above: Designer Frank Acuna. *Opposite*: A 1960s photograph of Liberace with his costumes.

were once stolen during a tour. He received a ransom note requesting two hundred dollars for their safe return. The exchange of brown bags was made in a dark alley. Arnett felt it was a bargain—the cost of the diamond buttons was many times more than the amount paid in ransom.

On August 16, 1968, Liberace filed suit with the US Tax Court when the IRS disallowed $153,841.37 in income-tax deductions for his jeweled jackets, candelabras, and mansion expenses. He was one of the first entertainers to challenge the agency on the ground that allowances should be made, as the costumes and illusions must be maintained for the act. In *Liberace: An Autobiography*, he related:

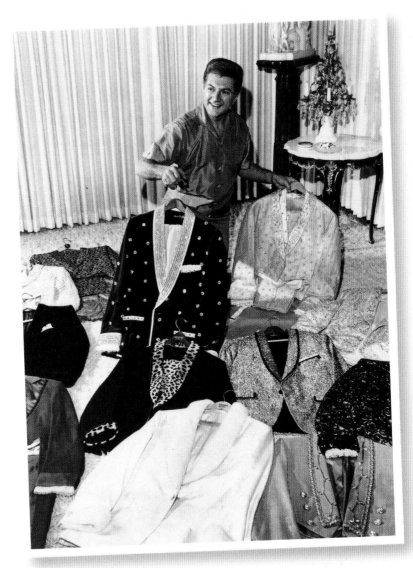

I went down to the meeting to discuss the matter, wearing one of my most elaborate outfits. . . . My lawyer said to the examiner, "You people claim that my client, Liberace, can wear these clothes on the street; therefore they are not deductible. Look out the window at what's happening downstairs. That crowd began to gather when Liberace stepped out of his car. The crowd's waiting for him to come out. People are banging on doors to get into the building. The police have had to lock it. In view of this, do you still think that cos-

tumes like this one he's wearing, which is from his stage wardrobe, can be worn on the street? Let me go further, would *you* wear it on the street?" "Hell no!" said the examiner.

"Then it must be tax deductible!" the lawyer said. The IRS considered the argument and decided to allow nineteen thousand dollars for these expenses.[41]

Besides the suits he made for Liberace, Acuna also designed and executed a number of tailcoats. He added "flamboyancy" to them by selecting an array of nontraditional colors and embellishing them with beading or rhinestones.

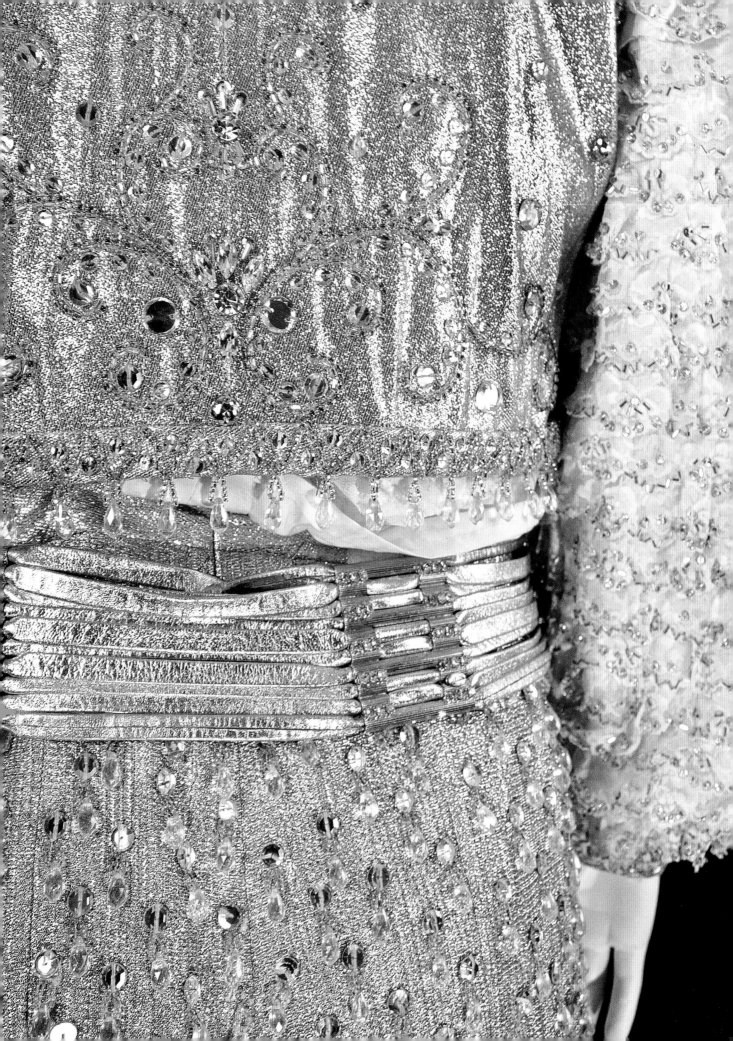

Silver Knickers · 1968

Costume design by Frank Acuna

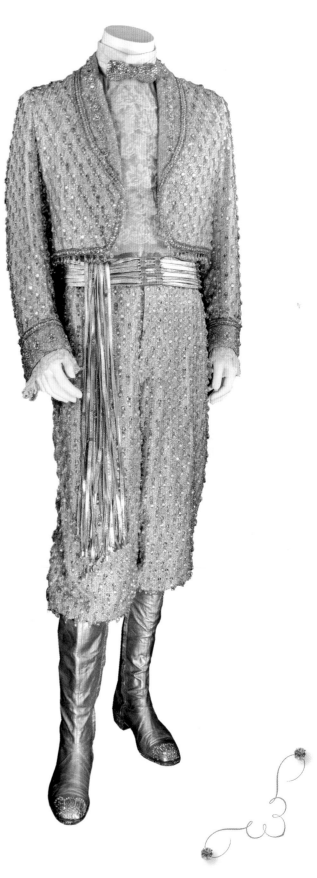

*I*nspired by the swashbuckling movies of Rudolph Valentino, this costume consists of a bolero jacket, knickers, and vest, a ruffled lace shirt with matching cuffs and jabot, a rhinestoned bow tie, banded collar, fringed leather belt, and boots.

The shirtfront is silver lamé with slightly gathered white lace ruffles patterned with silver. The shirtsleeves have rows of the same lace over white grosgrain ribbon. They are edged in a zigzag pattern worked in silver-lined crystal bugle beads with a finishing of crystal lochrosens secured with crystal seed beads. Zippers make the sleeves removable.

The vest is also silver lamé and is embroidered with crystal stones and small mirrors. On the lower edge of the vest and around each armhole are rows of crystal, AB-finished, pear-shaped, faceted hanging jewels. Each is suspended from two rows of crystal seed beads.

The knickers are silver lamé. They have crystal sewn-on stones anchoring crystal, AB-finished, pear-shaped, faceted hanging jewels. They are suspended from two short rows of small, dangling, crystal seed beads. The beading is done in alternating rows and tightly worked.

The jacket has the same beading as the knickers. Its lapels and cuffs are embroidered with silver-lined crystal bugle beads in a Cornelli pattern. Further embellishment of them consists of rosettes created from six sewn-on crystal stones in a circle pattern.

They are centered with a crystal rhinestone in a Tiffany mounting, which raises the pattern above the fabric.

The lapels, cuffs, and jacket are edged in rows of crystal seed beads and sewn-on crystal rhinestones. Their outermost rows are crystal, AB-finished, pear-shaped, faceted hanging jewels suspended from two short rows of dangling crystal seed beads. The cuffs and jabot are patterned with silver.

A white band collar sets off the bow tie, which is solidly covered in crystal rhinestones. A leather belt also accessorizes the costume. It consists of ten strips of silver leather crimped in four places by bands of silver metal accented with crystal rhinestones. The belt finishes with fringed ends extending almost to the knee. Matching knee-high silver leather boots feature crystal AB-finished rhinestone patterned toes and heels.

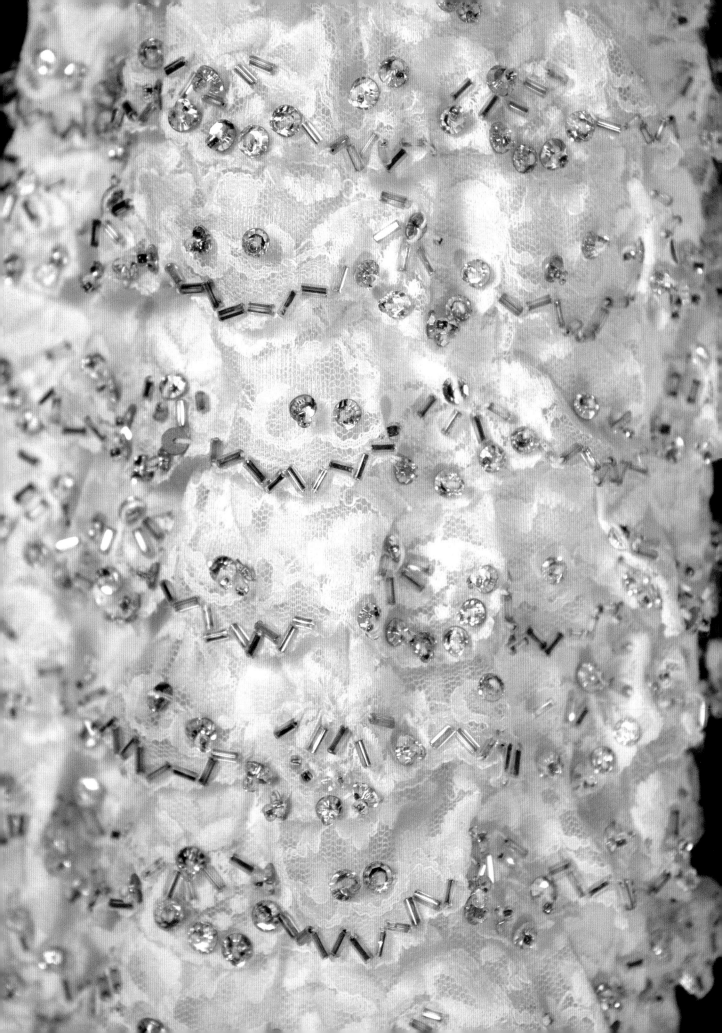

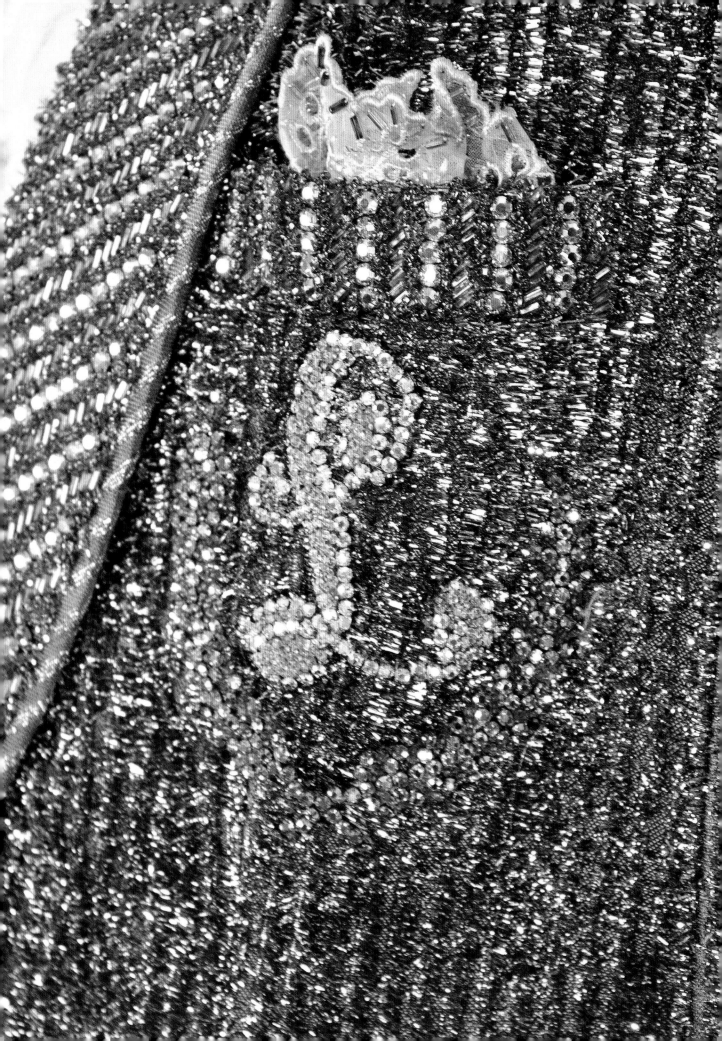

Gold Jacket with "L" on Pocket and Vest • 1965

Costume design by Frank Acuna

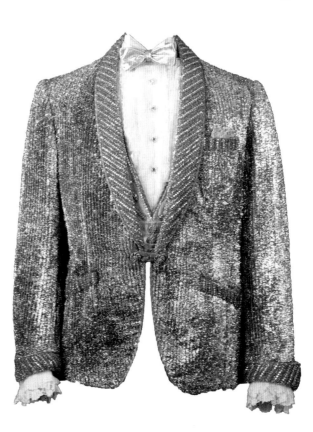

This costume consists of a shawl-collared dinner jacket and vest. The body and sleeves of the jacket are gold eyelash lamé. The shawl collar, pocket flaps, and cuffs are gold lamé and solidly embellished. On the breast pocket, Liberace's initial "L" is written in a cursive script worked in rim-set crystal and crystal AB rhinestones.

The shawl collar and cuffs have angular rows of rim-set and AB crystal rhinestones edged with gold seed beads and followed by a row of gold bugle beads. A vertical version of this pattern is on the pocket's flaps and top edge. The rest of the pocket is outlined in the same rhinestones with a pattern of five stones in a row. A lace handkerchief sits in the pocket.

The jacket's pocket flaps, collar, cuffs, and edges are finished with a pink-gold cording that has stripes of metallic gold and has been cut on the bias. It closes with two rhinestoned gold plastic buttons secured by a double-loop of gold cording.

The vest is gold lamé and uses both sides of the fabric; its body uses the wrong side of the fabric. It has angular, broken lines of rim-set crystal AB rhinestones. The lines are sandwiched between lines of gold seed beads and lines of gold bugle beads. The vest's front and sides are edged in rhinestones and a row of gold cording. It hooks in the back onto a two-inch elastic band.

The vest has an attached cummerbund, which is made from the right side of the fabric, resulting in two different, but matching, tones on the vest. It features three tucks of fabric and a V-shaped notch at center front. Each tuck has a gold plastic-and-rhinestone button.

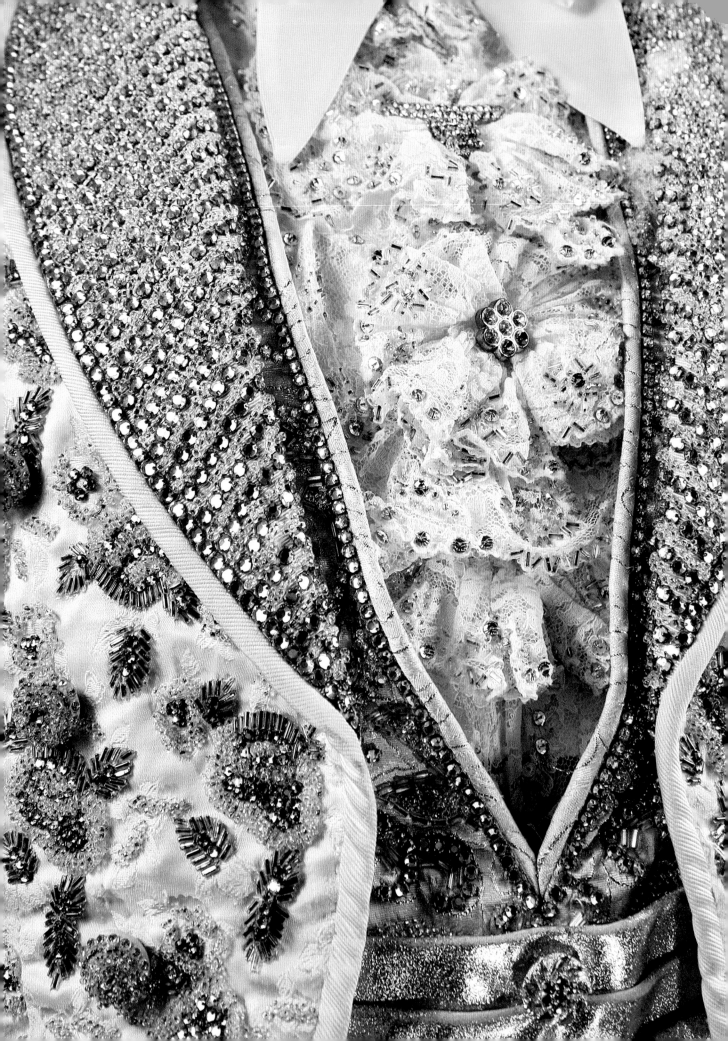

Cream Tailcoat Suit • 1966

Costume design by Frank Acuna

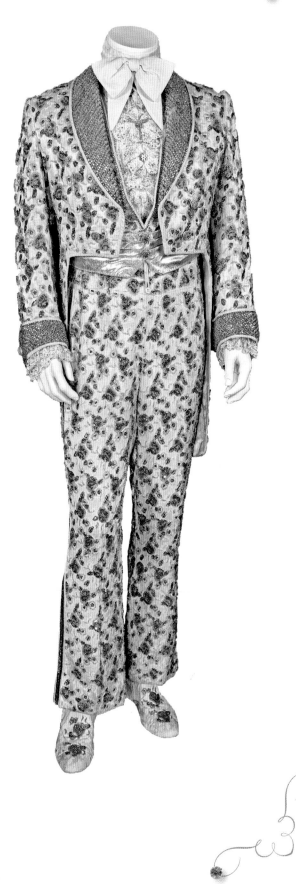

The costume consists of tailcoat, vest, high-waist pants, sleeveless white shirt, ruffled and gathered white lace cuffs and jabot, bow tie, and beaded slippers. The jacket is gold silk with a gold metallic printed pattern and light gold lamé cuffs and lapels. The pants match the jacket. The vest is solid-colored gold silk satin.

The vest, pants, and coat are decorated with rim-set crystal rhinestone motifs surrounded by eight lines of gold seed beads, four beads in each row.

A rhinestone and seed-bead pattern is on the coat's collar, lapels, and cuffs, and there are additional embellishments of three and five row sprays of rim-set crystal rhinestones outlined with rows of gold bugle beads. The three pieces are all edged with cording. The lace on the cuffs is edged with gold bugle beads.

The jabot is accented with sewn-on AB crystal lochrosens. The cream bow tie is oversize. The slippers are beaded.

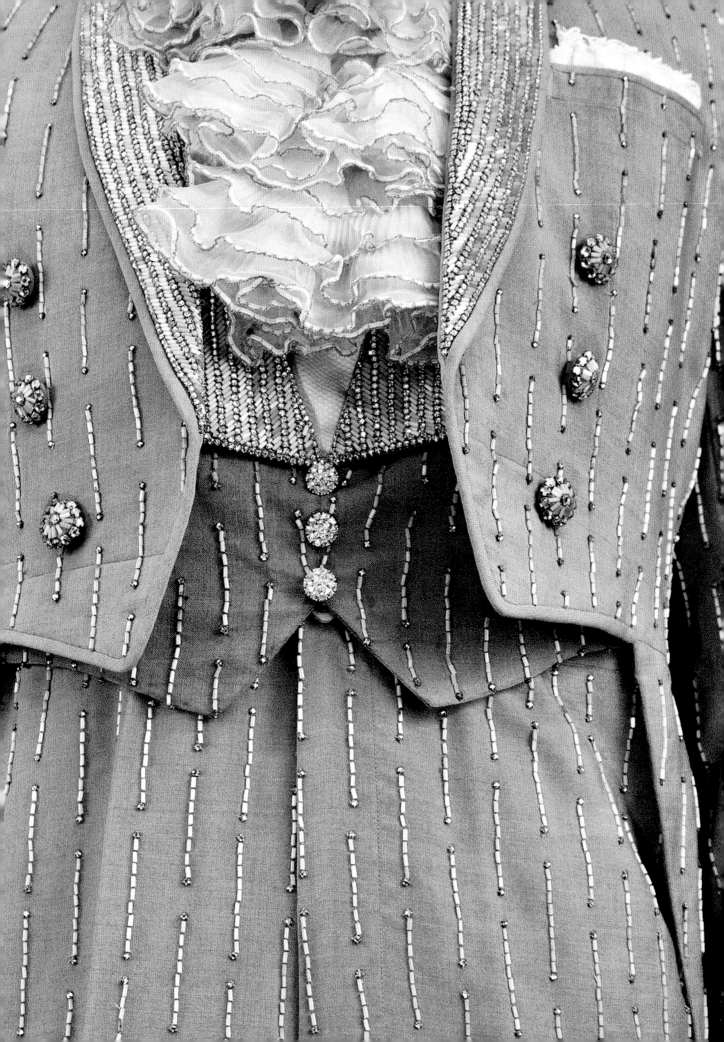

Olive-Green Tailcoat Suit · 1966

Costume design by Frank Acuna

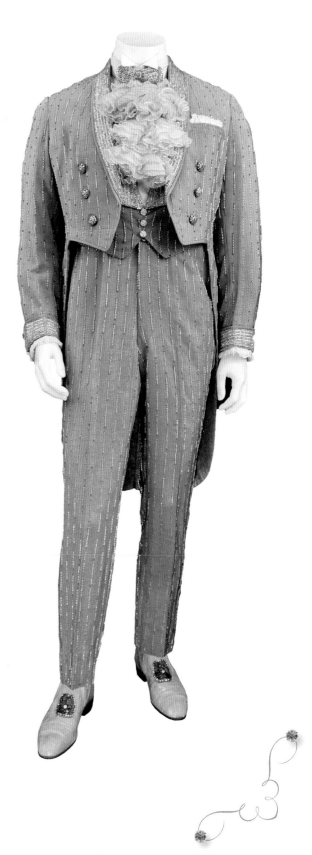

This costume consists of a vest and pants jumpsuit, tailcoat, slacks, sleeveless white shirt, ruffled lace-edged cuffs, ruffled pleated chiffon jabot, and bow tie.

The jumpsuit is made from olive-green wool. Its pattern is the same overall: broken lines of stoning and beading consisting of rim-set crystal rhinestones followed by eight matte white bugle beads, and ending with another rim-set crystal rhinestone. The vest lapels are solidly beaded and stoned in rows alternating between rim-set crystal rhinestones and matte white bugle beads stitched at an angle. Three AB crystal rhinestone buttons are center-front on the vest.

The tailcoat is constructed from the same olive-green wool as the jumpsuit, and the stoning and beading pattern is duplicated on it. The rhinestone and bugle-bead pattern of the vest lapels is repeated on the coat's collar and cuffs of the coat. The coat lapels are edged with self-fabric cording. Self-covered buttons are stoned with rim-set crystal rhinestones and matte white bugle beads. Six buttons are on the front of the coat and two are on the back. The removable cuff edge is gathered white lace.

The jumpsuit is worn with a sleeveless white wing-tipped shirt, lace-edged pocket handkerchief, chiffon jabot, and bow tie. The white, pleated, and gathered chiffon jabot is edged in gold crochet thread and gold seed beads. The bow tie is worked overall in the same stoning and beading pattern as the jumpsuit.

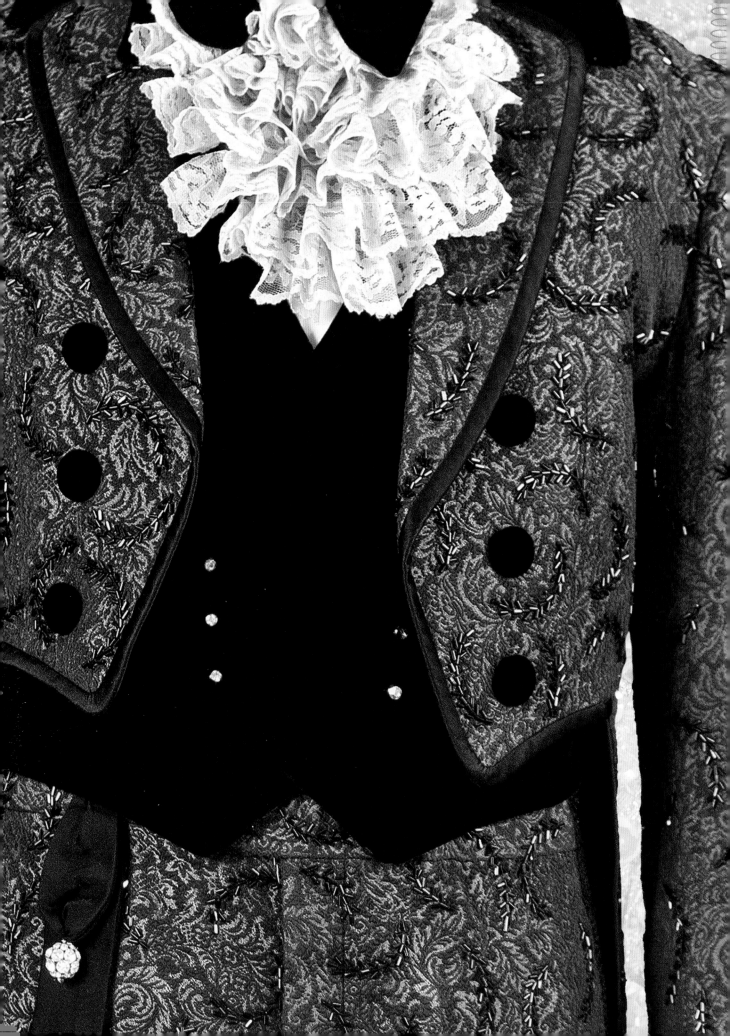

Purple Damask Suit of Tails · 1961

Costume design by Frank Acuna

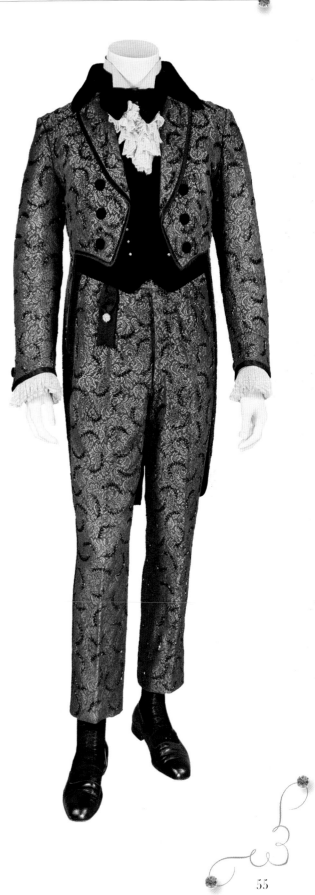

This suit consists of tailcoat, vest and slacks jumpsuit, sleeveless white shirt, gathered and ruffled lace cuffs and jabot, and bow tie.

The tailcoat and pants are constructed from purple silk–patterned damask and are beaded overall in an evenly spaced pattern of black AB-finished bugle beads worked in a shallow, curving feather motif. The pattern is repeated over both pieces.

The pants are accented with a double-sided black grosgrain ribbon extending from the waist. Folded, the ribbon's top portion is gathered to a crystal rhinestone jewel. Its bottom edge is cut into two points. The vest is made from deep purple velvet. Its only embellishments are six small crystal rhinestone buttons.

The cutaway coat is edged with black fabric piping around the lapels, tails, and outermost edge of the cuffs. It has six buttons that are purple velvet and self-covered. Its large fold-over collar repeats the purple velvet of the vest.

Finishing the suit is a sleeveless white wing-tipped shirt, jabot, and cuffs made of gathered lace, a velvet bow tie, and black slipper-style shoes.

Red Jacket and White Vest · 1961

Costume design by Frank Acuna

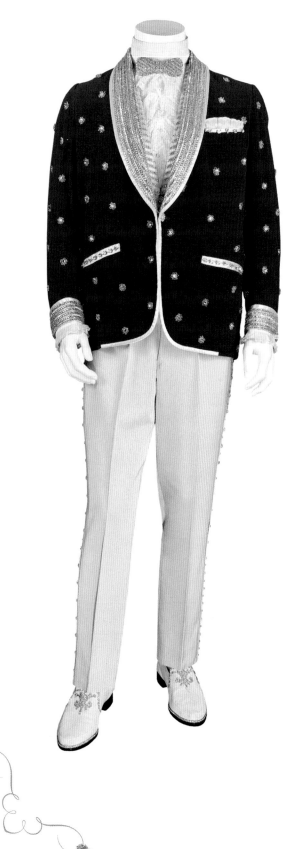

The coat in this ensemble is red velvet with white silk satin lapels, cuffs, and pocket trim. White satin cording outlines the lapels, cuffs, center front, and bottom edge of the jacket.

The lapels and cuffs are stoned and beaded with alternating rows of small, sewn-on crystal lochrosens and white bugle beads set at a slight angle. The three pockets are edged in white satin with a row of crystal lochrosens. Overall the jacket is decorated with motifs consisting of a large crystal center bead surrounded by short loops of crystal rocaille beads. These decorations add flash and texture.

The vest is worked in a solid pattern with white bugle beads set in a pattern similar to a brick stitch, in which the joined beads form a surface that looks similar to a brick wall. Its lapels are worked in a solid pattern of a row of sewn-on crystal lochrosens, a row of white seed beads, and a row of vertically stitched white bugle beads followed by another row of white seed beads. The pattern covers the lapels. The vest is edged with a white soutache braid and closed with three metal and rhinestone buttons.

The jacket is photographed with white slacks, ruffled lace jabot, lace-trimmed pocket handkerchief, pleated stand-up collar, crystal rhinestoned bow tie, and jeweled and stoned white slipper-style pumps.

Gold Paisley Jacket · 1965

Costume design by Frank Acuna

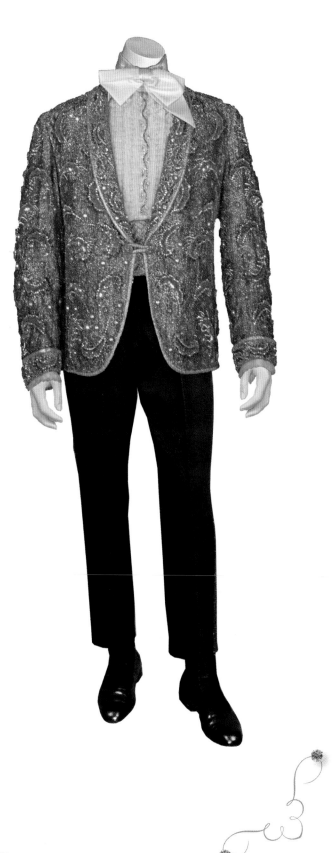

*T*his jacket is constructed from a paisley-patterned gold lamé with rim-set crystal AB rhinestones, gold seed beads, gold, orange, and teal flat sequins, gold cording, and gold plastic and rhinestone buttons.

Each paisley motif is outlined in closely set rows of rim-set AB crystal rhinestones, filled with flat gold sequins, and enhanced by radiating lines of teal and orange flat sequins surrounding the motif. Scattered rim-set AB crystal rhinestones encircled with gold seed beads also adorn the jacket.

The center-front buttons are in a double loop of gold lamé cording. There is also gold cording around the collar, cuffs, and outer edges of the jacket.

Electric Costumes

Gordon Young

In 1969 at the Valley Music Hall in Salt Lake City, Liberace was approached by a young man eager to show him his latest invention—electronically illuminated jewelry that generated light patterns in the dark. Gordon Young had created an electric ring for his wife to wear to the opera to assist her in reading the program. "Liberace was impressed and asked if the same thing could be done to a suit of clothes. He wanted his jacket, vest, and pants to flash as he worked onstage," Young recalled.

Liberace had already experimented with minor electrification in garments Frank Ortiz created for him; Young, however, took the performer's outfits to a new extreme. The first of several electric coats was delivered to Liberace a few months later. Acuna tailored them and Young electrified them.

The first electrified costume was black with lights on the front, back, and sleeves of the jacket, and a strip of lights that went down the side of each leg. A sign on the back of the costume lit up to read, "The End."

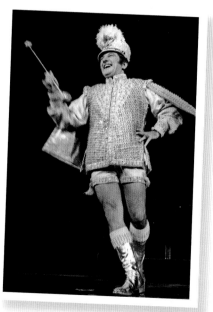

Left: Liberace in an electric marching band costume with a baton.

The lights were operated backstage via a handheld radio transmitter, and required a considerable amount of technology to work. Designed to light one at a time or in units, the lights could turn on and stay on or they could flash continuously.

One of Young's most complicated costumes featured 640 lights. He related, "I cut 640 small holes in one of Liberace's suits and sewed the lights, transistor components, and batteries into the inside. . . . The suit linings were sewn-in and covered the lights, wiring, and other equipment so they couldn't be seen. The lights flashed independent of each other."

The roaring approval of the audience matched the pulsing lights of the suit, and Young received a check in the amount of one thousand dollars for his work on this project, a nice sum in 1969.

Over time the costumes became more complicated. The final suit jacket had four thousand light bulbs in three colors. They were inserted into four thousand buttonholes, which generated patterns on the coat, and all operated from a small rechargeable battery pack about the size of two cigarette packages. The electrical unit in the jacket weighed more than twenty-five pounds. Needless to say, the batteries didn't operate long between charges—just long enough! A small on-off switch was placed on the left sleeve, along with a control to adjust the light flashing speed.

In 1969 Morton Moss of the *Los Angeles Herald Examiner* wrote: "Liberace now dresses like a one-man explosion in mixed media; he finds that his biggest wardrobe difficulty is to outdo his previous costume. However the candelabra kid is in there trying. He has finally electrified himself. . . . Greater love hath no man for the theater than to risk electrocution in order to entertain an audience."[42]

Red, White, and Blue Electric Suit • 1970

Costume design by Frank Acuna

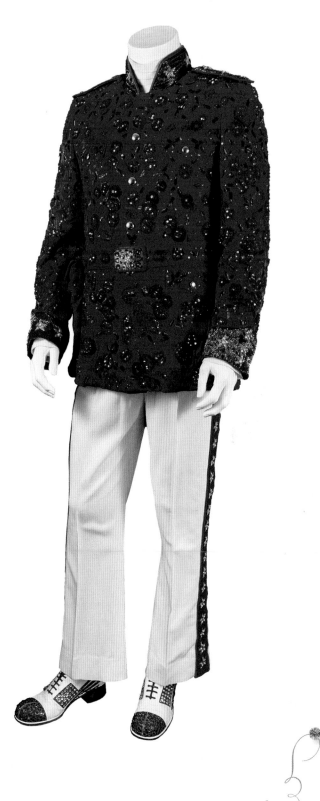

*T*his red, white, and blue patriotic costume is liberally sprinkled with clear electric lights, and is worn with a sleeveless, white-banded collar shirt. The jacket's vibrant military-style brocade has red bugle beads and seed beads, and light Siam, crystal, and AB crystal lochrosens. Tiny clear bulbs inside small hand-stitched buttonholes are scattered throughout.

On the outer right side of the costume there is a gun-shaped holster for the flashing units, radio control receiver, and battery packs. Gordon Young explained: "The large Amphenol plugged into the flasher unit for all lights, which were in groups scattered throughout the coat. The smaller, round plug plugged into the battery pack, which contained rechargeable nickel cadmium batteries. They required more than ninety volts to operate, so the low-voltage batteries were inverted to supply the necessary voltages. The jacket was radio-controlled from backstage."

The stand-up collar, epaulets, and cuffs have a royal-blue bugle bead background. It is topped with crystal stars made of silver bugle beads and crystal lochrosens fitted with clear lights in their center. A self-fabric belt at the waist is beaded to match the jacket. A belt buckle is fashioned from dark- and light-sapphire lochrosens, blue bugle beads, and another crystal lochrosen and bugle bead star. Silver buttons accent the front placket, which zips closed. Two pocket flaps are

stitched to the upper-chest portion of the jacket and two are at the waistline. Red twill piping outlines all edges.

The lightweight, cream-colored wool slacks have strips down their sides that feature the same pattern as the jacket cuffs, collar, and epaulets and are also edged with red piping. The strips are connected to the pants with two zippers, and multiple wires reach from them up into the coat where the light controls are located. The wires allowed the lights to blink independently.

The hat is a purchased white band hat with a large silver eagle that lights up. Light Siam, light sapphire, and crystal rhinestones are scattered over the hat. Fourteen stars of crystal lochrosens and silver bugle beads house light bulbs. The electronics are inside the top of the hat and were also controlled by offstage radio receivers. Originally, a white ostrich feather plume was glued atop the silver eagle.

The red, white, and blue oxford shoes were purchased and feature crystal light sapphire and crystal light Siam rhinestones. Red shoestrings add the final "pow!" to the shoes.

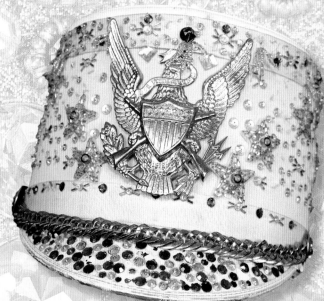

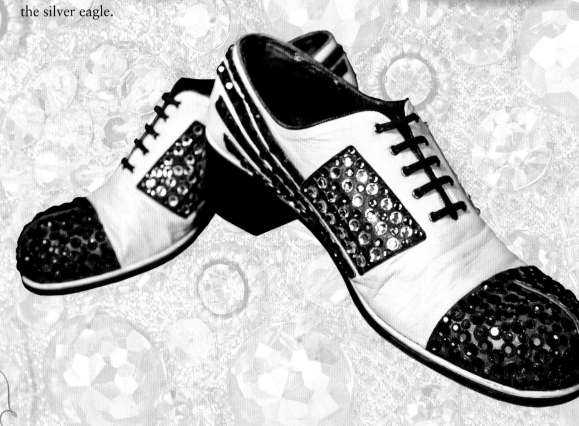

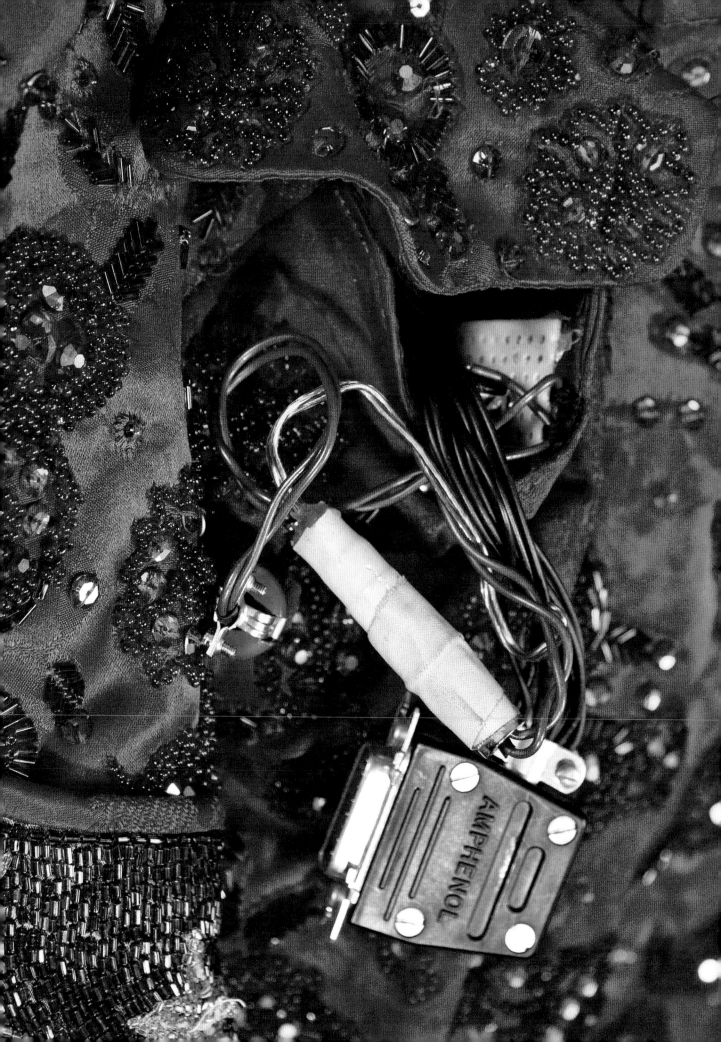

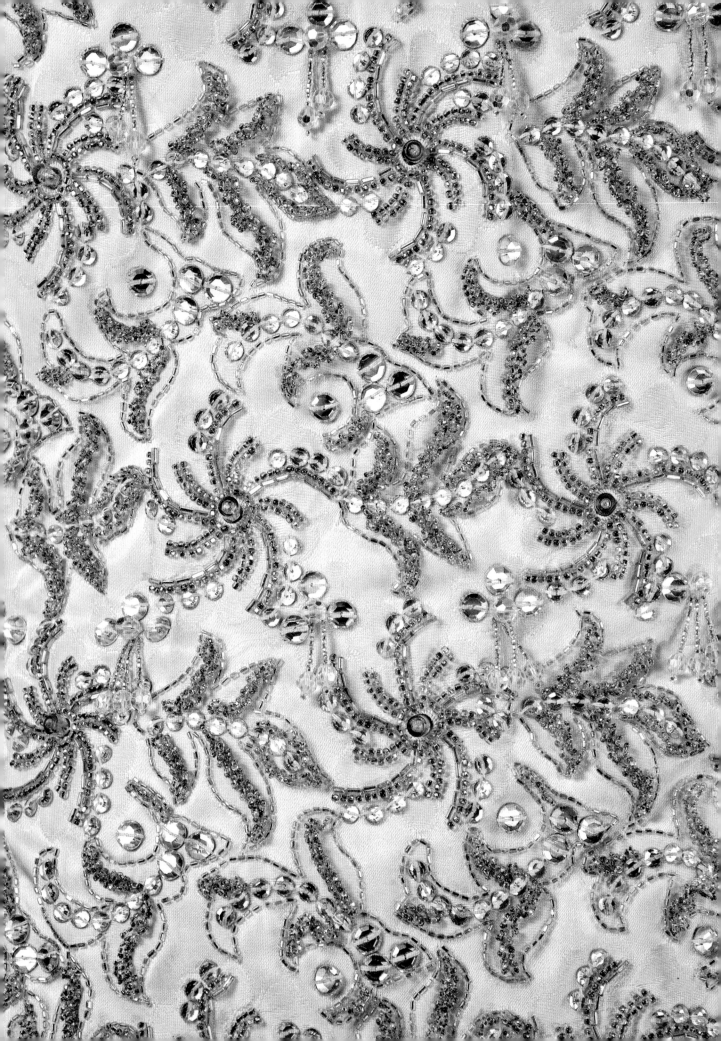

Cream and Silver Electric Jacket · 1969

Costume design by Frank Acuna

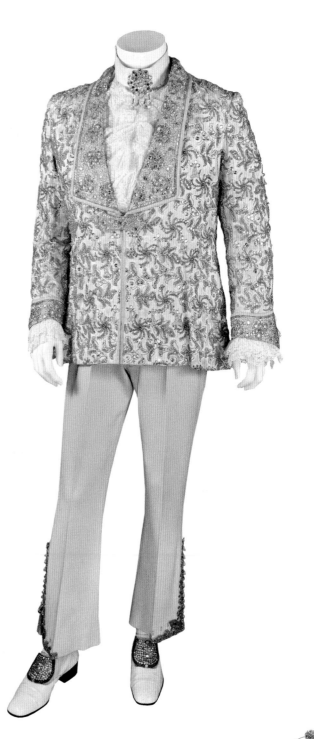

*T*his jacket has swirling floral and leaf patterns worked in crystal lochrosens, silver bugle beads, and silver seed beads. On the wide lapels and slit-back cuffs there is a floral pattern similar to the one on the body of the jacket, but with a slightly different floral design and fabric around the motifs that is embroidered with silver bugle beads.

The jacket's lapels, cuffs, and center front are outlined with a heavy, cream-colored cording. Next to this on the lapels and cuffs is a row of silver bugle beads stitched at a slight angle. The jacket is closed in front, right below the lapels, with a large crystal lochrosen, silver bugle beads, and a seed bead bar.

In the center of each floral motif is a neon light-bulb placed through the fabric via a hand-worked buttonhole the same size as the bulb. The bulbs glowed a light pink-orange and flashers connected to each lamp so they could flash at their own rate. Rechargeable nickel cadmium batteries powered the lights and were controlled by an offstage radio transmitter.

To complete the costume there is a sleeveless white shirt with a gathered lace front, a stand-up collar pinned with a large rhinestone broach, tiered lace cuffs, and cream-colored wool slacks.

Jim Lapidus

Jim Lapidus entered Liberace's world in 1973. He was a young entrepreneur working at a design house in Los Angeles called Pazazz Designs. He also had a side-business making beaded bow ties for high-end stores in Beverly Hills. An article in *California Men's Stylist* magazine read: "Silver crystal studs, gold nail heads, hammered gold bugles, rhinestones, sequin cloth, velvets, and plain old cotton—mix them up and you net a volatile collection of freaky, far-out, campy, or elegantly theatrical bow ties. Beading is back, if these sparklers from Jim Lapidus Creations (in Hollywood, Ca.) are to be believed. They retail at approximately $20 a shot." [43]

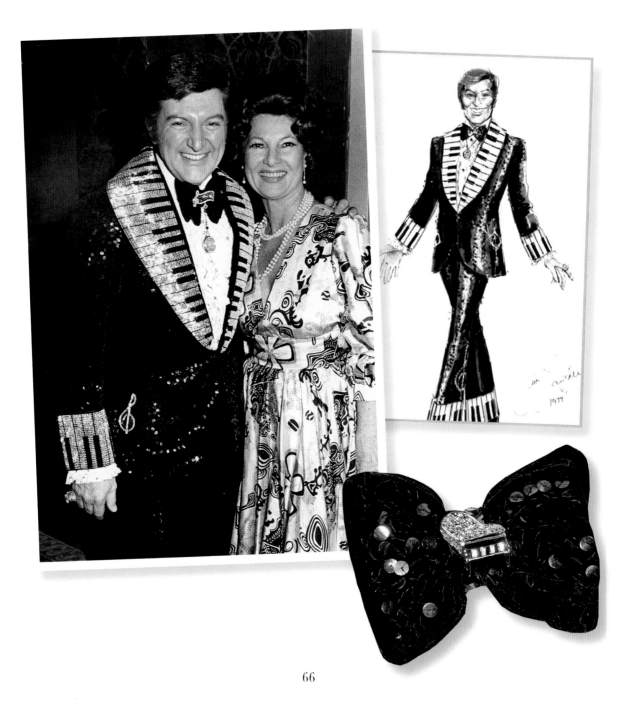

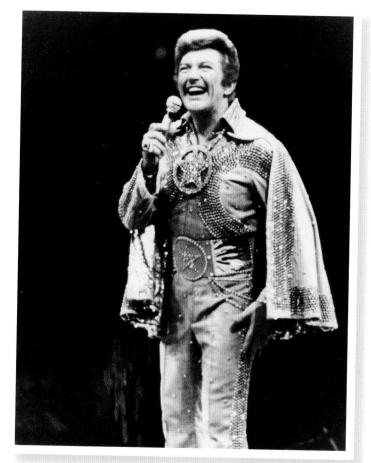

Opposite: Liberace with actress Ann Corio. *Right*: Liberace in his rainbow-stoned denim jumpsuit with attached cape.

The glittery bow ties caught Liberace's attention. He bought two at the Michael Bain men's clothing store and inquired where he might purchase more. The store contacted Lapidus who happily agreed to show his line of ties and asked if he could also show Liberace his sketches. A meeting was arranged at Liberace's house in the hills above LA's Sunset Boulevard.

About their meeting, Lapidus said: "He was amazing; not only did he buy all the ties I had, but ordered two outfits, the Piano Key Black Velvet Suit and the Denim Covered with Iridescent Sequins Suit, which he wore on *The Johnny Carson Show*. After that, I designed the Candelabra Suit with the full-length mirrored cape to the floor. I next designed the Rainbow Rhinestone Suit with Cape, which was a fun tribute to the Hilton and Elvis. I was twenty-one at the time and Lee launched my career. Because of Lee,

Elton John came knocking at my door for his world tour." [44]

Liberace's costumes were soon getting bigger reviews than his performances.

The *Las Vegas Review-Journal* stated, "Liberace can be depended upon to outdo himself on each return . . . with a more spectacular wardrobe (this time it's a dazzler whipped up by young designer Jim Lapidus)." [45]

Today, Lapidus is a renowned costume designer. He has worked on television shows such as *The Late Summer Early Fall Bert Convy Show*, *Dexter*, *Hawaii Five-0*, and *24*, which he worked on for eight seasons. Lapidus has been nominated for three Emmy Awards for his contributions in costuming for a television series. In the film world, he worked as a costume designer for *The Animal*, *Raven*, *Madhouse*, *Angel in Green*, and *Mr. and Mrs. Ryan*.

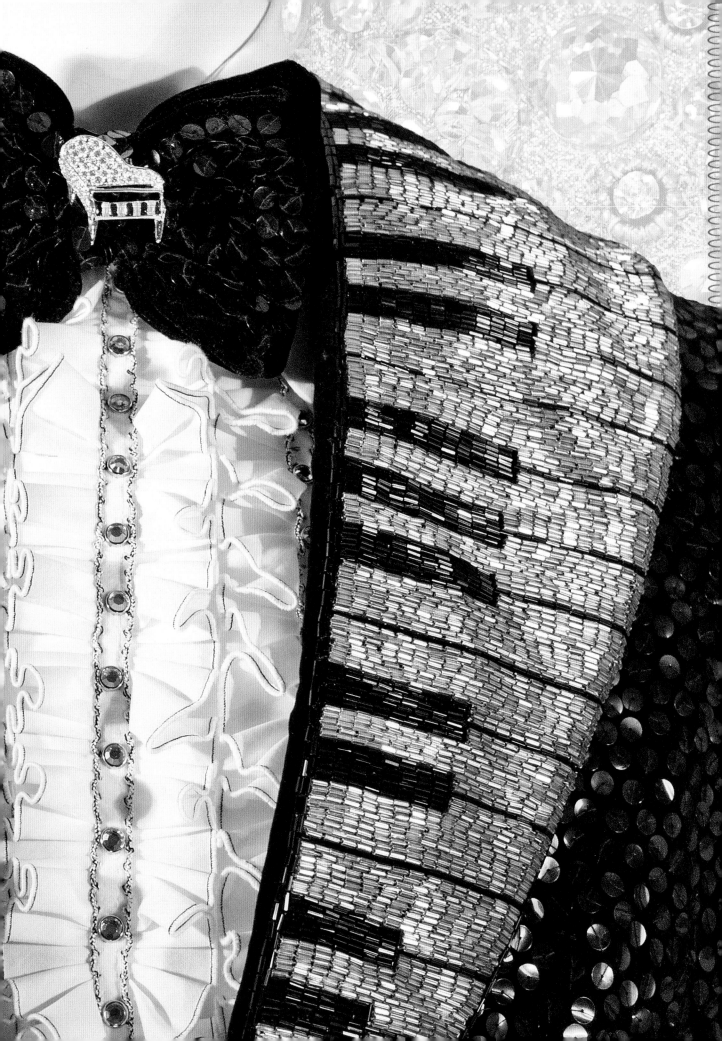

Piano Keys Suit · 1974

Costume design by Jim Lapidus

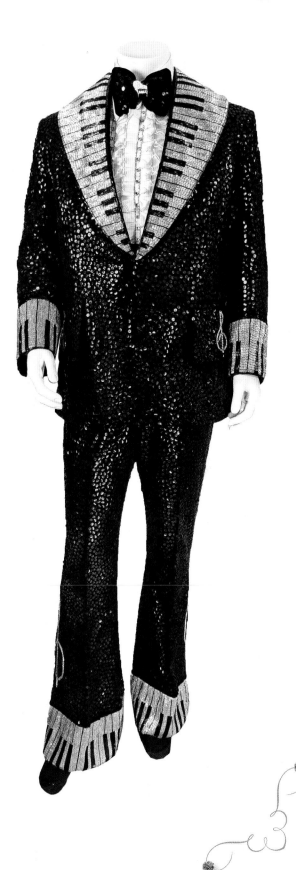

This suit is made of black silk velvet covered in black sequins. The jacket features lapels and cuffs designed to look like piano keys. They are beaded in silver and black bugle beads. A pocket on each side of the jacket is adorned with a clef note made from silver bugle beads.

Matching pants have 1970s-style flare. On the flare, the piano keys motif is repeated and is the same size as those on the jacket. Above these are repeats of the silver bugle bead clef notes.

All bugle beads on the suit are Japanese glass, and lined in silver or solid black crystal. Sequins on the jacket, pants, and bow tie are flat. The jacket bears a label from "JC Costume Co. Hollywood," the company that was both the tailor and beader for this suit, which is still located on Laurel Canyon Boulevard in North Hollywood. Very few of Liberace suits have a label with this type of information.

The suit is accessorized with a black cummerbund and white ruffled tuxedo shirt. The ruffles are edged in a black thread single stitch; the thin center placket is edged with a black-and-white, twisted-thread trim. The center of the placket is set with silver-finished, rim-set crystal rhinestones.

Finishing the outfit is a wide, black-sequined, velvet bow tie. It is pinned with a silver rhinestone piano brooch and set with crystal rhinestones. Black platform shoes have a rhinestoned toe and heel.

Rainbow-Stoned Denim Jumpsuit with Attached Cape • 1974

Costume design by Jim Lapidus

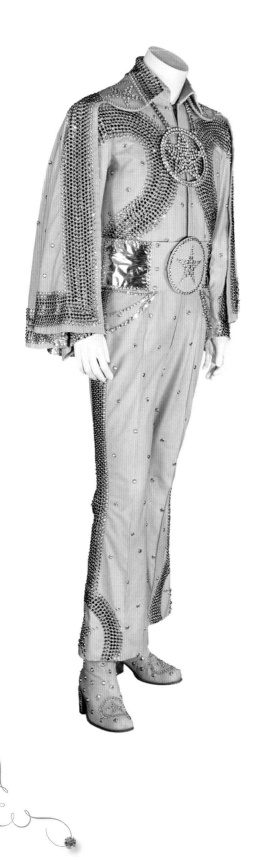

This light-blue, brushed-denim jumpsuit, thought to be an homage to Elvis, has an attached cape and a zip front. The jumpsuit and cape are liberally sprinkled with rim-set AB crystal stones in silver-finished mountings.

Patterning on the chest features semicircles made from rows of rim-set, silver-finished rhinestones. The colors featured in these rows are clear crystal, topaz, hyacinth, light Siam, light sapphire, and emerald. The collar edge leads off with the same sequence of colors, and a short row of light Siam to fill the top of the front collar.

The pants are flared with rhinestones extending from the waist toward the hem. At the hem, a circle on each leg is formed from stones in six rows, one of each color. In its center is a star of crystal stones.

The denim belt also features a circle with a star inside; both are clear crystal. The sides of the belt are a metallic silver fabric and have three silver chains of graduated sizes draped over each hip. The belt is finished with crystal stones outlining its edges.

Stoning on the cape near the edges mimics the jumpsuit's eleven-row pattern. The cape's back has a star of crystal stones in a circle of twelve rhinestone rows. The cape's front shoulders have a semicircle outlined with rhinestones and a star of crystal stones.

A custom-made necklace is formed from two chains of crystal rhinestones, each of which has two lines of rhinestones set with

chatons or pointed backs in Tiffany-prong mountings. The chains suspend a star pendant that lies slightly higher than mid-chest. The star is encircled by two additional rows of stones.

Matching denim boots also have encircled crystal stars on the toes. The heels are covered in rows of stones that are crystal, topaz, hyacinth, light Siam, light sapphire, and emerald-colored. AB crystal stones are scattered on the boots!

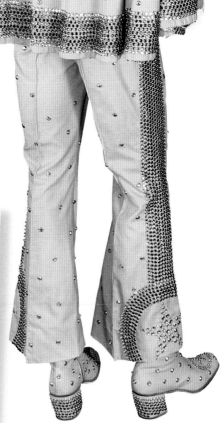

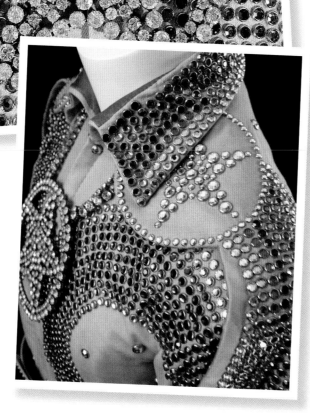

Anna Nateece

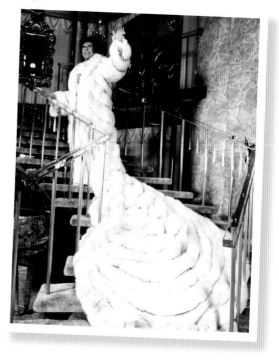

A native of Athens, Greece, Anna Nateece was a prodigy in her country. As a young girl, she discovered she possessed a talent for fashion design. "I worked with designing, dressmaking, and patternmaking in school, which I enjoyed very much," she recounted in an interview with *Luxury Las Vegas*. "I love fashion. It has been in my blood ever since I was born." [46]

At age fourteen, Nateece was presented to Queen Frederika of Greece. A proclamation by the queen honored her as the student with the highest score in her academy. It would be one of seven awards personally presented to the young Greek by the queen. The Royal Court appointed her Queen Frederika's exclusive couturier.

Nateece married an American doctor who enticed her to relocate to the United States in 1965, and the young couple settled down in Boston. Nateece, known for her beauty and elegance, established herself in Boston's fashion industry through modeling and design, and quickly built a large base of well-to-do New England socialite clients.

In 1970 the couple moved to Las Vegas. The seventies in Las Vegas were a time of glamor, and it was not unusual to see members of the Rat Pack (Frank Sinatra, Dean Martin, and Sammy Davis Jr.) or Elvis in the audience of a casino show. In Vegas, Nateece's reputation grew as a designer and furrier. She began work at an exclusive fur salon in the Las Vegas Hilton. In 1970 fate intervened; Liberace and his entourage entered the salon where Nateece was employed. Unbeknownst to Nateece, Queen Sophia of Spain—the daughter of Queen Frederika—had suggested that Liberace meet Nateece.

There was an instant rapport between the designer and the entertainer, and Liberace commissioned a mink trench coat to be worn during his opening at the Hilton. Liberace told the young designer, only twenty-five years old, "I want you to design a stop-traffic showpiece." [47] The result was a luxurious, black diamond mink coat with horizontal mink panels separated by

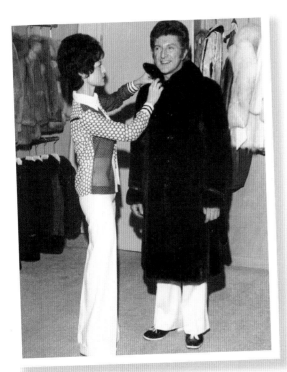

rhinestone-studded snakeskin. Said Nateece: "At the time, this was considered to be quite flamboyant for the stage. I suggested that Lee try on a cape that I had on the boutique floor that was designed at the time for another big name, Cyd Charisse, a performer of some renown. I convinced him that I could create a gorgeous cape for him with the lining being constructed entirely out of rhinestones." [48]

The costume construction required five fittings at Liberace's home in Las Vegas. The weight of the cape increased significantly after each fitting; Liberace requested more rhinestones each time he tried it on. In the end, the cape was floor-length and lined with forty thousand 2.5-karat Austrian rhinestones, each one sewn-on by hand. The cape is currently valued at $750,000.

For Liberace, furs were the symbol of opulence and elegance, and, accordingly, they became an integral part of his personal and onstage wardrobes. The black diamond mink coat, one of Liberace's favorite Nateece creations, was the first piece of what would become one of the world's most expensive and elaborate fur collections.

In 1973 Nateece married her second husband, a master furrier. They established LeNobel, a fur salon in the Dunes Hotel and Casino. LeNobel was the place one would frequent to buy luxury items. A coat with a lining embroidered with the name "Nateece" was considered the height of fashion, and Nateece was soon making one-of-a-kind luxury garments for stars such as Liza Minnelli, Jacqueline Kennedy Onassis, Naomi Campbell, and Sharon Stone.

Still, Liberace was a favorite customer of Nateece's. Working closely with his clothiers, she designed all his stage and personal furs, as well as presents for his staff, family, and friends, and even mink bedspreads for him. "Every Christmas, every birthday, he's beautiful, so well-dressed. . . . Every one of

them had lovely things from me. Lee was so perfect," she recalled. [49]

She would often travel to be with him at his performances. Her business card read "Couturière to Queen Frederika of Greece and the Great Liberace." She fondly remembered the time that Liberace flew to Vegas to surprise her at one of her fashion shows.

Nateece was a close friend and confidante of Liberace's for fourteen years. When he passed away in 1987, little was known about HIV/AIDS. People were fearful and refused to pick up costumes held at the dry-cleaners. This did not deter Nateece. Loyal to the man who had supported all of her endeavors, she reclaimed his belongings, some of which are now part of the Liberace Museum.

Today, Nateece is also a consultant for the care and preservation of the Liberace costume collection, as well as a valued member of the Liberace Foundation's board of directors.

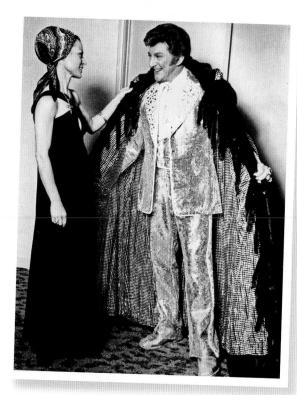

Opposite, left: Anna Nateece and Liberace at a fitting in her salon. *Opposite, right*: Liberace in a white mink coat designed by Michael Travis. *Above*: Liberace in his black diamond mink suit.

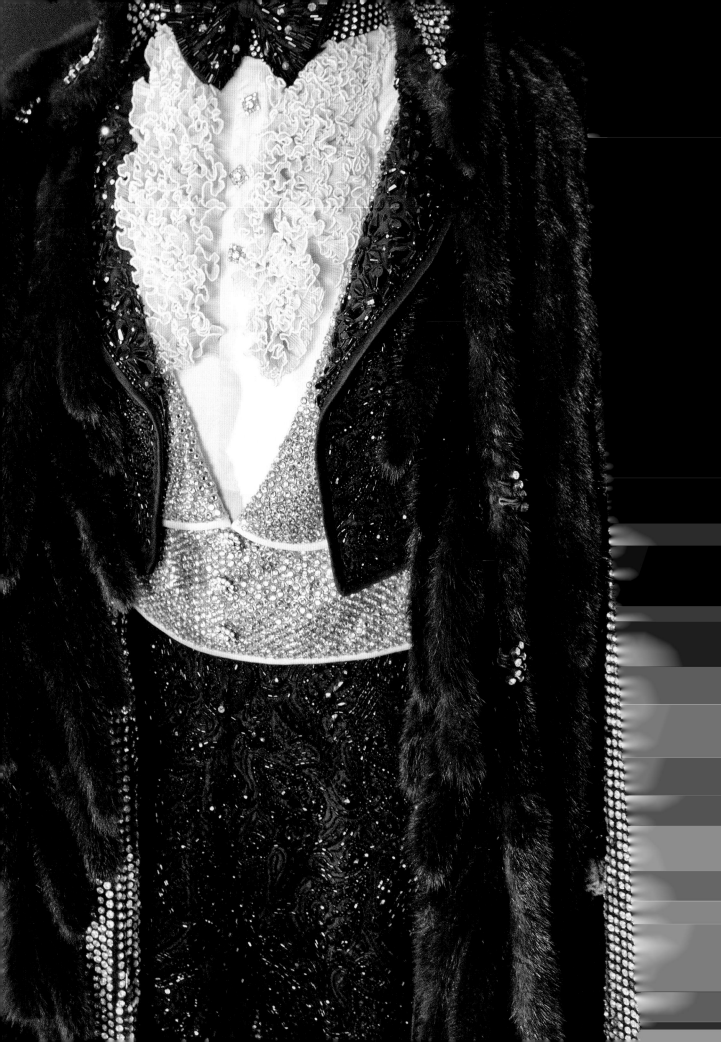

Black Diamond Mink Cape and Suit • 1975

Costume design by Michael Travis

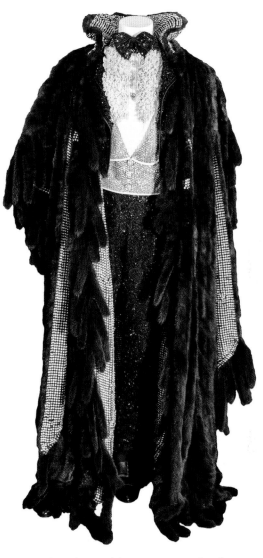

Worn under Nateece's black diamond mink cape, this suit is a perfect match. The tailcoat jacket and pants are black-patterned silk damask. Their rhinestones are crystal and jet-black, and the navettes, sewn-on jewels, lochrosens, and bugle and seed beads are all jet-black. Self-fabric cording outlines the jacket edges, lapels, and cuffs.

The vest is off-white poly gabardine covered with hundreds of crystal rhinestones and three crystal rhinestone buttons. Its

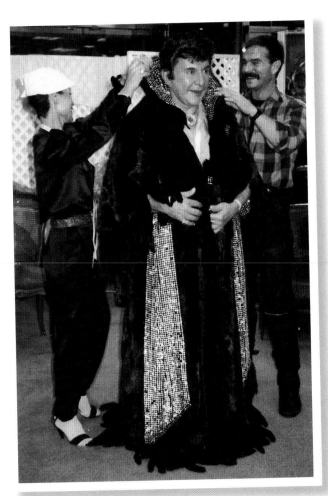

V-neck, lapels, and bottom are edged in cream-colored cording.

To complete the suit, there is a dickey with a ruffled front, a placket with square pearl buttons, gathered white lace cuffs, a black bow tie with black bugle beads and crystal lochrosens, a black-and-silver patterned collar band, and black slipper-style shoes.

Left: Liberace, Anna Nateece, and valet Terry Clarkson at a fitting.

Black Diamond Mink Cape · 1975

Costume design by Anna Nateece

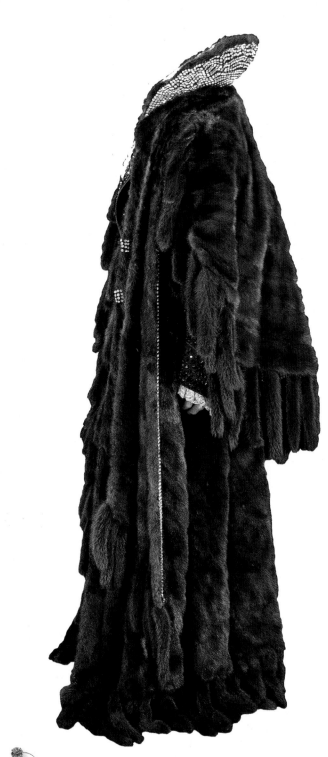

Created in 1975 and worn many times in the seventies and eighties, the black diamond mink cape is made from authentic Danish black mink and five hundred top-quality skins. The mink fur is worked diagonally and the cape is floor-length.

The cape is trimmed from the collar, down the front, and around the hemline with more than two hundred black mink tails. The back features a second, very full, shawl cape laid over the base cape. This second cape, extending from the neck and shoulders down past the waistline, is trimmed around its perimeter with black mink tails.

The base cape is lined with more than forty thousand crystal rhinestones. They lie flat—set into black banding and hand-stitched to it. On each side of the cape's center front there are two crystal rhinestone clasps. These are four rows wide and wrap around the front edge of the cape.

The large stand-up collar is covered front and back with hand-stitched rhinestones. These are of the same kind as the rhinestones on the lining, and they are edged with a small row of mink fur.

The cape also has a matching fur scarf. The scarf is worn under the collar and extends approximately twelve inches, with the bottom edge cut on a diagonal. The scarf is also lined with crystal rhinestones.

Together, the cape set and scarf weigh approximately 150 pounds.

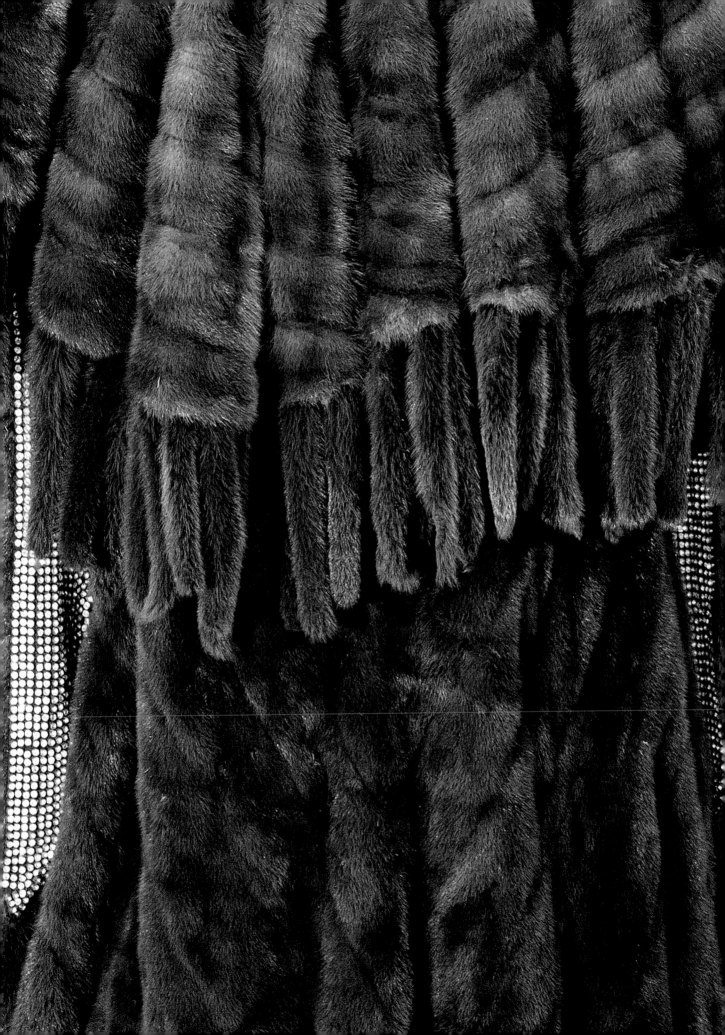

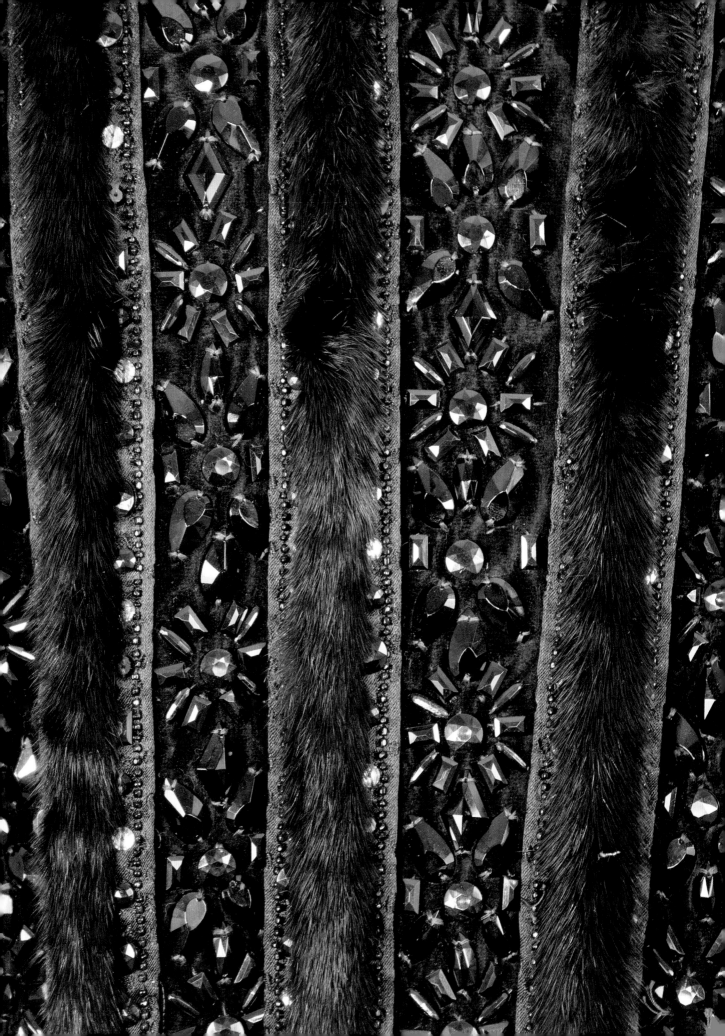

Black Mink and Snakeskin Coat • 1970s

Costume design by Anna Nateece

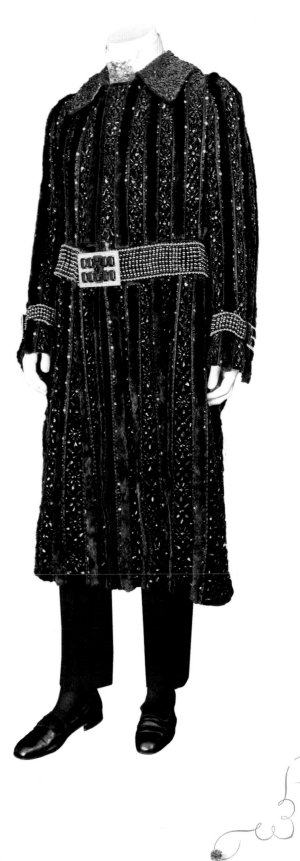

This trench coat made by Anna Nateece is constructed from alternating bands of black-dyed snakeskin and black mink. It has large, elaborate beading patterns encompassing jet-black rhinestones, crystal and topaz lochrosens, black seed beads, and small topaz beads.

On the snakeskin strips, large floral patterns use jet-black, sewn-on, flat-back rhinestones. The pattern is densely worked and covers the majority of the snakeskin. The beading on the mink strips is on the edges, which are decorated with crystal lochrosens, jet-black rhinestones, and a row of jet-black seed beads.

The coat's zip-out lining is gold lamé with topaz lochrosens and beads. Its custom-made black leather belt has alternating rows of crystal rhinestones and jet-black rhinestones. The belt buckle is also studded with several rhinestones. The pattern on the belt and buckle is, in smaller dimensions, also on the sleeves.

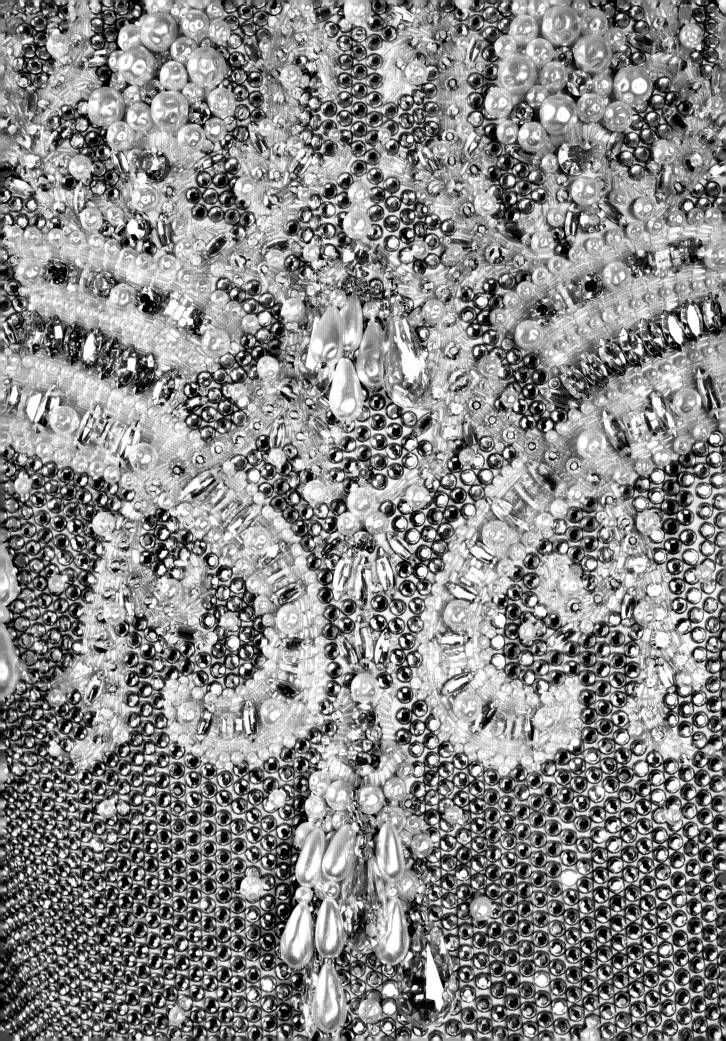

Rhinestone Suit · 1982

Costume design by Michael Travis

When Anna Nateece met Michael Travis, they bonded over their shared Greek heritage. When they collaborated to make ensembles for Liberace, the results were consistently spectacular.

Liberace wore this tailcoat suit during his tours in the 1970s, most notably at the Las Vegas Hilton. The cutaway coat, vest, and

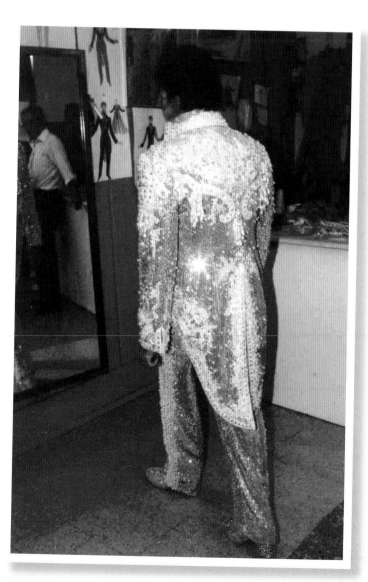

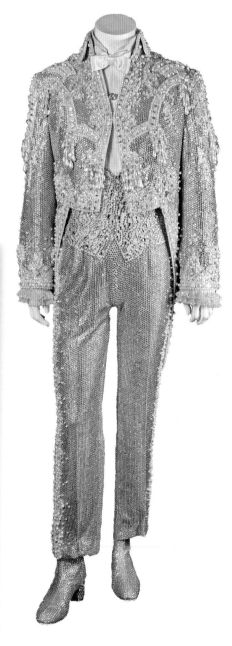

Left: Liberace at a fitting with Michael Travis.

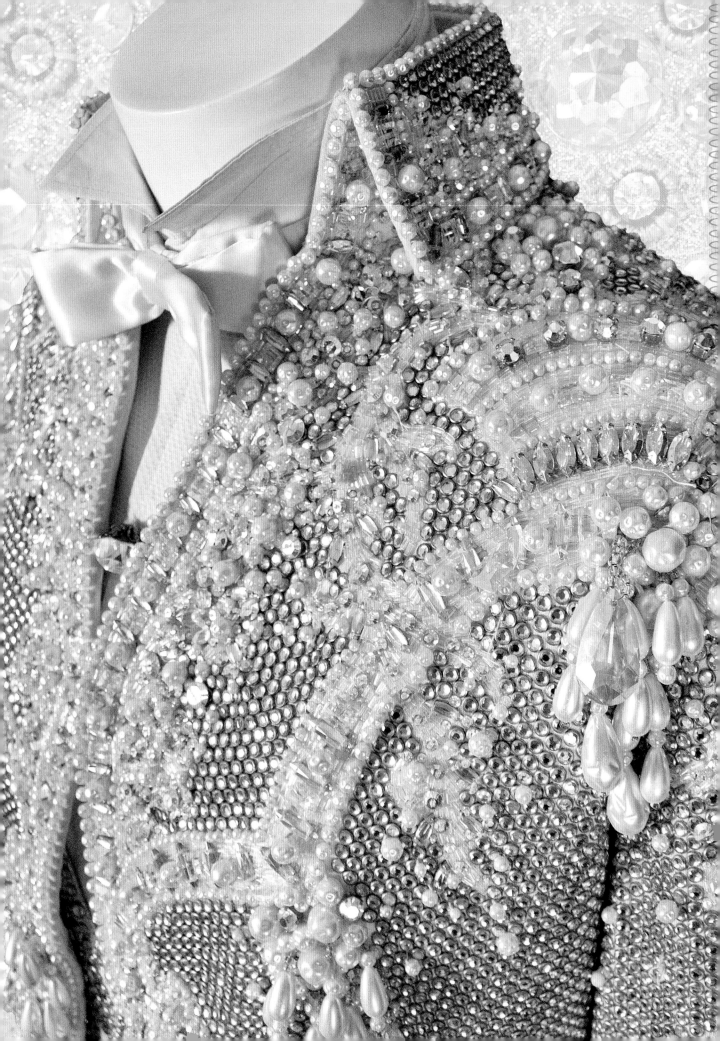

pants are fully encrusted in crystal rhinestones and adorned with elaborate pearl designs.

The base fabric for the suit is white polyester gabardine. On the front of the coat, square jewels, pearls, and navettes cover banding that curves across the chest and shoulders. The banding also has dangling clusters of pearls. Each pearl in the cluster is topped with a smaller pearl and silver rocaille beads. In the center of the clusters, dangling from a loop of silver rocaille beads, is a faceted, AB crystal pendant jewel. Stitched around the clusters are additional pearls, and crystal AB lochrosens.

Continued embellishment includes fan-shaped motifs at the bottom edge. These motifs are composed of pearls, clear bugle beads, and crystal AB navettes that are Tiffany-mounted and sewn on. At each shoulder there is a pattern in the shape of a quarter circle. It consists of rows of crystal AB navettes, pearls, crystal AB jewels, and Tiffany-mounted crystal AB rhinestones.

On the back of the coat, heavy beading from shoulder to mid-back features the same patterns as on the front. Five large clusters of dangling pearls and AB pendant jewels extend toward the waist. At the waistline, under a cluster, is a spray of crystal AB navettes, pearls, crystal lochrosens, and Tiffany-mounted AB rhinestones, which join the beading around the slit in the tails.

Around the back edges of the coat and extending up the slit of the tails, three bands of pearls are surrounded with an AB crystal navette and sewn-on jewels. On the innermost side of this strip are loosely shaped triangles created from clear bugle beads, AB crystal lochrosens, crystal navettes, and pearls.

The vest is a part of the jumpsuit. It is made from silver lamé appliquéd to white polyester gabardine, and worked in an open rhinestone pattern, allowing portions of the lamé to show.

At the top of each sleeve is a medallion pattern with Tiffany-mounted, sewn-on crystal AB pearls and clear bugle beads. Single pearls, as well as clusters of pearls topped with smaller pearls, are scattered near it. Faceted crystal AB pendant jewels dangle from and surround the medallion. Further encrustation of the sleeves, rising from the cuffs, is accomplished with pearls, AB lochrosens, AB rhinestones, and clear bugle beads.

The cuffs are double-tiered gathered chiffon with a merrowed edge, and have the same patterning as the coat's edges. The rhinestone-covered, fold-over collar is worked in the same pattern along the bottom edge as the front of the coat, and edged with small pearls.

On the side of each leg is a strip consisting of a pearl surrounded by an AB crystal navette and sewn-on jewel, followed by an AB crystal sewn-on jewel. This sequence goes down each leg and is outlined with white pearls. On both sides of the strips are loosely shaped triangles made of clear bugle beads, AB crystal lochrosens, crystal navettes, and pearls.

A wing-tipped dickey of cream-colored silk, cream satin bow, and matching boots complete the look. The boots are silver leather, covered on the shaft and heels in rim-set crystal rhinestones. They were made by Pasquale Di Fabrizio.

The ensemble features a shallow, scalloped center front. The inside front and part of the bottom edge are lined with white stones set in solid crystal banding. The remainder is lined with white satin.

White Azurene Mink Cape · 1982

Costume design by Michael Travis, fur made by Anna Nateece

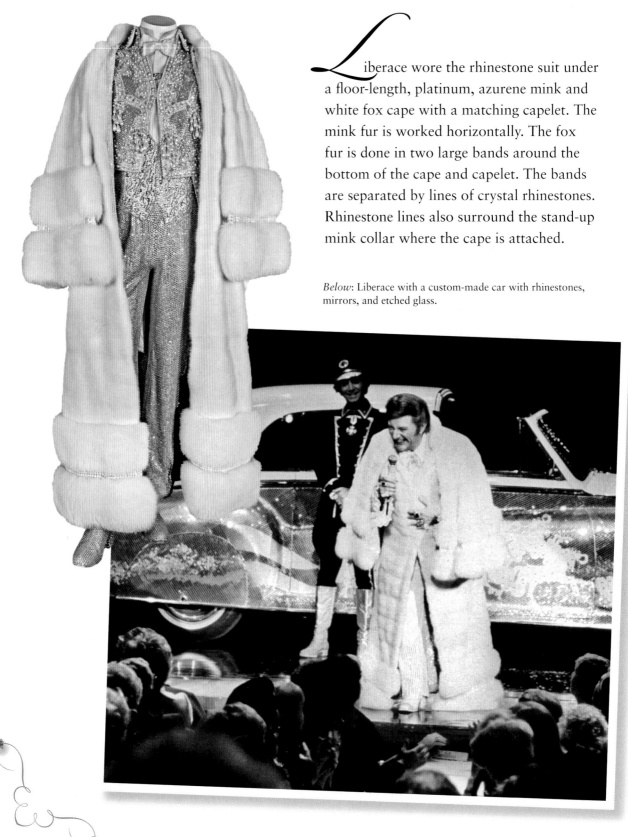

Liberace wore the rhinestone suit under a floor-length, platinum, azurene mink and white fox cape with a matching capelet. The mink fur is worked horizontally. The fox fur is done in two large bands around the bottom of the cape and capelet. The bands are separated by lines of crystal rhinestones. Rhinestone lines also surround the stand-up mink collar where the cape is attached.

Below: Liberace with a custom-made car with rhinestones, mirrors, and etched glass.

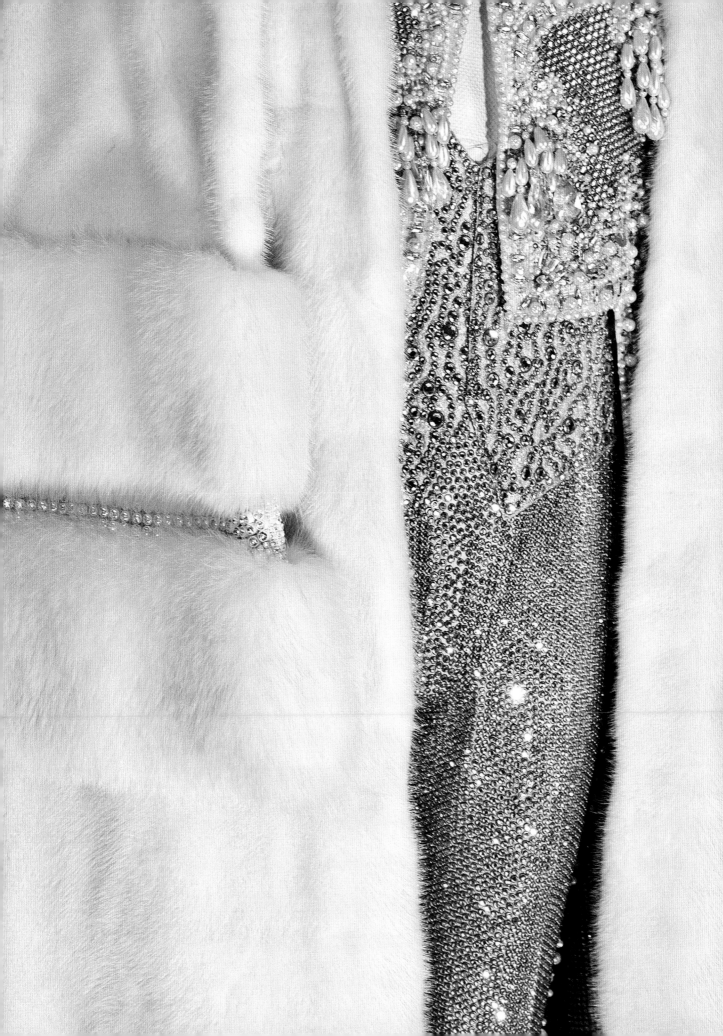

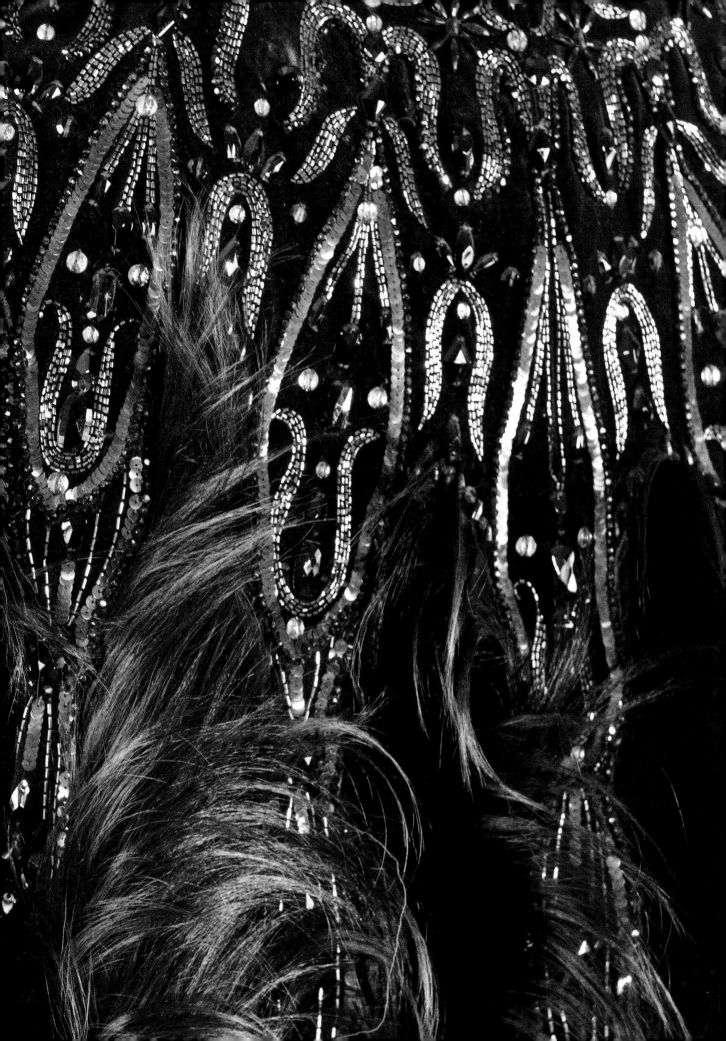

Black Upside-Down Monkey Fur Cape • 1970s

Costume design by Anna Nateece

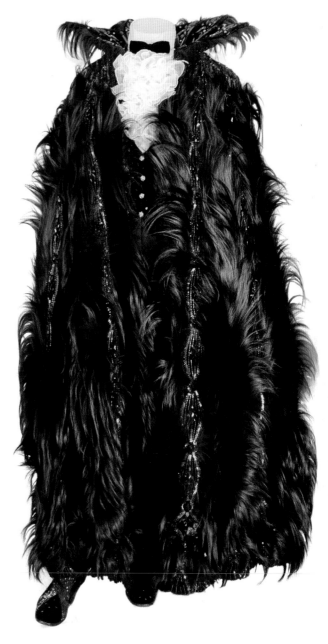

Monkey fur was popular from the mid-nineteenth century through the 1940s, and this monkey fur cape was worn by Liberace at the Las Vegas Hilton in 1982 and during his cross-country tour that same year. Made by Anna Nateece, Liberace bought the cape from actress June Havoc, the sister of Gypsy Rose Lee, and had it redesigned for his show.

It is floor length and made from the pelt of the Abyssinian black-and-white colobus—a monkey found in central Africa. The fur is long (reaching lengths of five inches or more), sleek, and shiny. It looks and feels eerily like human hair. When placed upside down, the long length of the fur creates a natural curl at the end, hence it got its name as "upside-down monkey fur."

The cape is embellished with silver bugle beads, sewn-on jet-black rhinestones and lochrosens, crystal lochrosens, and sequins in gradating colors of silver, gray, and black.

Between the wide strips of fur in the cape body are leather strips, four in the front and five in the back. They connect to the yoke in the back and the shoulder portion of the yoke in front. Each strip is edged in silver sequins and bugle beads, and further decorated with motifs made from jet-black rhinestones, lochrosens, bugle beads, and sequins.

The cape's back and shoulders feature a lavishly embellished yoke that extends into a large stand-up, crown-shaped collar. The collar and yoke have rows of silver bugle beads repeated in an undulating pattern inter- spersed with jet-black rhinestones, lochrosens, jewels, and sequins. Lines of monkey-fur edging are sandwiched between the beading patterns. The lining of the cape is worked in a bargello pattern of sequins, which graduate from bright silver to gray to black.

Michael Travis

ichael Travis, a Greek American from Detroit, originally planned to study medicine after his army service, but fate intervened. His glasses broke while he was stationed in Paris during World War II, and he was assigned the duties of taking shorthand and typing. The three-year stint provided Travis ample opportunities to travel. He could hop aboard a military vehicle for free and set off for European art museums and historical sites that would open his eyes to new directions his life could take.

Discharged in 1949, Travis opted to stay in Paris and applied to the École nationale supérieure des Beaux-arts and the Sorbonne for studies under the G.I. Bill of Rights. Later he attended Guerre-Lavigne to study fashion couture, and it was there that he met renowned fashion designers Jacques Fath and Pierre Balmain.

Travis would on occasion submit sketches and do line drawings for Fath and Balmain, and sometimes his work would be shown in their collections. But he was impatient to begin his design career in earnest, so he booked a third-class passage to New York and began his search for employment in the industry. He found work as a secretary at the Eaves Costume Company. Established in 1863, it was the premier costume house for Broadway shows.

Travis worked there for five years; however, as he says, "I was always looking past the desk at the sketches that the designers brought in; that was what I wanted to do." He eventually became an assistant to the owner, Andrew Geoly. Geoly, realizing that Travis's dream was to be a designer, allowed him to assist designers in pulling costumes. He also gave him the job of cataloguing Eaves's extensive collection of historical costumes.

Encouraged by his boss to prove his abilities, Travis took the union costume exam and passed. This made him a member

Above: Liberace in his Fabergé costume at Radio City Music Hall. *Left and opposite*: Michael Travis.

of the Designers Guild and allowed him to assist or design for Broadway shows or a union film. Afterward, his boss fired him. "You're too talented to hold back," Geoly said. "Go out, get a show and come back. We'll build the costumes together, and I'll help you any way I can."[50] Travis was forever indebted to his mentor for this. They remained friends until Geoly's death twenty years later.

Initially, Travis found employment as a designer's assistant at Eaves's rival company, Brooks Costume Company. He assisted some of Broadway's most famous designers, Miles White, Raoul Pene du Bois, and Irene Sharaff. He particularly admired Sharaff, assisting her on a Broadway production of *Aladdin*. She had an incredible eye and was a stickler for detail. Travis recalled that an orange sash with coral and pink cords had to be specially dyed. The production company remarked, "Well, those details are not noticed on TV," whereupon Sharaff replied, "but I will know it's there."[51]

Travis received his first big break designing for the famous producer Harriet Parsons's film *Rape of the Belt*. His career spiraled upward from there. The venture led to working on Eugène Ionesco's successful Broadway play, *Rhinoceros*, starring Zero Mostel and Jean Stapleton. The director of *Rhinoceros*, Alan Schneider, then hired him to design the costumes for a series of weekly theatrical classics presented on Public Television Theatre. In due course Travis became the designer for *The Voice of Firestone*, a radio show became a television show featuring popular musicians and Broadway stars. He also worked on *The Bell Telephone Hour*, the first television series to be telecast exclusively in color.

In 1958 Richard Dunlap, producer of the Academy Awards, and Margaret Herrick, head of the Academy of Motion Picture Arts and Sciences, hired Travis to work for the program under famed costume designer Edith Head. Travis and Edith became good friends. "Edith said, 'You do all the production numbers and I'll concentrate on the stars.'"[52]

Travis worked on the awards program for eight years, commuting from New York to Los Angeles. Finally, Head told him it was enough: "If you want to make it in Los Angeles you have to burn your bridges and move west."[53] In 1965, reading the trades, Travis discovered that a producer by the name of George Schlatter was doing a show in New York. Travis called a friend and asked for an introduction. A few meetings later, Travis got the contract for *The Steve Lawrence Show*. It lasted twenty weeks.

There was a mutual admiration between Travis and Schlatter; and a year and half after *The Steve Lawrence Show*, Travis heard Schlatter was producing a variety show called *Laugh-In*. "I can't have you do the pilot, it has to be a NBC designer," Schlatter told him, "but if it gets bought then you got it." Lucky for Travis, it did. "Pack your bags, you got the show," he was told.[54] He never forgot this phone call.

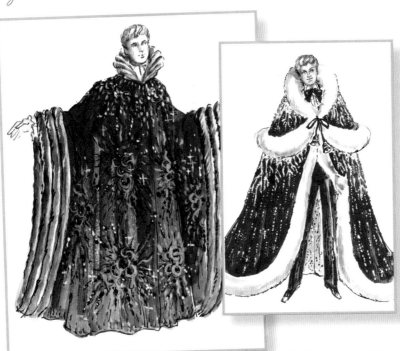

before he was designing for the *Hollywood Television Theatre* as well as the award-winning television movie *The Andersonville Trial*.

In 1973 Ray Arnett, Liberace's road manager at the time and a good friend of Travis's from New York, called. "Lee needs a new designer," he said.[56] Ortiz had retired from the business and Anna Nateece was primarily a fur designer. Liberace needed a designer capable of conceptualizing the fantasies he wished to wear onstage. Travis was up to the challenge.

In preparation for the meeting with Liberace, Travis created a variety of sketches to show. As Travis recalls, Liberace said: "I'll take this one, this one, and this one. . . . Now you're not going to charge me too much for these are you?" It was a comment made in jest, for as Travis attested, "Liberace was incredibly generous and money was no object in order to obtain the [desired] results."

Travis was masterful in his creation of an attractive silhouette for Liberace: making his chest appear broader, his waist slimmer. His first design for Liberace was a chauffeur's costume that coordinated with one of his cars. The costume was all blue—fashioned with splendid beading and dazzling rhinestones trimmed with blue mink. In 1975 inspired by nineteenth-century designs, Travis created a Chopin-style jeweled suit. The ensemble was in honor of the United States' bicentennial celebration and was a jeweled red-and-blue suit topped with an all-white ostrich cape.

Fortuitously, *Laugh-In* became a wildly popular television variety show that ran for three years. It was an incredible experience, but also a strenuous one. Each show had new guest stars and new production numbers that required identical fantasy costumes for the stars, dancers, and singers. It was not unusual to need more than three hundred costumes for an episode. Before construction, Travis would show Schlatter the designs for approval. Travis was a master of understanding the power of design. He knew that he had successfully conceptualized the characters for the comedy series when Schlatter would exclaim, "Michael, they're so awful! They are marvelous!"[55]

For three years, *Laugh-In* had provided financial security for the designer; when the series ended, Travis experienced momentary panic. He had become accustomed to having an ongoing gig. However, he need not have worried. Relationships with celebrity clients such as Diana Ross and the Supremes, Wayne Newton, and Tony Orlando led him to more opportunities. It was not long

Travis designed the outfits and all the beading patterns himself. Following Liberace's approval of a design, Travis would oversee all aspects of the costume's creation: tailoring, beading, trapunto, stoning, and sequin application. Costumes would take months to manufacture and required the skills of a tailor, four to six experienced seamstresses, and four to six people to do the beading, stoning, and sequining.

The base fabric was typically a polyester gabardine; such a durable fabric was required to support the weight of the embellishments. The tailoring was done in Los Angeles by well-known shops, such as Primo Costume Tailors. Then the outfit would be taken to Getson D. Eastern Embroidery Company to execute the design. Costumes had both machine and hand embroidery. Heavily embroidered coats could easily weigh forty-five pounds, but Liberace never complained about this. Travis recalled that once during a fitting, he had trepidations about the weight of a coat. He asked if Liberace could lift his arms. Liberace looked at him, took a drag off his cigarette, and responded, "Don't worry about it." Liberace wasn't one to worry about such things.

After a costume was tailored and jeweled, it was often thread-marked for fur to be placed. Nateece would suggest fur types, and she and Travis would collaborate to determine the best one. Then she would execute the fur application, deciding how the fur should be patterned and applied. Great skill was required so that it would lay properly. The skill of the two designers ensured that few costumes would require more than two fittings.

Said Travis: "It takes about two months' planning time to allow for cutting and fitting, and the tremendous detailing required in finishing touches for such elaborate costumes. It means I have to wear roller skates just to get around to fabric people, cutters, furriers, beaders and embroiderers, to have the work come out on time. I do the original sketches from my home studio, and the rest is then processed through various workshops. . . . As for Liberace, he's a pussycat. He's sweet, wonderful, very kind, and thoughtful. His popularity is incredible. He never ceases to amaze me."[57] For more than twelve years, Travis's designs took Liberace's costumes to new levels of grandeur and unparalleled extravagance.

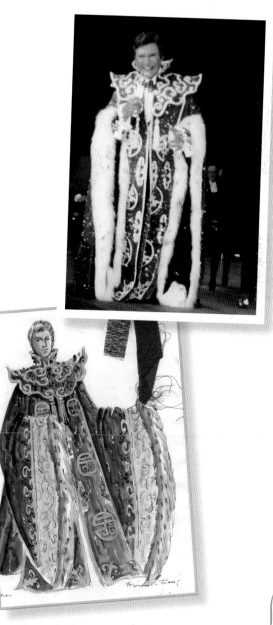

Above: Liberace in his green mandarin cape.

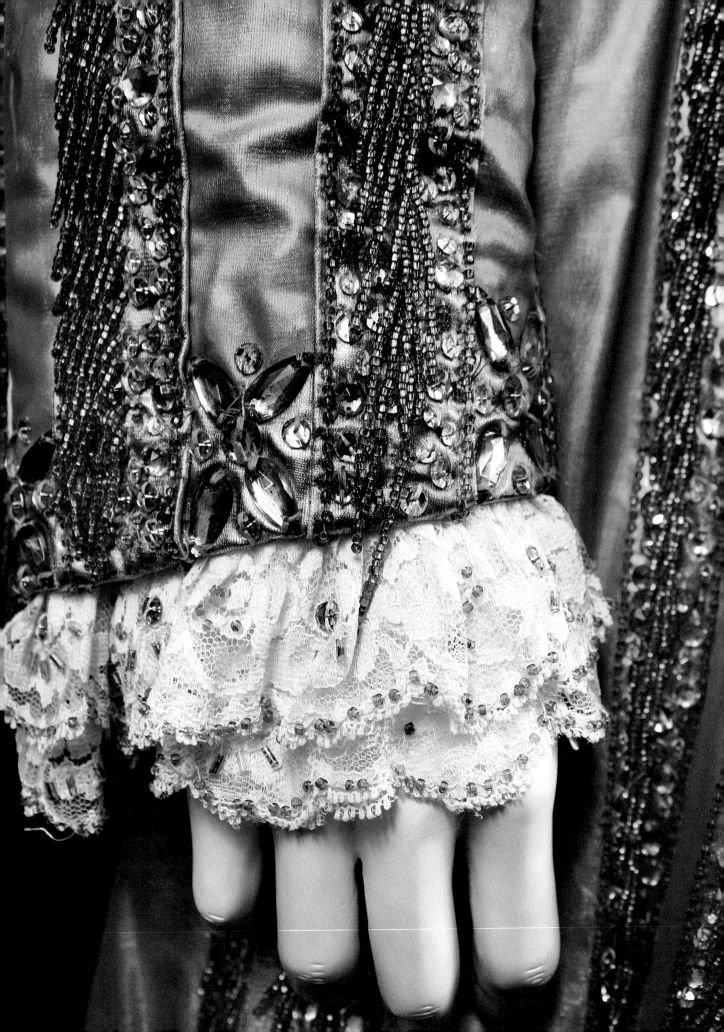

Blue Fringed Vest and Jumpsuit • 1974

Costume design by Michael Travis

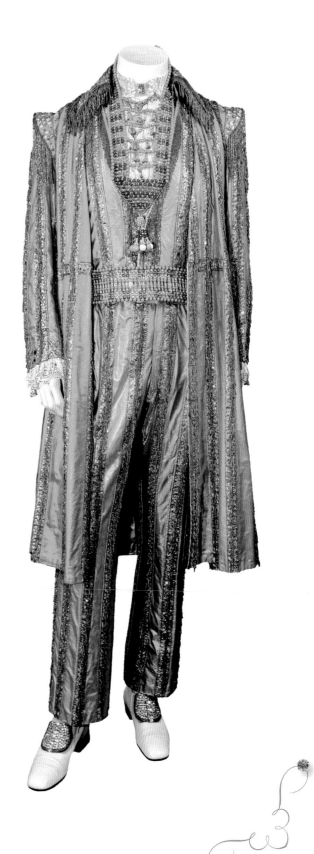

Bright blue and turquoise, this costume features a jumpsuit, faux belt, coat, and custom-made jewelry. There is a sleeveless white shirt with a ruffled lace front; a band collar with white lace; a rhinestone accented bow tie; ruffled, blue seed bead accented lace cuffs; and slipper-style shoes.

Metallic blue lamé is the base of the jumpsuit and coat. On the jumpsuit, medium-blue seed beads, fringe, light sapphire and crystal lochrosens, and sewn-on jewels create a tone on tone look.

The knee-length coat has horizontal strips at center front and is appliquéd vertically with bands of self-fabric. Each band has light sapphire and crystal lochrosens and light sapphire sewn-on jewels, and is edged with medium-blue seed beads and fringe. A pleat, at center back and running from collar to hem, is outlined with an embellished strip.

Extended shoulders are stiffened and stand away from the sleeves. They are worked in a floral pattern using sapphire sewn-on jewels and crystal lochrosens. Interspersed between these motifs are light sapphire navettes and crystal lochrosens. Medium-blue seed bead fringe runs around the edge of the shoulders.

The large fold-over collar is nearly covered in light sapphire and crystal lochrosens and light sapphire sewn-on jewels. A row of medium-blue seed bead fringe outlines the collar. The coat is self-lined.

The jumpsuit has the same fabric and strips as the coat. The faux belt is created with horizontal rows of the same turquoise beads, sapphire and light sapphire faceted beads, and crystal rondelles. It is also embroidered with blue seed beads and light sapphire and crystal lochrosens. The jewelry accentuating the costume is made from sapphire and light sapphire faceted crystal beads and turquoise glass beads interspersed with crystal rhinestone rondelle spacers. Spaces in the necklace are filled with clusters of three teardrop-shaped turquoise beads dangling from crystal rondelles. At the bottom, there is a large tassel made from a round jewel of multi-crystal rhinestones attached to crystal rondelles, sapphire crystal beads, and turquoise beads.

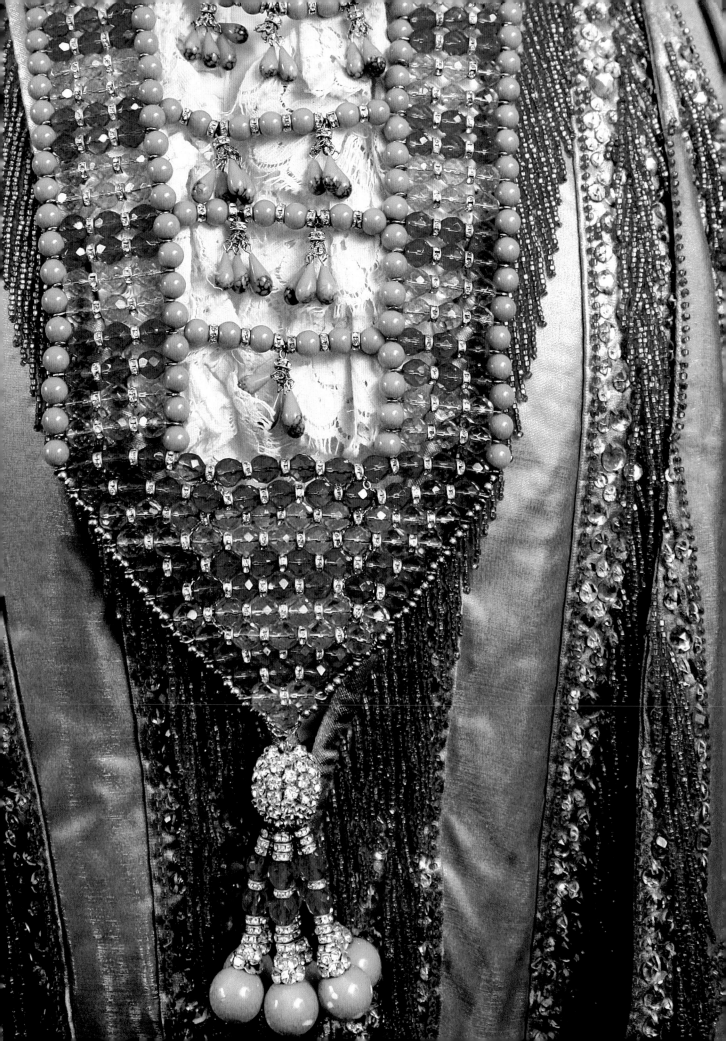

The 1970s and '80s

When asked in February 1984 to what he attributed his success, Liberace replied, "To showmanship more than talent. There are millions who can sing like I can and play the piano better. But I created the person—the crazy suits, hairstyles, shoes . . . in this business, image is everything." [58]

The eighties was an era of prosperity and excess. Ronald Reagan was the nation's president. Television shows such as *Dallas* and *Dynasty* prospered—with themes of wealth, deception, and decadence. Movies such as *Raiders of the Lost Ark*, *Wall Street*, *Working Girl*, and *Amadeus* were popular. Cyndi Lauper, Boy George, Michael Jackson, Madonna, and Prince were the decade's top performers. Yuppies—young urban professionals—were enamored of a lifestyle filled with expensive toys, cars, and electronics.

The designs, opulence, and extravagance of the costumes of this decade mirrored the glamour of the lifestyles being pursued. So too did Liberace's decadence, and he was once again in the forefront of entertainment. In 1986 fashion critic Richard Blackwell paid tribute to Liberace: "I only give this award once every seventy-five years. I won't be here to do it again. I gave it to the person with the most flamboyance, drama, and flair, for his out-of-this-world, brilliant array of flashy, glitzy glamour." [59]

Liberace may have said it best when he described his life: "It's fantasy. I'm a one-man Disneyland. It all sort of developed gradually. None of it is accidental. . . . I'm always trying to see how far I can go. Ten years ago, I couldn't get away with the extremes in costumes that I can get away with now. I might have paid $10,000 for a costume then. Now one can cost eighty dollars—or $100,000." [60]

By the 1980s Liberace had been performing for more than forty years. He'd ended his own TV show in 1969 to avoid overexposure, but he'd always understood the importance of staying in the public eye, and was successful in growing his fan base by appearing on programming that would attract different demographics. Among other ventures, he hosted an episode of *MTV* and guest starred on *The Muppet Show* and *Saturday Night Live*. He was also on *The Johnny Carson Show* more than twenty times from 1972–1986, and on *The Phil Donahue Show, The Michael Douglas Show*, and *The Oprah Winfrey Show*. In 1982 he hosted the Academy Awards. In 1985 he appeared with Hulk Hogan on *WrestleMania*.

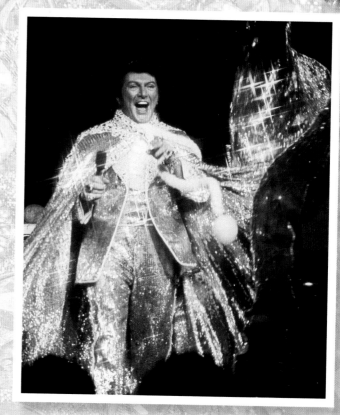

Liberace wanted his costumes to entertain and delight his audiences, and with Michael Travis and Anna Nateece that goal was exceeded. Still, Travis always strove to keep the costumes as masculine as possible. He wanted Liberace to look fabulous; he also wanted him to look handsome. Most of his fans were women, and many were in love with the performer.

As Liberace told a reporter in 1986: "I'm wearing something on stage that no one else in show business could afford to wear or would dare to wear. I'm in a class by myself. . . . My costumes are works of art. The audience expects it. Liberace is one of a kind."[61]

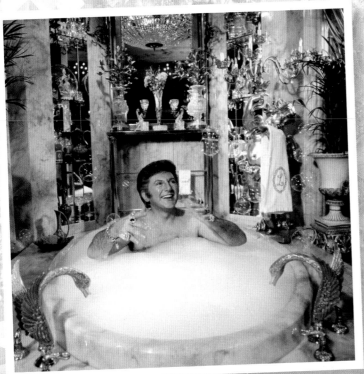

Above: Liberace in a fully beaded and rhinestoned costume with a matching cape.
Left: Liberace in his private bathroom.

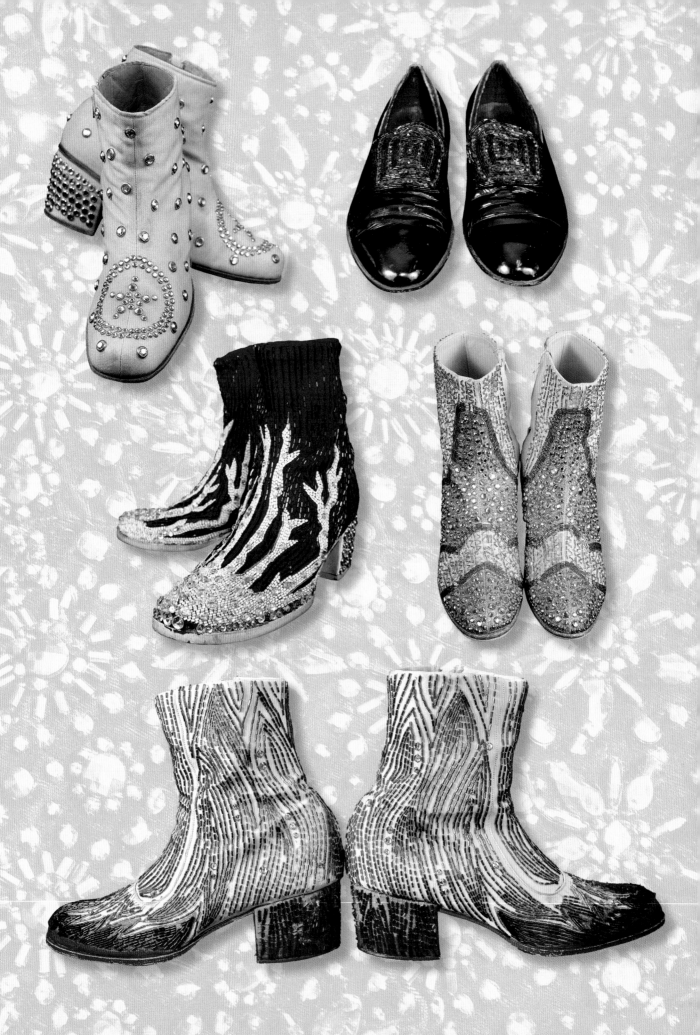

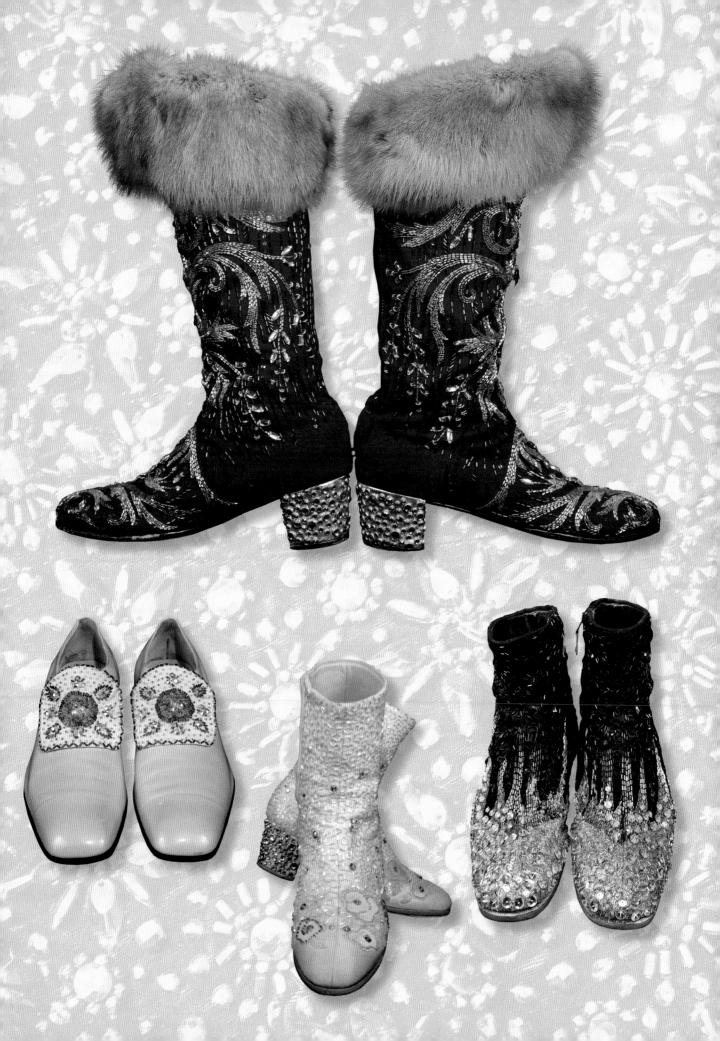

Shoemaker to the Stars:

Pasquale Di Fabrizio

For Liberace, an outfit was not complete without footwear specially designed for it. During the 1970s and 1980s, the man charged with this task was LA-based Italian shoemaker Pasquale Di Fabrizio.

Di Fabrizio said that the story behind his work with Liberace began in 1960 when he was working with Dean Martin, singer for the Rat Pack. "Dino asked me to make a pair of house slippers," he said. "He liked them, so he ordered forty pairs. Then he ordered some for Sinatra. That's how it started." [62]

Di Fabrizio was soon making shoes for Hollywood legends, including Cary Grant, Danny Kaye, Fred Astaire, Ginger Rogers, and Warren Beatty; he even made Hugh Hefner's loafers. Among his most famous creations were the bodacious platform boots he created for the rock band KISS. As he did with Anna Nateece, Michael Travis would collaborate with Di Fabrizio to make an outfit come together seamlessly. Travis would sketch the shape and style of the boot he wanted and the cobbler would realize it. "I draw the foot and take measurements," said Di Fabrizio. "Then, according to the heel they want, I make the mold from wood. I have to make sure the twenty-six bones in each foot go in the right place. Then they can walk—that is the art of making good shoes." [63]

The starting price for women's shoes made by Di Fabrizio was $650 a pair; for men's, $1,000. Liberace once paid four thousand dollars for a pair of Di Fabrizio's shoes. He was trumped only by Michael Jackson. Said Di Fabrizio, "We made shoes for Michael Jackson using eighteen-karat gold. They cost $5,000 and were for his museum. He could never wear them—there was so much gold." [64]

Although Di Fabrizio passed away in 2008, his company is still going strong under the leadership of his namesake and nephew. The Di Fabrizio workshop has now stitched custom footwear for more than fifty years and one thousand movies. The walls of its Hollywood shop are lined with columns of shoeboxes. Each one is labeled with the name of a star customer and inside is a custom-made wooden sculpture of the star's feet—bunions and all.

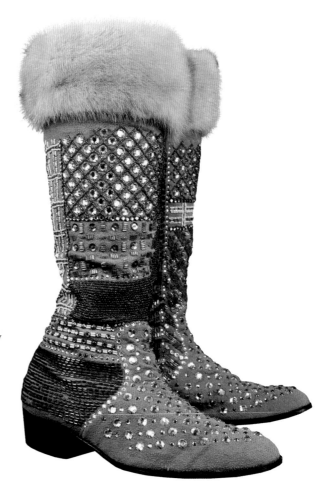

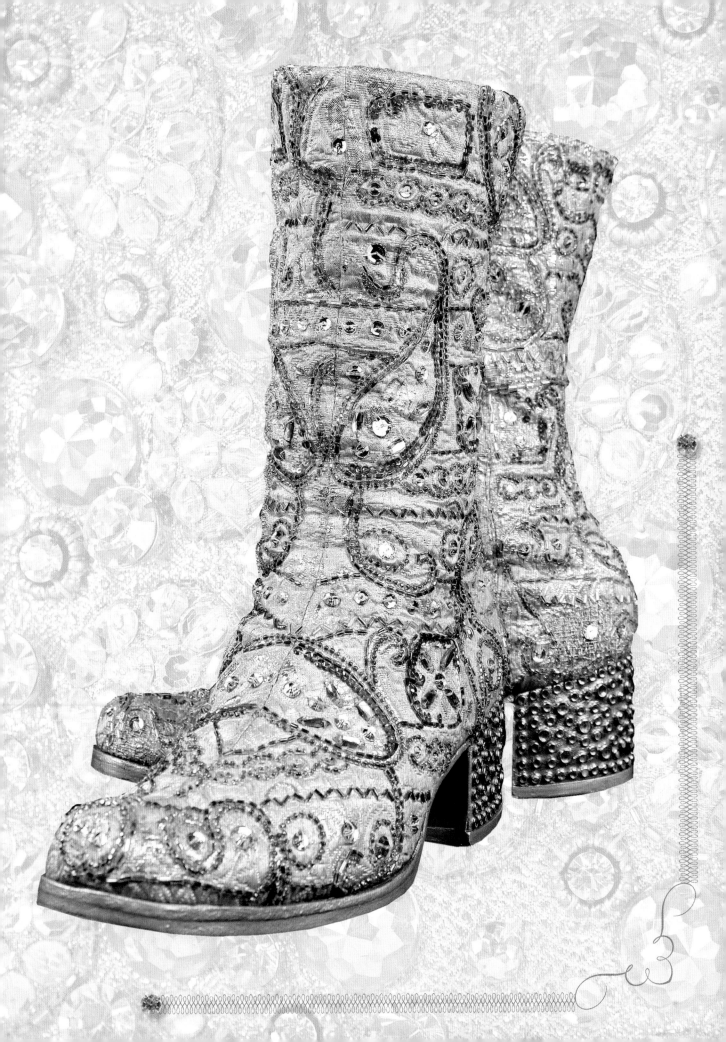

Blue Crazy Quilt Suit • 1970s

Costume and fur design by Michael Travis and Anna Nateece

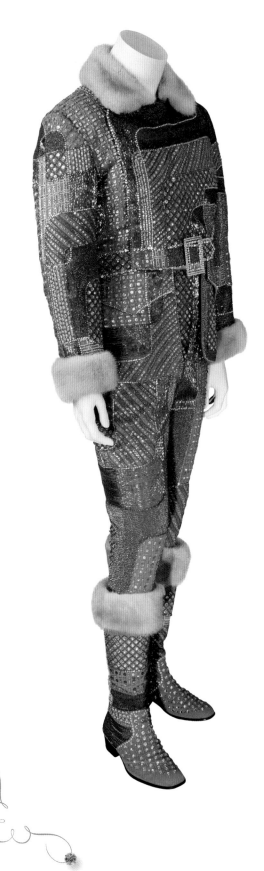

This costume was the first one Michael Travis created for Liberace. Liberace wore it in his 1974 performances and made his entrance onto the stage of the Las Vegas Hilton, that same year, in a matching blue sports car.

The costume consists of a jacket and pants made from a heavy, denim-blue double-knit fabric. The patterns and colors of the patchwork design were created from blue lochrosens topped with small seed beads, Tiffany-mounted crystal and sapphire rhinestones, and bugle beads. Bead colors range from silver to turquoise to dark navy.

The jacket has a lapped zipper up the front; the lap is held in place by snaps. A beaded strip runs horizontally across the stomach and has a crystal rhinestone at its center, thus creating the illusion of a belt. The illusion of a belt facilitated quick changes into other costumes during a show because it meant one less piece of clothing had to be removed. The jacket's collar is composed of sable fur, which also trims the cuffs. Calf-high boots with a repeated beading pattern and sable trim finish the costume.

Green Mandarin Cape • 1974

Costume and fur design by Michael Travis and Anna Nateece

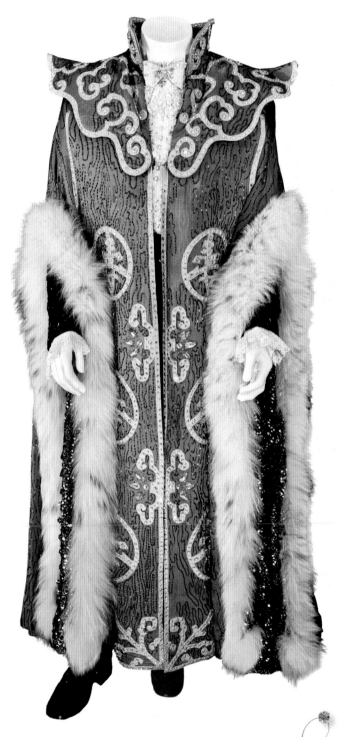

This cape of heavy green silk features an Asian theme. The sparkle is achieved by overall beading made from bugle beads in a free-form pattern.

Both the front and back of the cape feature six round Asian motifs constructed from wide pieces of silver lamé. The bottom border of the cape and its front portion are edged with a banding of small, silver-lined, crystal rocaille beads and rim-set crystal rhinestones. The same banding and beading are used to create additional patterning on the main body of the cape and is enhanced there with large, sewn-on crystal jewels.

The scalloped yoke extends low in the front and back. It features flared shoulders extending over the natural shoulders, standing away from the cape, and ending in a stiff stand-up collar. The underside of the shoulder area is lined in silver sequins. Embellishment for the yoke, collar, and their edges continues along the silver lamé banding. It is edged on each side with crystal rocaille beads and set along its length with rim-set crystal rhinestones.

The arm openings are edged with belly Russian lynx, and the cape is lined solidly in silver sequins that were applied with a Cornelli machine. At the time it was created, the fur for this costume cost in excess of fifty thousand dollars. The cape is worn with a sleeveless white ruffled shirt, a stand-up collar, a white bow tie embellished with crystal rhinestones, black wool slacks, and black slipper-style shoes.

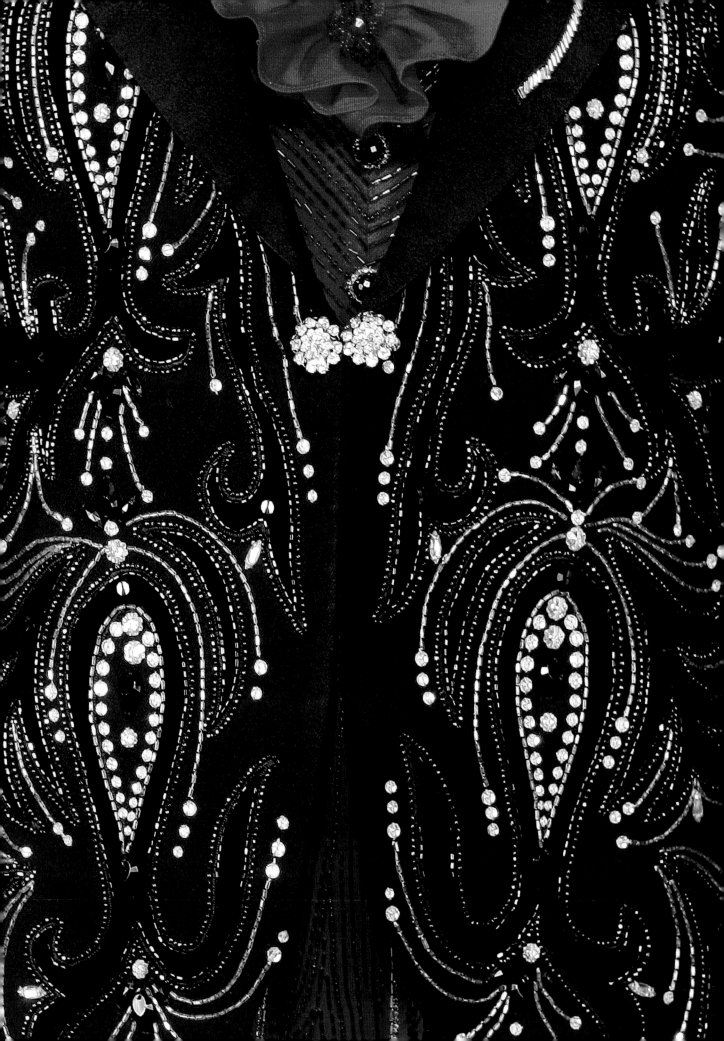

Red Jumpsuit and Black Jacket • 1980

Costume design by Michael Travis

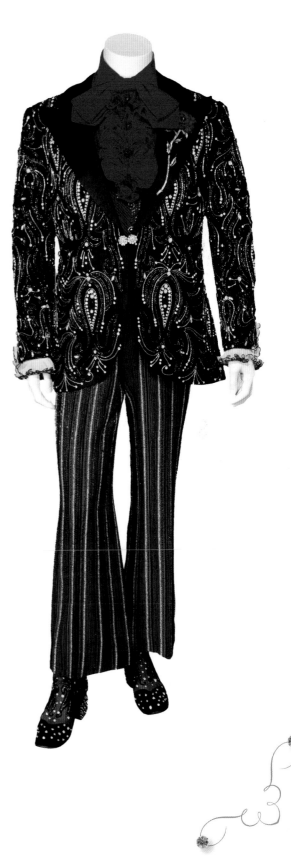

This suit of black and vibrant red mixes patterns to achieve a fun, sophisticated look. Both the jacket and jumpsuit are constructed from polyester gabardine. The paisley pattern on the jacket was created using velvet appliqués, which are edged in dark pewter-colored AB-finished bugle beads and seed beads. Around the motifs are sprays created from silver bugle beads, crystal lochrosens and margaritas, and oval and jet-black jewels. The centers of the designs are outlined with these same materials.

The right lapel is unadorned, and the left features an appliquéd red rose with petals

defined by red rocaille beads. A light Siam lead crystal is in the rose's center. The black appliquéd stem and leaves are created with silver bugle beads.

The red gabardine vest is beaded in a chevron pattern with rows of red bugle beads and red rocaille beads. The two buttons are formed by jet-black faceted lead crystal jewels encircled with a row of jet-black seed beads and a row of crystal rocaille beads.

The red pants are stitched in vertical rows of a repeating beading sequence, creating stripes. A row of silver bugle beads is next to a row of silver rocaille beads. This is followed by a small space, then two rows of red bugle beads, another small

space, then a row of black bugle beads and black rocaille beads. This is followed by two spaced rows of red bugle beads, a row of red seed beads, and two more rows of spaced red bugle beads.

The costume is worn with a red ruffled dickey. Its placket is adorned with red seed and rocaille beads, Tiffany-mounted AB crystal rhinestones, and light Siam navette sewn-on jewels. Also featured are a white banded collar, a red bow tie, and ruffled, pleated chiffon cuffs with a merrowed edge of red.

Black-and-red boots made by Di Fabrizio feature velvet appliqués outlined in silver bugle beads, and are scattered with rim-set crystal rhinestones.

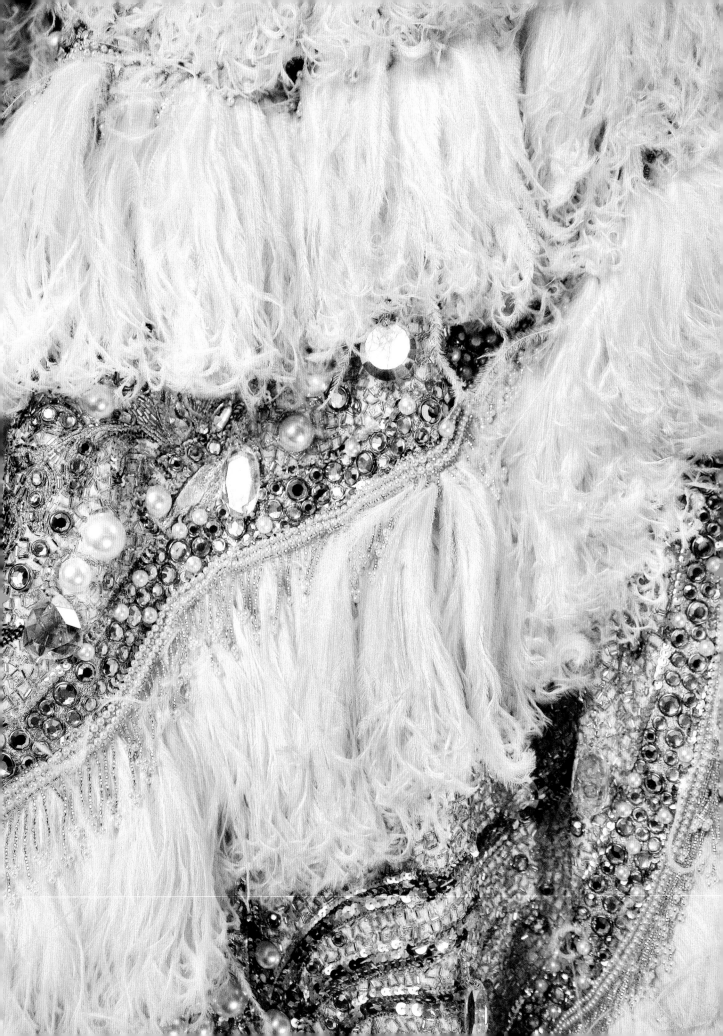

White Ostrich Cape • 1977

Costume design by Michael Travis

*T*ravis stated that in designing for Liberace, "Our thing is always to out-dazzle the most jaded eye." [65] Liberace and Travis embraced these ideals in the creation of the white ostrich feather cape. There are few styles of rhinestones, jewels, mirrors, and pearls that are not used to embellish it.

Constructed from silver lamé, the cape features five rows of white ostrich feather fringe encircling it in cascading rows. The remainder is solidly encrusted with rim-set and Tiffany-mounted crystal and AB crystal rhinestones, rim-set mirrors, silver sequins, bugle beads, rocaille beads, pearls, and crystal lochrosens. Sewn-on jewels—including navettes, pear shapes, ovals, and rounds—create elaborate patterning. Crystal AB-finished teardrops and ovals dangle from small loops of crystal seed beads. The cape closes with a silver clasp.

The standing, crown-shaped, stiff collar has scalloped edges. Echoing the scallops are two rows of pearls, Tiffany-mounted crystal rhinestones, and sewn-on AB-finished crystal jewels. Between the pearl rows, the collar is almost solidly worked in rows of silver bugle beads and rim-set AB crystal rhinestones. The edge of the collar is set with pearls and at the dip of each scallop, a teardrop-shaped, baroque pearl is topped with a smaller teardrop-shaped pearl.

The cape is worn with a white gathered chiffon jabot edged in white sequins, a banded collar, a large white bow tie, and silver beaded boots.

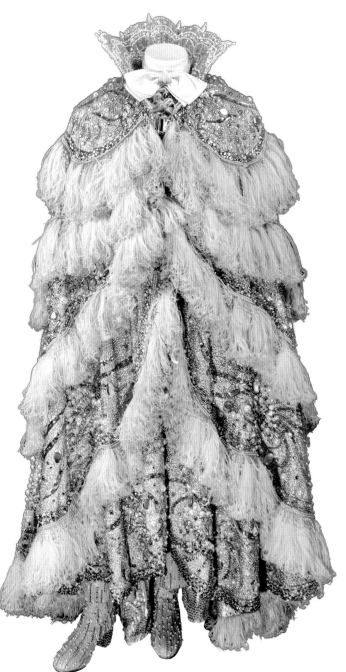

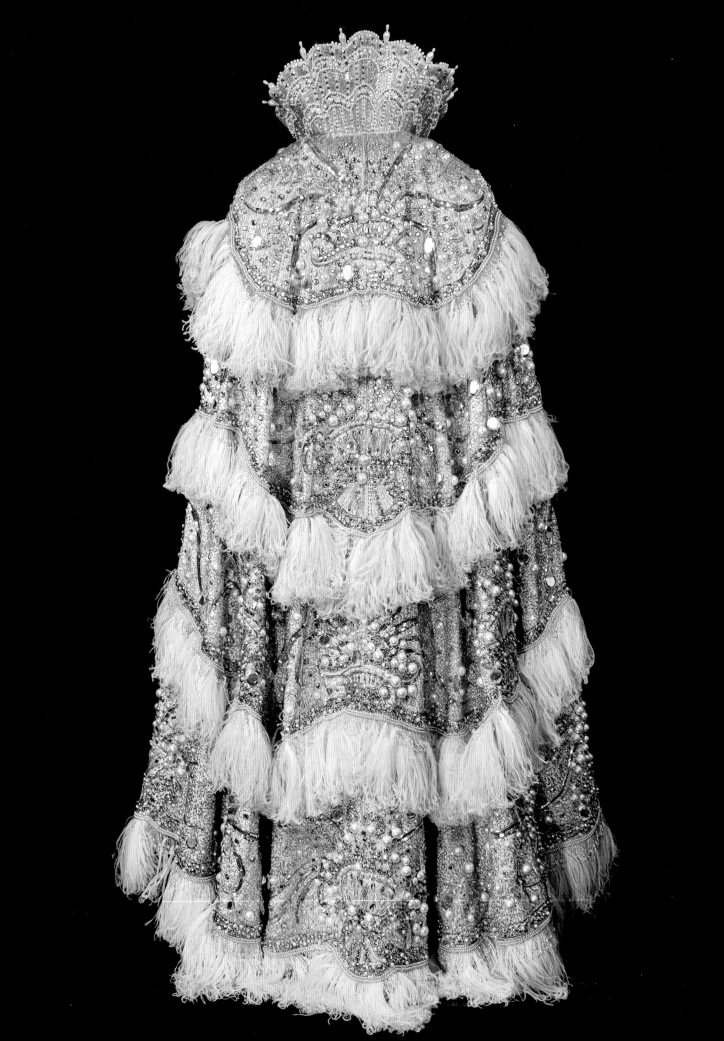

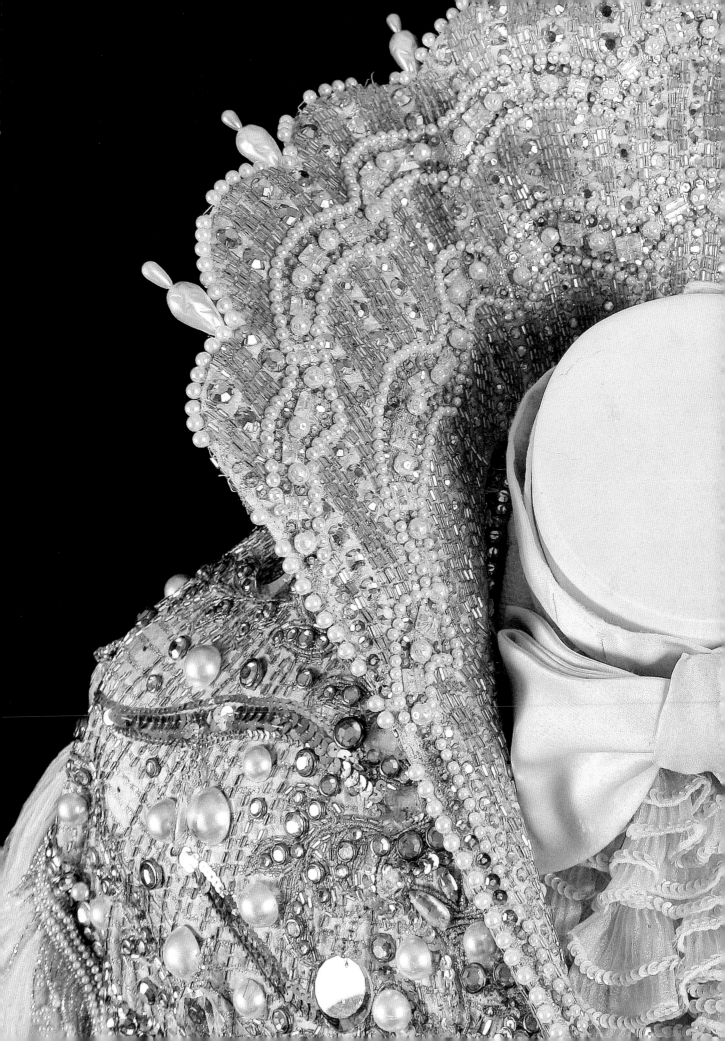

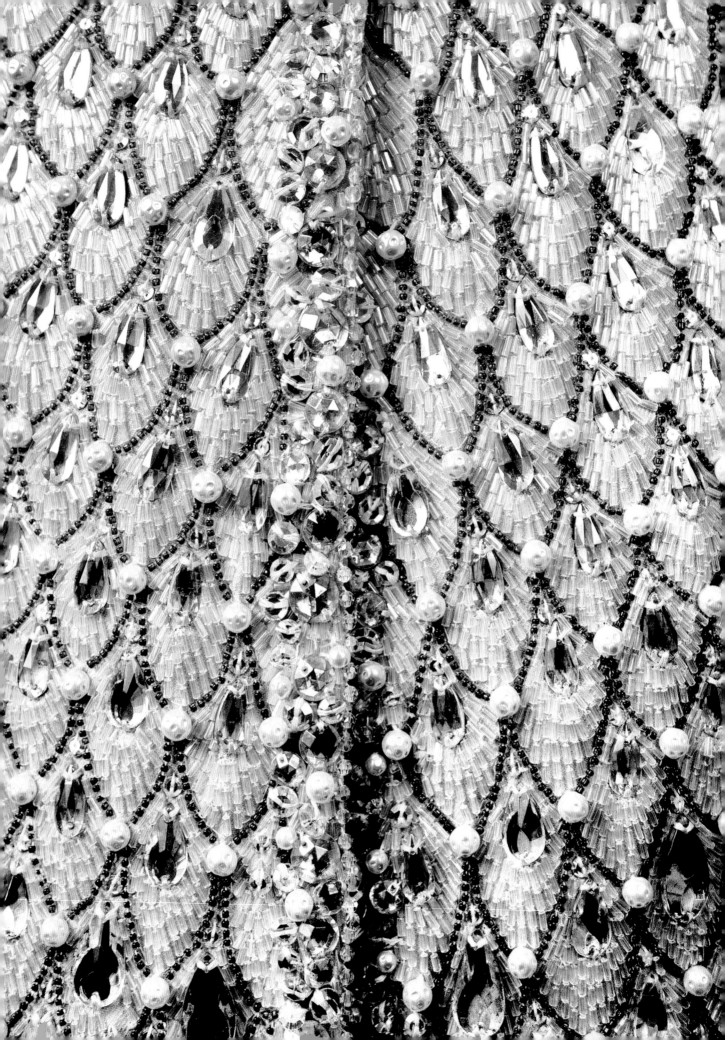

Ice-Blue Rhinestone Cutaway Suit · 1980s

Costume design by Michael Travis

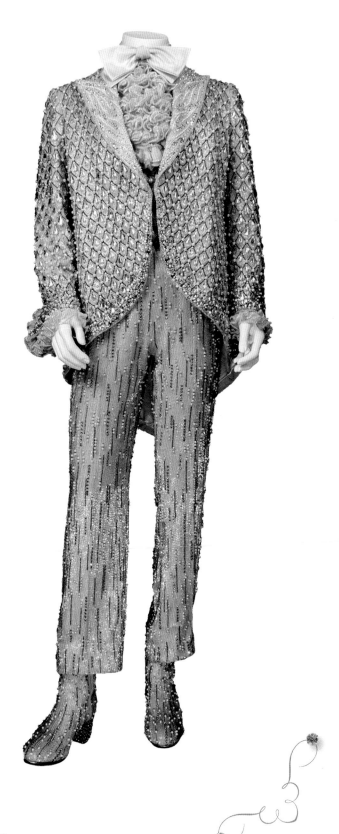

The ice-blue rhinestone cutaway suit was worn during Liberace's 1985 performance in Atlantic City and his 1986 performance at Radio City Music Hall in New York.

The suit derives its name from the color created by the clear bugle beads stitched onto the light-blue brocade fabric. The jacket body and sleeves are worked in a rounded diamond pattern made from tiny gold seed beads. Each diamond is filled with clear bugle beads stitched in a fan shape. In the center of each diamond there is a pear-shaped crystal AB faceted jewel topped with crystal AB lochrosens. The largest of these jewels are near the bottom front of the coat and at the tails. At the cross points of the diamonds are baroque pearls.

The lapels are white silk and patterned with curving rows of graduated pearls and crystal AB lochrosens. The cuffs, collar, jacket edge, and tips of the tails are encrusted with a band of baroque pearls, crystal AB lochrosens, and crystal AB pear-shaped jewels. The edges of the coat, cuffs, and lapels are set with a closely stitched row of crystal AB lochrosens.

The vest is white silk and stitched in a bargello-style pattern using clear, silver, and navy blue bugle beads. At the center of the vest's front, rows of crystal lochrosens are stitched atop bugle beads. Four large half-pearls surrounded by crystal lochrosens form the buttons. The edge of the vest is also defined by crystal lochrosens.

The matching blue pants are vertically embroidered with rows of clear bugle beads. Spaced portions of rows of the same beads are stitched in a zigzag motif, creating a reflective sparkle. Interspersed between the rows are partial rows of tiny gold seed beads and rim-set, crystal AB rhinestones. There are also short vertical rows of pearls. The majority of the pattern is clear bugle beads, but the addition of the pearls, rhinestones, and seed beads create a textured effect.

The suit is worn with a dickey that has a banded collar; a large white bow tie; a pleated, ruffled organza jabot; and cuffs made of the same material that are trimmed with a row of AB-finished white sequins.

The Di Fabrizio boots match the pants, creating a continual leg line. The heels are silver and have rim-set crystal rhinestones.

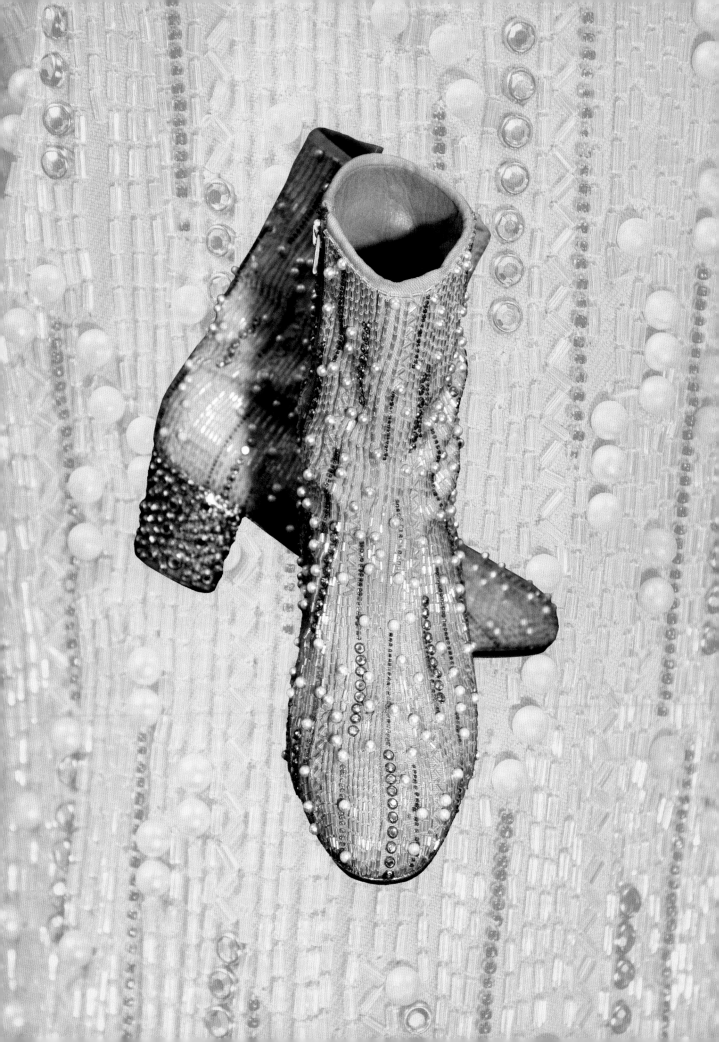

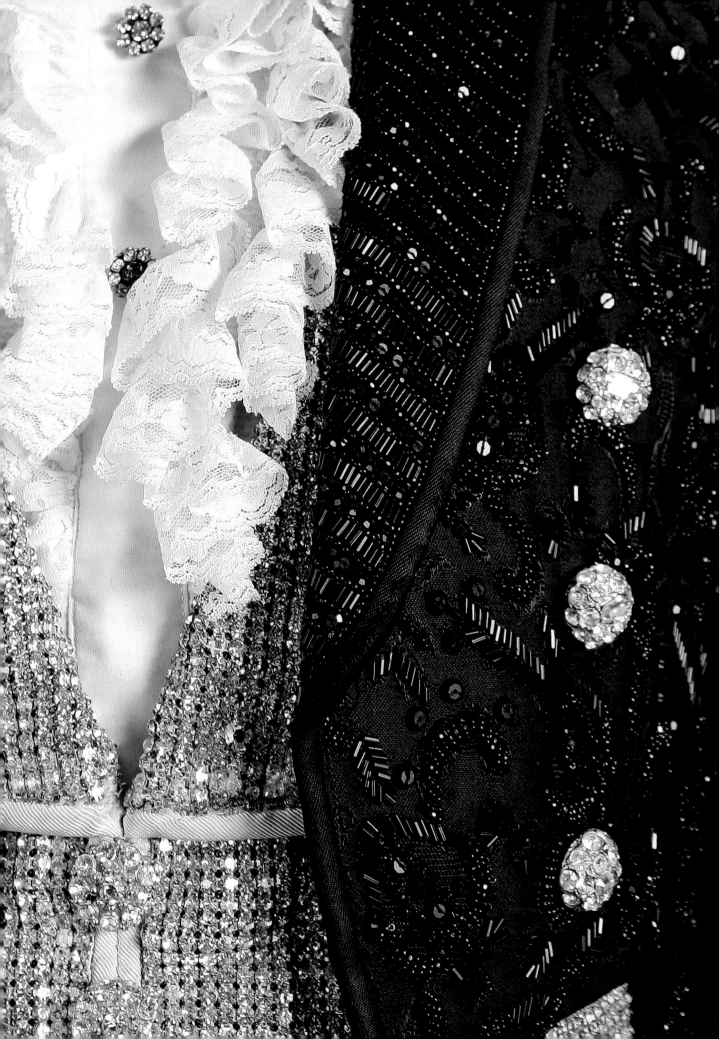

Black Silk Damask Suit · 1985

Costume design by Michael Travis

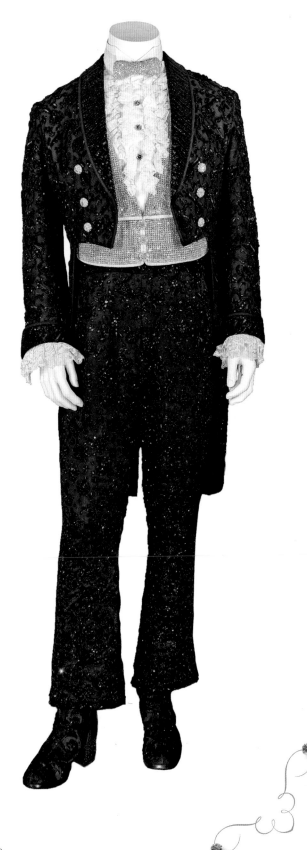

This tailcoat is fully covered in crystal and jet-black lochrosens, black seed beads, and black bugle beads. The beading follows the wavy pattern of the damask. The lapels and cuffs are set with a row of horizontal black bugle beads edged with black seed beads and black lochrosens. The pattern is worked solid and at an angle. Six large crystal rhinestone buttons are on the front of the coat.

On the back of the coat, the tails end at the knee and are lined in black silk chiffon. Two rhinestone buttons are set at the waist. The slit cuffs, lapels, and tails are edged in self-fabric piping.

The backless vest is covered in crystal rhinestone banding. Its lapels and edges are defined with cream-colored satin piping, and the vest is lined in the same satin. Two rows of Tiffany-mounted AB crystal rhinestones form the edge of a fake pocket, and the same type of rhinestones are on the lapels. Three crystal rhinestones close the front.

Matching black damask pants are attached to a sleeveless, round-necked black cotton shirt. A band of black grosgrain defines the waistline. The allover black beading pattern on the pants matches that found on the coat.

The suit is worn with a ruffled white pique lace dickey accented with three crystal rhinestone buttons and a white wing-tipped collar band. Ruffled lace cuffs, a small crystal rhinestone bow tie, and matching black beaded and rhinestone-heeled Di Fabrizio boots finish the costume.

Black and Red Geometric Cape • 1981

Costume design by Michael Travis

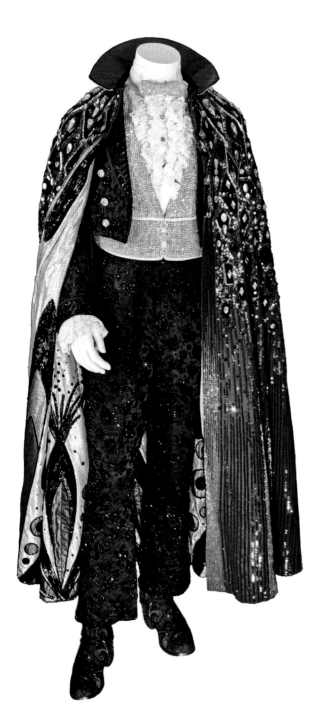

Worked on a base of red twill, this ankle-length cape has hundreds of black velvet appliqués.

The appliqués have red sequins stitched on using a Cornelli machine; they are encrusted with crystal and jet-black jewels, as well as rim-set and Tiffany-mounted crystal and jet-black rhinestones and lochrosens. Each appliqué is edged with one or two rows of black or silver sequins. The patterns extend front to back around the cape, and approximately half its length.

Beginning at the center front and also extending around the cape are black bugle beads stitched vertically in bands that become increasingly loosely aligned, allowing red fabric to show. Crystal and jet-black rhinestones and lochrosens are sprinkled throughout this section.

The collar is red twill on the inside and black velvet on the outside. It is edged in silver seed beads, five rows of silver bugle beads, and a row of crystal lochrosens.

The cape is lined with silver lamé and its bottom third is stitched with red and pewter lamé appliqués. Each appliqué is outlined with a row of black sequins. Around the appliqués are Tiffany-mounted jet-black and crystal AB rhinestones.

The border of the cape is stitched with vertical rows of red sequins. Cascades of black bugle beads extend from the appliquéd areas.

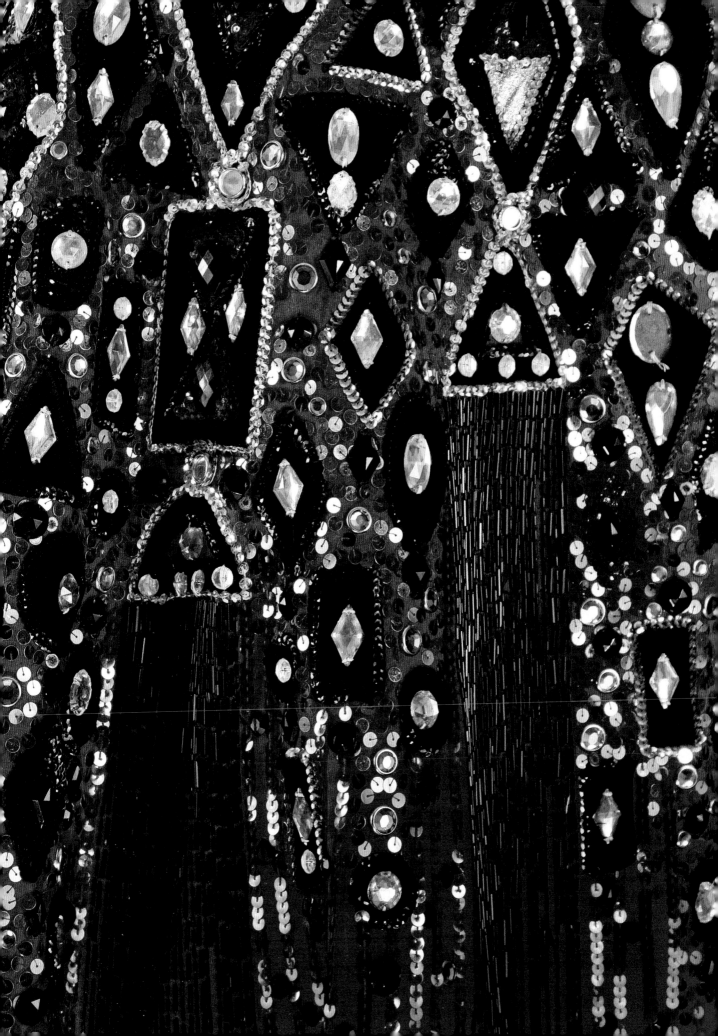

Gold Geometric Beaded White Tailcoat and Jumpsuit • 1983–84

Costume design by Michael Travis

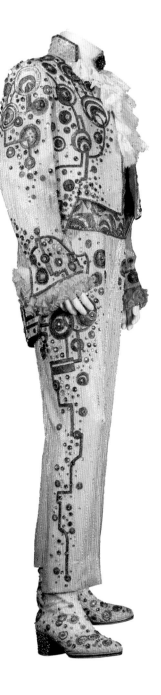

his cutaway tailcoat and jumpsuit of white polyester gabardine have an overall treatment of clear bugle beads set in straight lines. Small crystal lochrosens are scattered between the rows of bugle beads.

On the front of the coat, circular shapes are created from gold, pewter, and silver bugle beads. Geometric lines worked primarily from dark gold bugle beads intersect them. Scattered throughout are Tiffany-mounted topaz rhinestones, topaz lochrosens, and

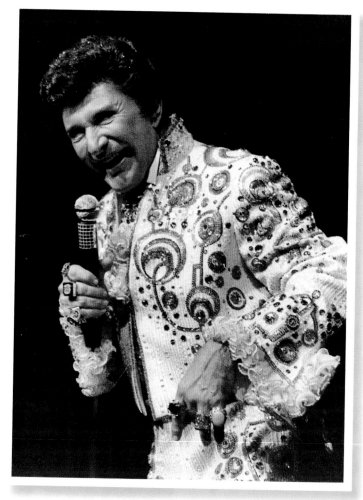

Right: Mr. Showmanship.

topaz and crystal sewn-on jewels. At the center of most of the shapes are crystal or topaz lochrosens, or topaz jewels. Many are rimmed with gold seed beads.

The shapes, lines, and enhancements run down the sleeves and around the cuffs. The same beading and stoning pattern is on the back of the coat, but on a larger scale, as well as on its tails. At the shoulders, connecting the front and back motifs, are three circles of gold and silver bugle beads with a crystal lochrosen in the center of the smallest circles.

On the stand-up collar, clear bugle beading is enhanced with crystal lochrosens that are topped with a crystal seed bead. The edge of the collar is finished with three rows of gold bugle beads and topaz lochrosens. Three rows of gold bugle beads also finish the edges of the coat, cuffs, and tails. The coat is closed at center front with a hook and eye.

The vest is outlined at the bottom with three rows of gold bugle beads and topaz lochrosens. Silver lamé is appliquéd to the gabardine, and curving rays are stitched atop it using gold and silver bugle beads. Four topaz rhinestone buttons are at center front.

The matching pants feature complementary beading running down the outside of each leg, using the same stones, beads, and jewels as are on the jacket.

Worn with the coat and jumpsuit is a high-banded, collared white dickey decorated with a tiered, gathered lace jabot pinned with an antique gold and topaz broach, and ruffled and pleated organza cuffs with a narrow crocheted edging of gold metallic thread.

Repeating the beading patterns of the suit, white gabardine Di Fabrizio boots are stitched with clear bugle beads and gold bugle bead motifs accented with topaz and clear lochrosens. The gold heels of the boots are decorated with rim-set topaz rhinestones.

Hapsburg Eagle • 1983

Costume design by Michael Travis

The Hapsburg eagle costume was first worn by Liberace in his 1983 performances. It can also be seen on Liberace's 1985 video, *Liberace Live*, which was filmed at the Wembley Centre in London.

The coat is lavishly appliquéd using gold lamé with metallic-brown stippling outlines. Bands of gold bugle beads outlined with a row of small copper bugle beads trim the edges of the coat and cuffs, extending into the coat's body and sleeves.

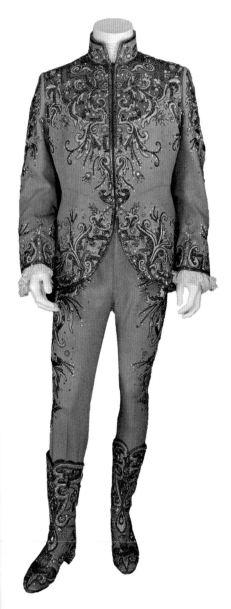

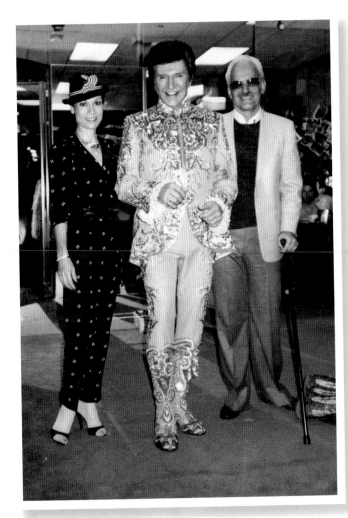

Left: Liberace with Anna Nateece and Michael Travis.

Further embellishments to the appliqué include gold seed beads, rim-set crystal AB rhinestones, crystal AB sewn-on jewels, crystal lochrosens, and gold metal beaded rims. Beading and appliqué cover the top of the coat, narrowing to a point at the waist, then spread over its bottom third.

On both sides, a rounded yoke effect is created by using a darker shade of matte satin than the jumpsuit. On the back, the yoke area is heavily beaded, appliquéd, and embellished, and covers approximately one-third of the coat. The bottom third is heavily patterned and extends up from the split in the coat. The design is worked to slightly above the waist.

On the sleeves, similar appliqué, beading, and embellishments reach from the top to above the elbow and around the slit cuffs. There are also white gathered lace cuffs and a stand-up collar, which is edged at the top with gold seed beads. Solid rows of dark gold bugle beads outline it and create the main beading pattern. Gold bugle beads, crystal lochrosens, sewn-on crystal AB navettes, and sewn-on crystal AB jewels, the larger of which are framed with a gold metal beaded rim, complete its embellishments. The coat closes with a zipper and is edged with gold seed beads.

The pants are narrow. From the waist to several inches below the knee, matching appliqués and beading are applied to the sides, and narrow down the leg.

Matching Di Fabrizio boots are constructed from the same matte satin and feature complementary trapunto appliqués, metallic brown stippling, and beading. They are also embellished with gold bugle beads, gold seed beads, rim-set crystal rhinestones, and sewn-on, teardrop-shaped AB crystal jewels. To finish, gold seed and bugle bead tassels dangle from the center of the cutout scallop, and black heels are covered in rim-set crystal rhinestones.

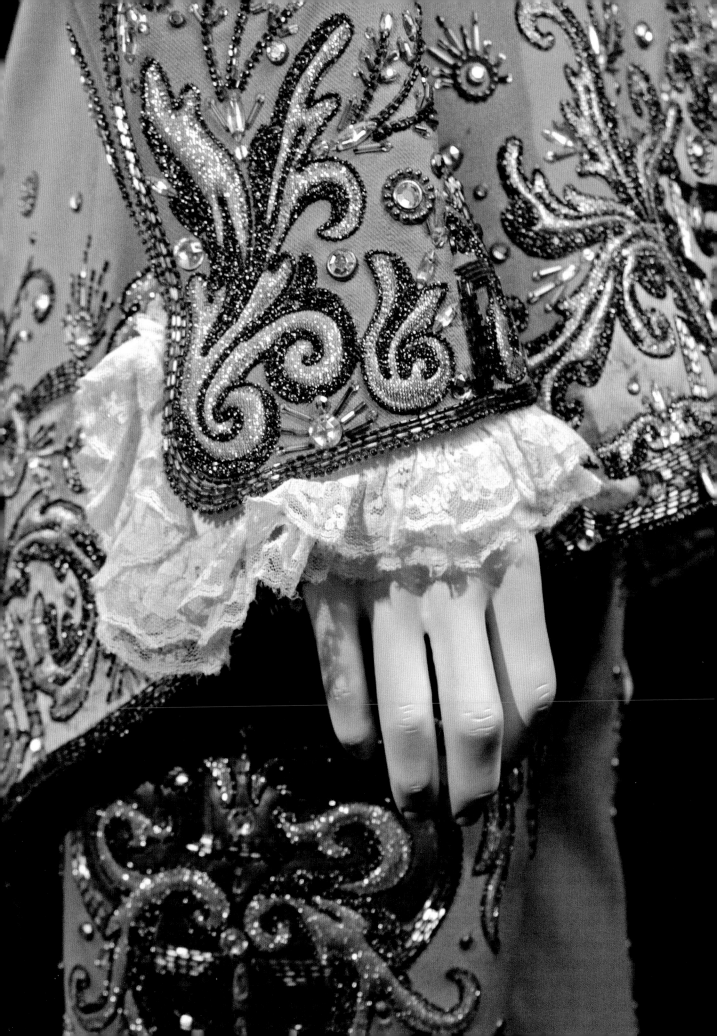

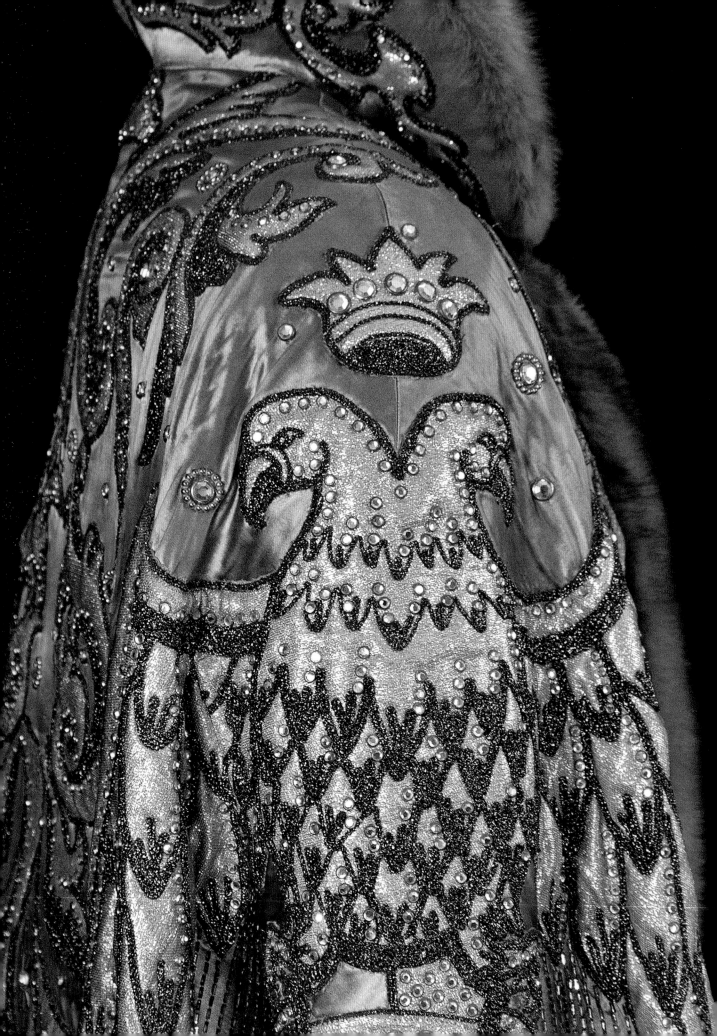

Hapsburg Eagle Cape • 1983

Costume design by Michael Travis, fur made by Anna Nateece

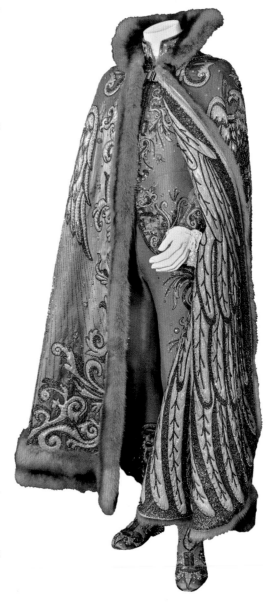

The cape features a double-headed eagle on each shoulder and takes its name from the crest of the Hapsburg family—rulers of the Austrian Empire. A child of the Great Depression, Liberace was drawn to images of royalty and wealth. To him, the costume symbolized his rise to fame and success.

The sable-fur–trimmed cape, coat, pants, and boots are brown matte satin with pink undertones. The floor-length cape is decorated from shoulder to hem with a twining pattern, reminiscent of vines and leaves, executed in gold lamé and trapunto appliqué.

Each appliqué, including the eagle crests, is outlined with a heavy metallic-brown thread stippling, which accents and raises the trapunto appliqués. The appliquéing is narrow at center front, extends wider at the front edge, and continues around the entire bottom. The appliqué areas have crystal lochrosens and rim-set crystal AB rhinestones. The largest rhinestones are framed with a gold metal beaded rim.

Radiating vertically and at a slight angle from the wings of the eagles are rows of gold bugle beads. They extend to the appliqués at the bottom of the cape.

On the back of the cape, a band of gold lamé and trapunto appliqués is accented with metallic-brown machine stippling and continues to the hem. The appliqués cover the shoulder areas and meet the eagles' wings. As on the front of the cape, they are embellished with and surrounded by rim-set, crystal AB rhinestones. The largest of the surrounding ones are, again, framed with a gold metal beaded rim.

The back of the stand-up collar repeats the gold lamé trapunto appliqués, metallic-brown stippling, rim-set crystal AB rhinestones, and lochrosens. Honey-brown sable fur trims the front and bottom edges of the cape and lines the collar.

The inside of the cape is worked entirely in gold lamé trapunto appliqués. Its metallic-brown stippling creates an overall pattern of rows of overlapping feathers.

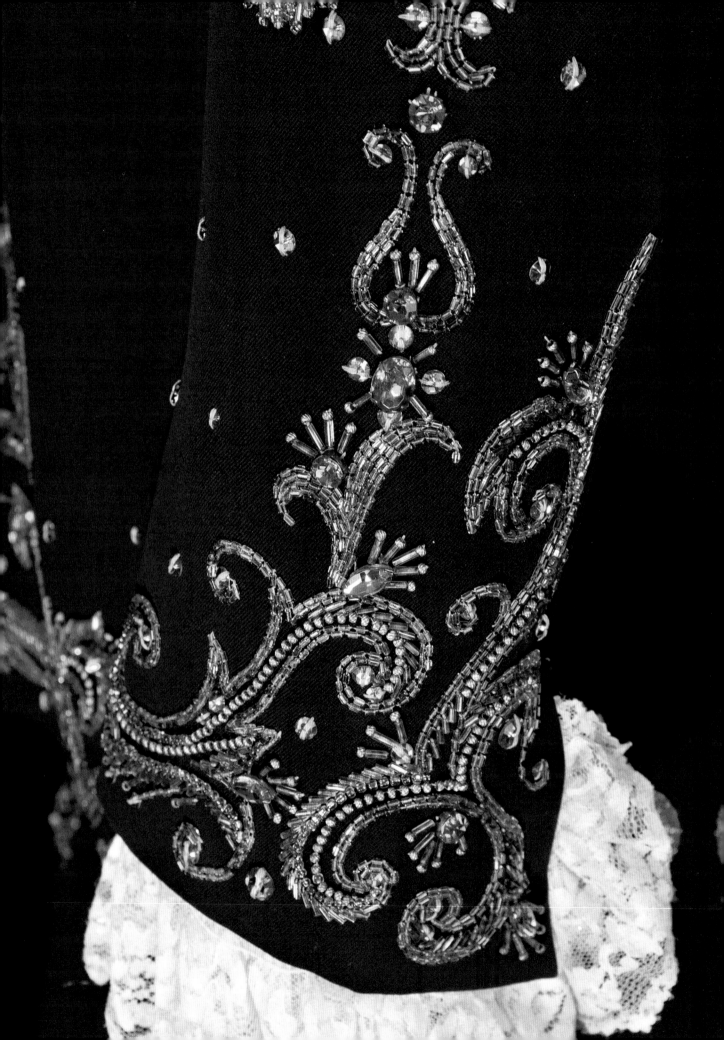

Blue and Gold Military · 1978

Costume design by Michael Travis

The blue and gold military costume was worn during Liberace's 1985 performances. At Radio City Music Hall, he wore it while playing his Strauss medley on a coordinating blue and gold Steinway grand piano. Behind him were fountains of "dancing water," one of his signature backdrops.

With approximately ten yards of gold trim, the costume consists of a jacket, matching pants, lace cuffs, a banded collar, and matching boots. Costume pieces were constructed from royal blue gabardine and feature elaborate patterns made from gold bugle beads accented with sewn-on topaz rhinestones.

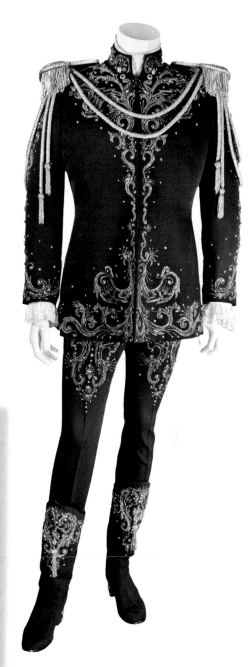

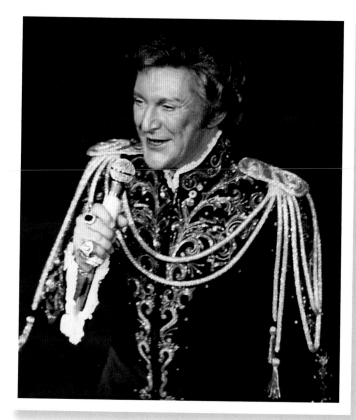

Left: Liberace in performance mode.

Beading covers the mandarin collar and top of the jacket and tapers down the center zippered front to the bottom of the jacket, which is encrusted with a matching pattern. On the sleeves, this pattern begins above the cuffs and extends approximately six and a half inches. Interior shirt sleeves are attached to the coat's lining with zippers, and the mandarin collar is lined with a white banded collar. On the back, the same patterning reaches approximately one-third of the way up the jacket.

The royal blue gabardine pants carry on the gold beading with large (eleven-inch) motifs at center front. These extend from under the hem of the jacket down the legs of the pants.

Two pieces of gold cording drape the top front of the jacket in the shape of a necklace, and extend to the top of the shoulders, under the gold-fringed epaulets. The epaulets broaden the shoulders and end in beaded gold tassels. Although the cords appear to be uncovered gold rope, they are actually completely embroidered with small gold bugle beads that wrap around the cording in a continuous circular pattern.

The tall (eleven-inch) boots were made by Di Fabrizio and use the same blue gabardine fabric. They repeat the embroidered and rhinestoned pattern, have beaded gold tassels, and are finished with a small, gold-embroidered and stoned pattern on the heel.

Originally, the costume was worn with an elaborate cape of chinchilla, blue gabardine, and gold-patterned beading. However, the cape has deteriorated and, until restoration is completed, it is not available to be photographed.

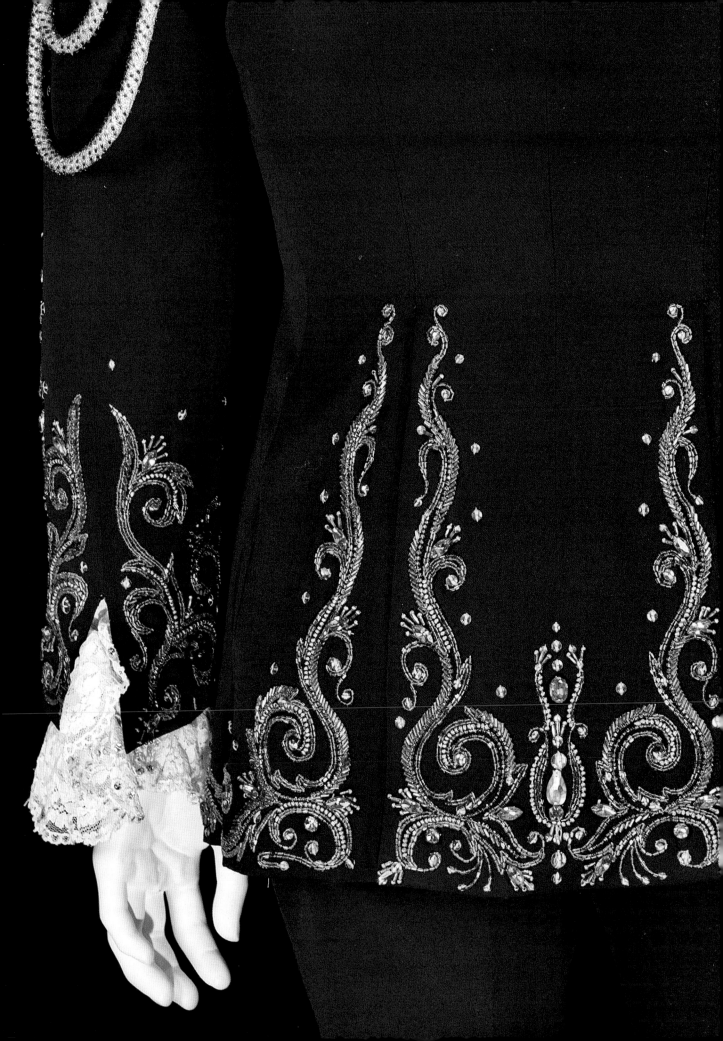

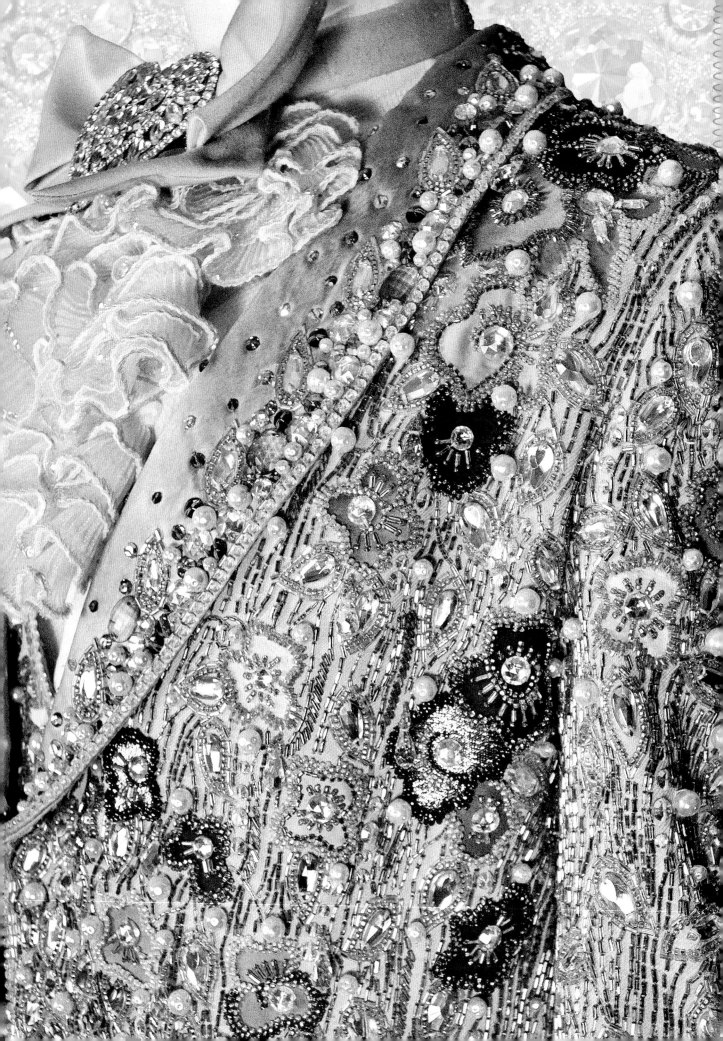

Fabergé Costume • 1978

Costume design by Michael Travis

The Fabergé costume was worn by Liberace during all twenty-one of his Radio City Music Hall performances in 1985. He would make his entrance in this flamboyant costume, emerging from a twelve-foot replica of a Fabergé Easter egg that was specially constructed when Liberace was asked to be part of Radio City Music Hall's Easter show. It became one of his most spectacular and memorable shows and costumes. "You can either have the Easter Bunny or Liberace, not both," he would say.[66]

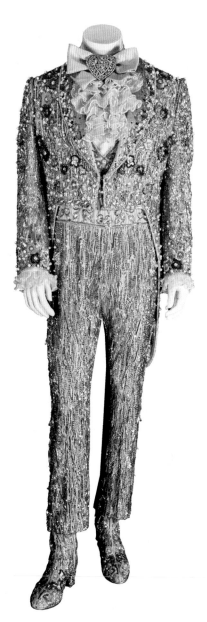

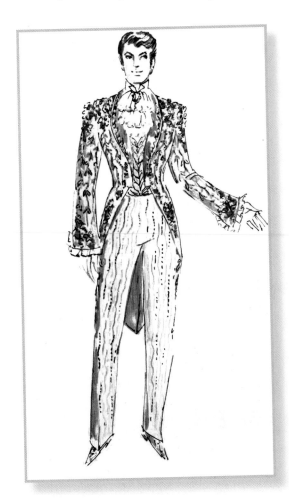

Underneath a fabulous cape, the costume, constructed from pink gabardine and silk, consists of a tailcoat, jumpsuit, ruffled cuffs, ruffled jabot, bow tie, brooch, and matching boots. It is encrusted with silk satin appliqués, pastel seed and bugle beads, AB crystal sewn-on stones, hanging AB crystal pennant jewels, AB-finished clear paillettes, and pearls.

The cutaway coat begins with an under layer of silver bugle beads embroidered in a moiré pattern. On this are appliquéd flowers in peach, rose, and red lamé, and red silk satin. These are enhanced with rocaille and seed beads in the same colors with the addition of lavender and aqua. The coat is further embellished with silver bugle beads surrounding large AB crystal, pear-shaped, sewn-on jewels and rhinestones. Pearls and hanging AB crystal pennant jewels complete the design.

Pink silk satin lapels are embellished with a matching beaded and appliquéd pattern using the same stones, beads, and pearls, but on a smaller level.

The ruffled cuffs and jabot are accentuated with sewn-on AB crystal rhinestones. An oversize pink bow tie and band collar hold a rhinestone, heart-shaped broach.

Interior shirt sleeves are attached to the coat's lining, but are removable.

The vest is worked overall in a loose paisley pattern of silver bugle beads surrounding large AB crystal, pear-shaped, sewn-on jewels, and rhinestones. The pattern is accented with pearls. The separation between "vest" and "pants" is created with two rows of silver bugle beads and a row of sewn-on AB crystal rhinestones.

The pants also have silver bugle beads in a moiré pattern. Down the side of each leg are bugle bead, rhinestone, and appliqué patterns, which match those found on the coat.

Matching boots by Di Fabrizio were constructed from the same pink gabardine as the jumpsuit and feature the same embroidered and rhinestoned pattern.

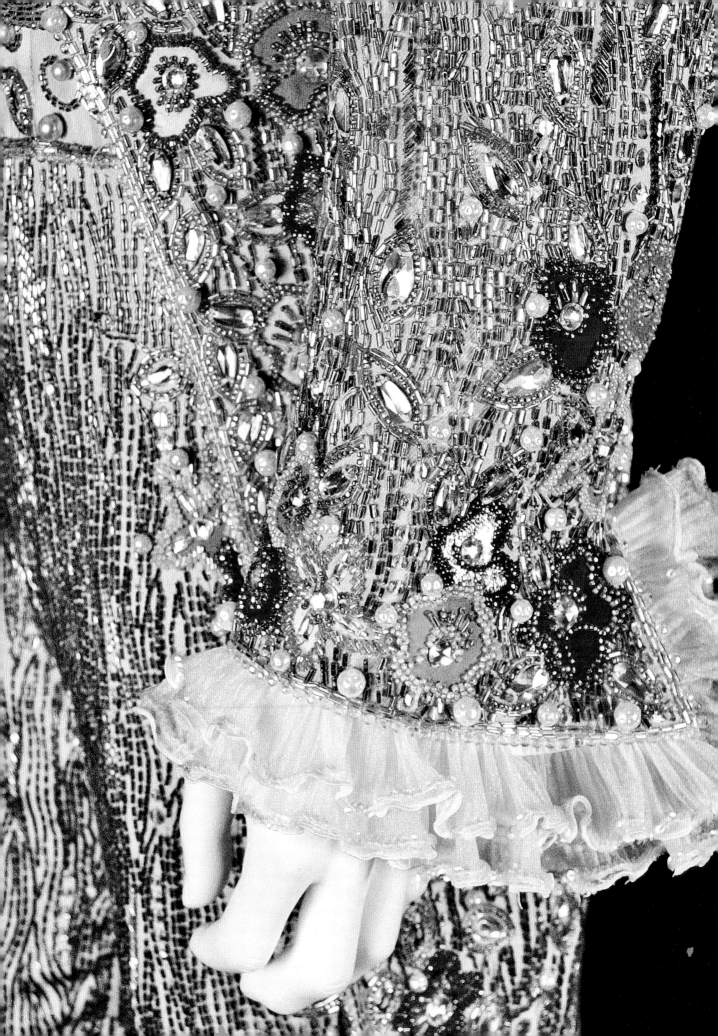

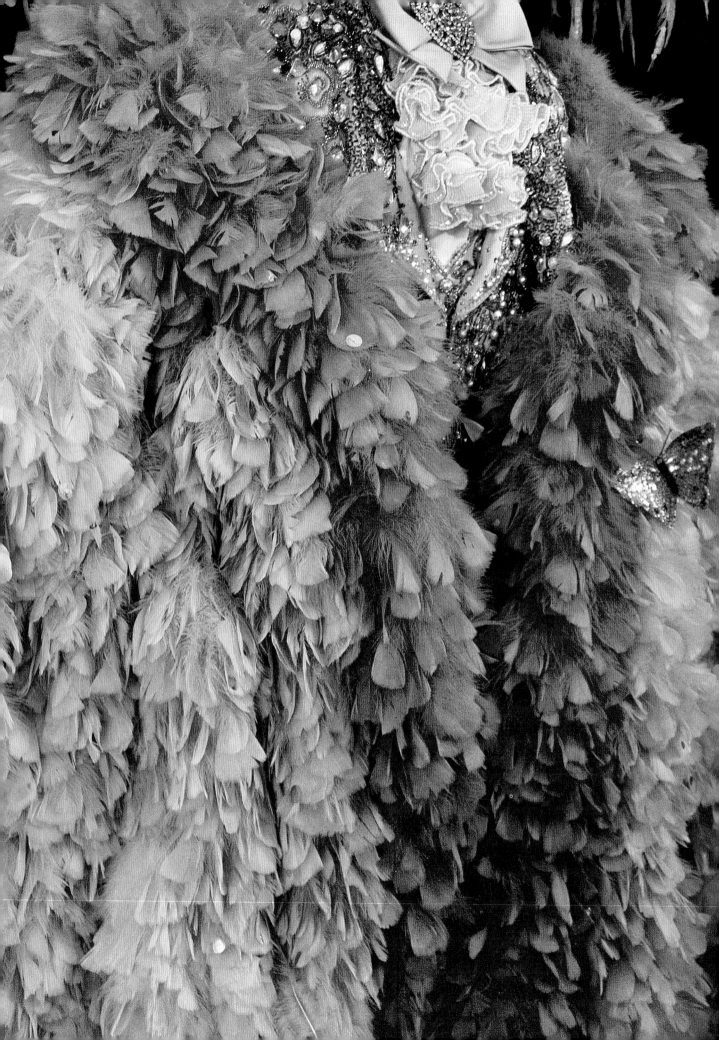

Fabergé Cape · 1985

Costume design by Michael Travis

The cape is made predominately of three shades of pink turkey feather boas stitched onto a heavy pink cotton duck fabric and lined in shiny pink lamé. Clear paillettes with an AB finish are scattered over it. From the center back, the cape measures nine feet long and twenty-six feet wide.

The cape's back yoke has the same appliqué and beading patterns as the coat. Its large, detachable collar is embroidered in a leaf motif comprising silver bugle beads and crystal rocaille beads. The rest of the collar is filled in with the same bugle-bead moiré pattern, AB crystal rhinestones, and pearls.

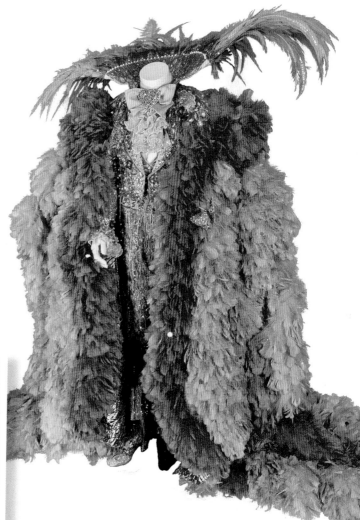

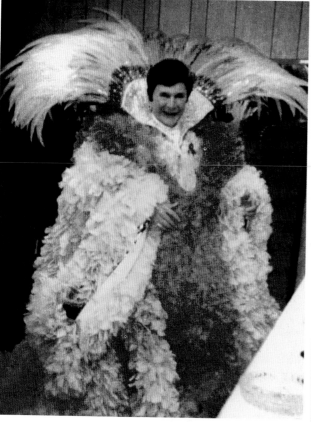

The collar is edged in several rows of long coque feathers in three shades of pink.

The cape is finished with free-standing, custom-created butterflies worked in pastel pink and peach sequins, sewn-on rhinestones, bugle beads, and seed beads.

Left: Liberace prepares for a show at Radio City Music Hall.

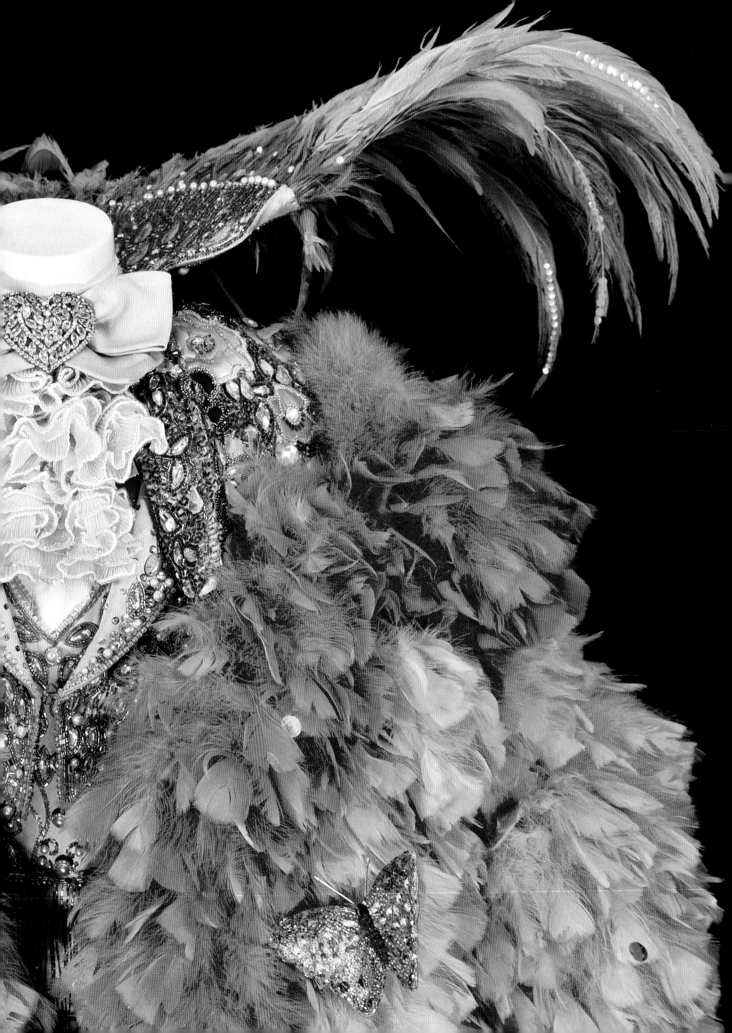

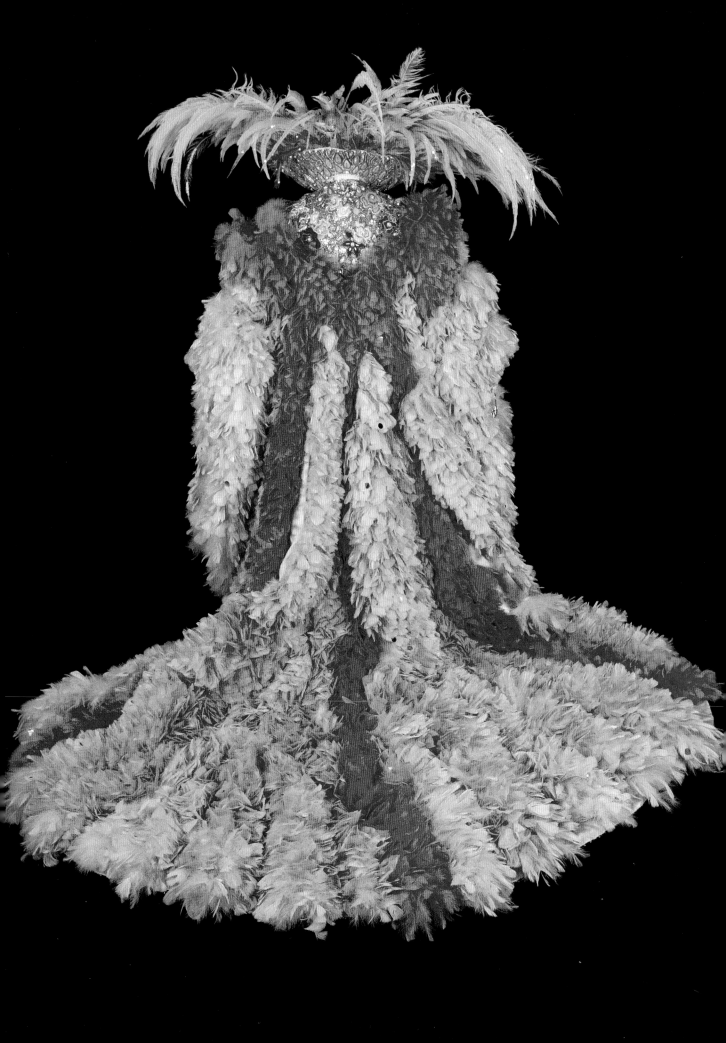

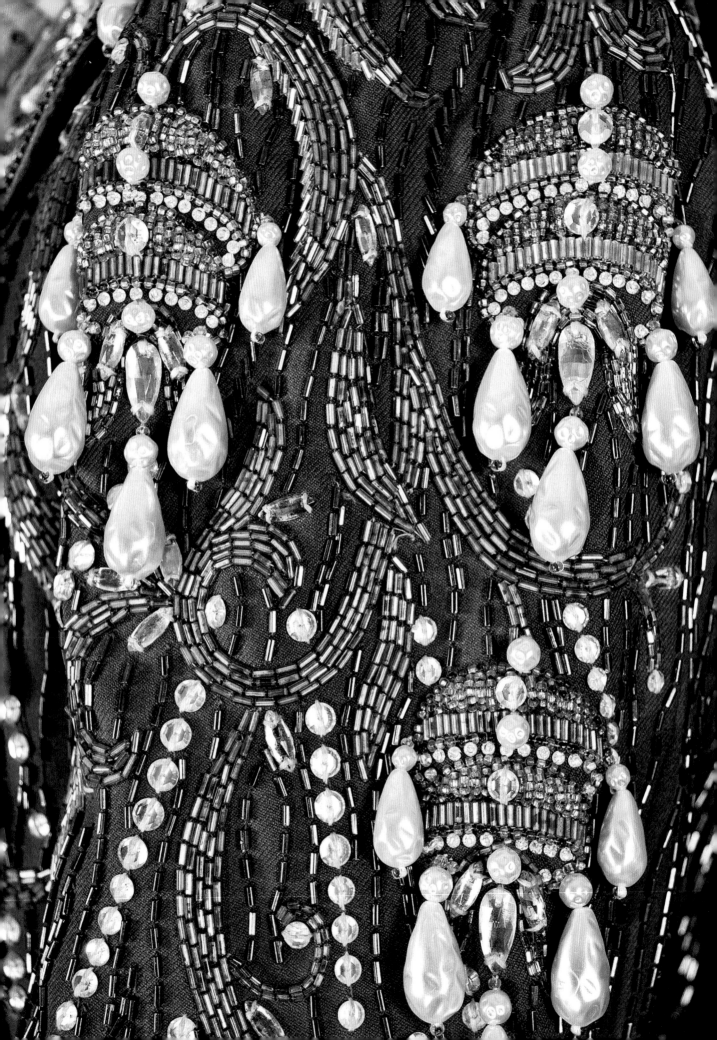

Blue and Gold Rococo Costume • 1980s

Costume design by Michael Travis

Rococo style, fashionable during the eighteenth century, refers to a style of decoration that makes use of S-curves, sprays and tendrils, foliage, and whimsical interpretations of classical forms such as seashells, leaves, and animals. The style originated during the reign of King Louis XV of France (1715–74), as a reaction against the heavy, formal fashion of Louis XIV. The French designer Pierre Lepautre is credited with having introduced rococo style.

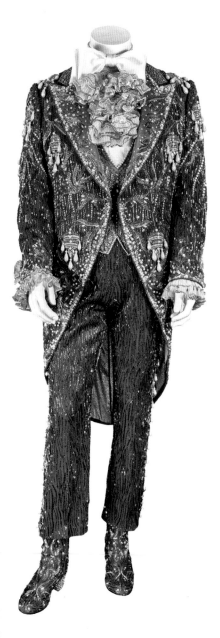

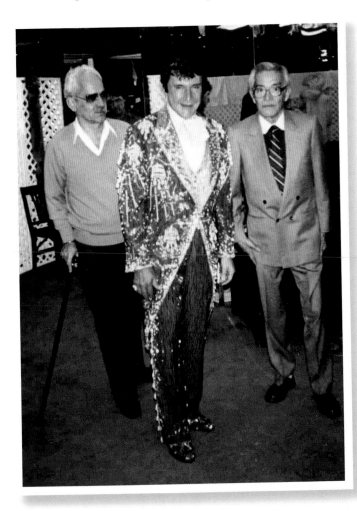

Left: Liberace, Michael Travis, and Primo, his tailor.

Styles associated with European royalty inspired many of Liberace's costumes, and this costume exemplifies that preference. The costume consists of a swallow-tailed cutaway coat, jumpsuit, ruffled cuffs, deeply ruffled jabot, bow tie, collar, cape, and matching boots.

The swallow-tailed cutaway coat is steel-blue gabardine with gold patterning and crystal bugle beads tracing S-curves, softly curving tendrils, and organic shapes. All are enhanced with pearls and crystal and sewn-on topaz. Large motifs of crystal and gold rocaille beads, crystal rhinestones, and pear-shaped baroque pearls suspended from smaller, round pearls are scattered over it.

The patterns on the top and bottom of the sleeves repeat the patterns on the rest of the jacket. Heather-blue silk satin lapels also repeat the patterns, on a smaller scale.

The vest is heather-blue silk and satin and worked in a leaf pattern made from silver bugle beads. It is accented with pearls and sprinkled liberally with rim-set crystal rhinestones

The collar is heavily rim set with topaz rhinestones. The jabot and cuffs are pleated and gathered organza with each layer edged in gold sequins. Interior shirt sleeves are attached with zippers to the coat's lining. A large bow tie and banded collar accessorize the costume.

The back of the jacket is encrusted with the same materials, and the same pattern is splayed across the shoulders, broadening them. The deep vent is embellished, tapering at the waist to create a slimming effect. The edge of the jacket is finished with one row of gold bugle beads and one row of dark topaz seed beads.

The legs are steel-blue gabardine and beaded with AB-finished, dark-gray bugle beads in a moiré pattern. Down the side of each leg is a bugle bead, rhinestone, and pearl pattern coordinating with that found on the jacket.

Matching boots by Di Fabrizio are constructed from the same blue-gray gabardine as the jumpsuit. They repeat the beaded and rhinestoned pattern, with the addition of crystal and topaz rim-set rhinestones. Their heels are solidly covered with rim-set crystal rhinestones.

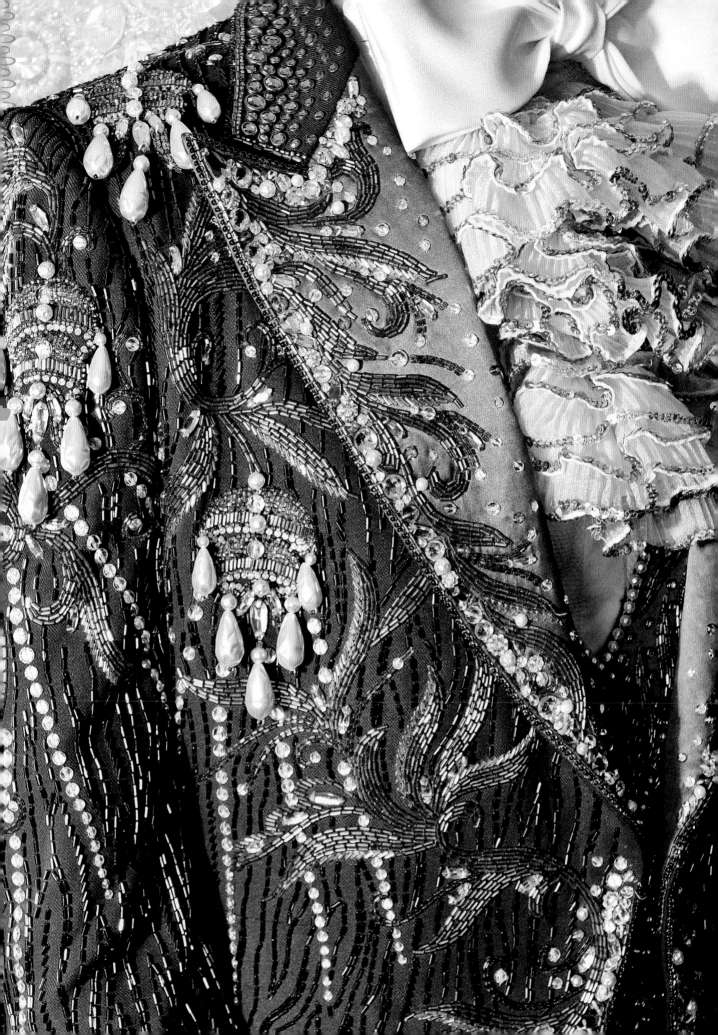

Blue and Gold Rococo Cape • 1985

Costume design by Michael Travis, fur made by Anna Nateece

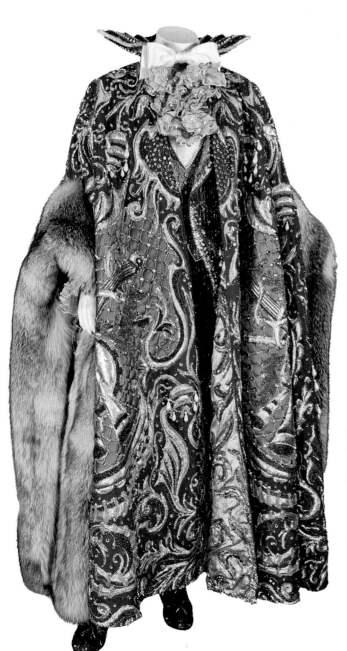

This magnificent cape is made from steel-gray gabardine with areas of matching heather-blue silk and satin. The cape is covered with an overall patterning in gold lamé trapunto and copper-brown stippling. Each pattern is outlined and accented with silver sequins.

The cape is heavily embellished with gold lamé trapunto, creating a pattern that follows traditional rococo styles and features large musical motifs. Coppery-brown stippling accents and raises the trapunto.

Two large designs are on the front of the cape. One features a gold violin and two crossed horns; the other side features a gold mandolin and two crossed horns. Behind these motifs and embroidered in gold is a square grid pattern highlighted with a rim-set light Colorado topaz rhinestone at each crossed grid line. Further enhancements on the cape include rim-set crystal rhinestones, pearls, and large pear-shaped baroque pearls suspended from smaller, round pearls.

On the back of the cape, rococo patterning continues. A large center motif features a trapunto, stippled lyre, and two horns surrounded by an elaborate ray design. The front and back of the tall (twelve-inch), stand-up, scalloped collar adopts the ray patterning in gold lamé, silver sequins, rows of pearls, bugle beading, and rhinestones. The front and back of the collar are patterned the same way. The inside of the cape is a light gold lamé with a rococo pattern stitched in copper and silver sequins.

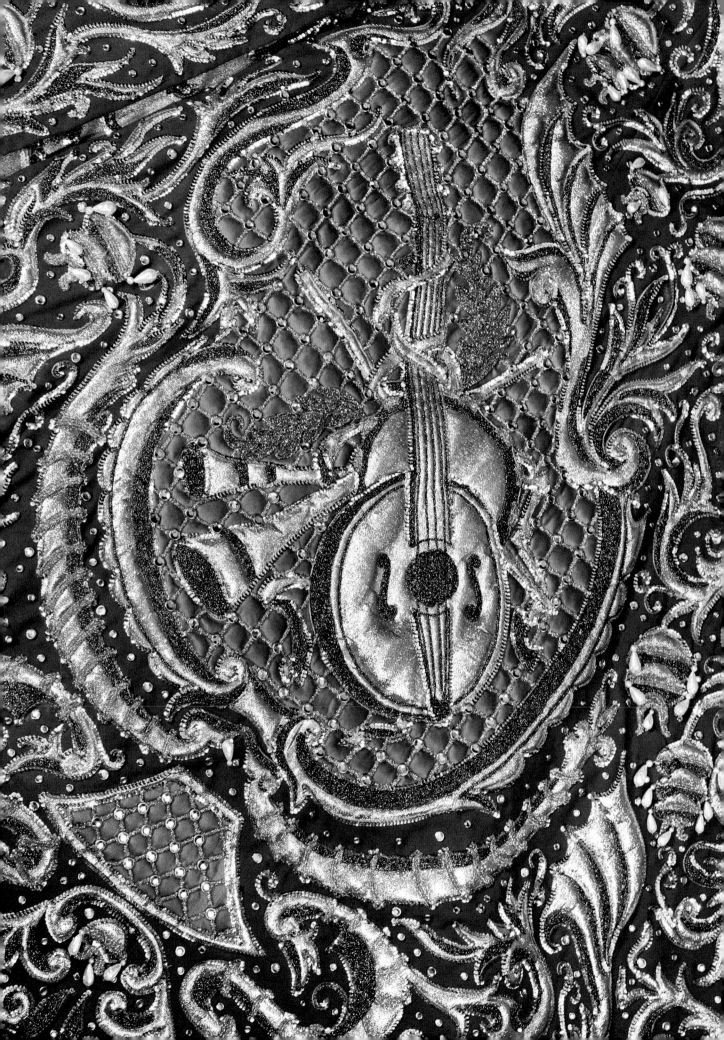

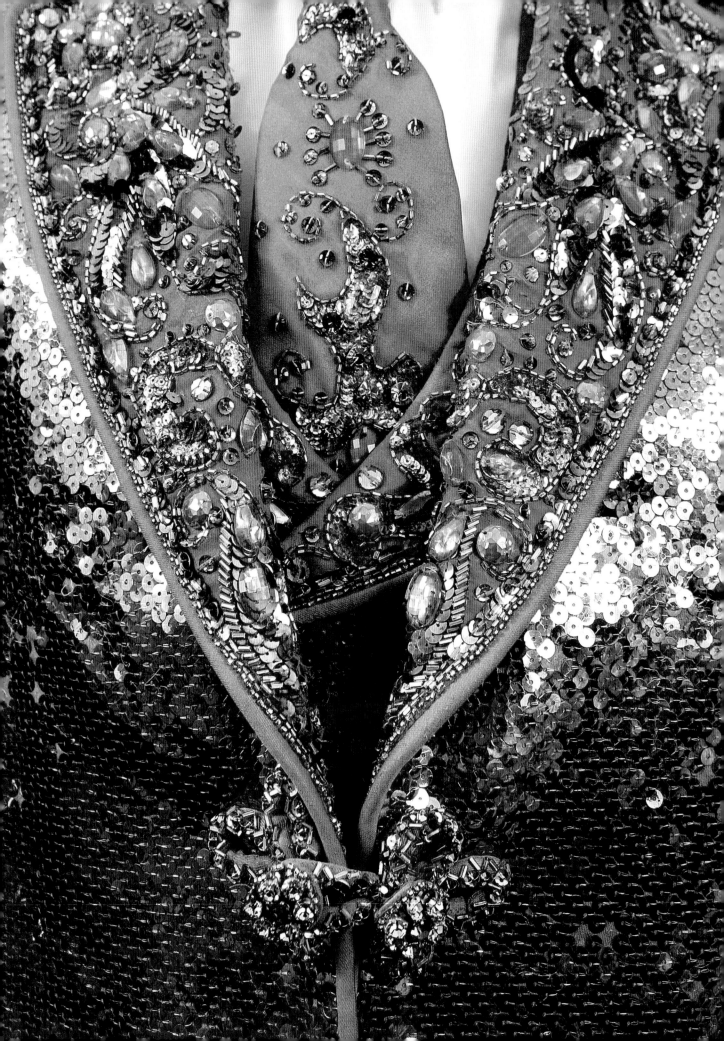

Pink Sequin Suit and Cape • 1980

Costume design by Michael Travis

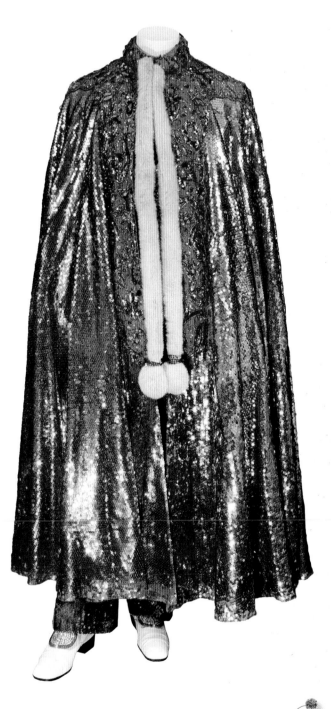

Brilliant pink sequins and lavish embellishments are the basis for this cape, jacket, and jumpsuit. A matching tie and a white dress shirt complete the costume.

The jacket is covered in hot-pink sequins and has hot-pink polyester gabardine lapels and cuffs. Light-rose and crystal AB lochrosens, pink and fuchsia sequins, silver bugle beads, and several shapes of light-rose and crystal sewn-on jewels lavishly cover the lapels and cuffs in a loose paisley-style pattern. The lapels, jacket edges, and cuffs are outlined with pink gabardine cording, two rows of silver bugle beads, and a row of fuchsia sequins.

The closure for the jacket is a large frog made from pink gabardine cording. It is completely covered with light-rose and crystal lochrosens topped with pink seed beads.

The vest portion of the jumpsuit is also constructed from hot-pink polyester gabardine. The shawl collar features the same embellishments and patterning as the jacket's lapels and cuffs. The tie is pink gabardine and is beaded with a complementary pattern using the same beading as the jacket, vest, and cape.

The pants and floor-length cape are also fully covered with hot-pink sequins. The mandarin collar, yoke, center front, and hem trim beading echo the embellishments and patterns of the jacket lapels, cuffs, and vest. From the neck to hip, there are two cream-colored fox boas. They end in two puff fur balls topped with a band of pink sequins. The cape closes at the neck.

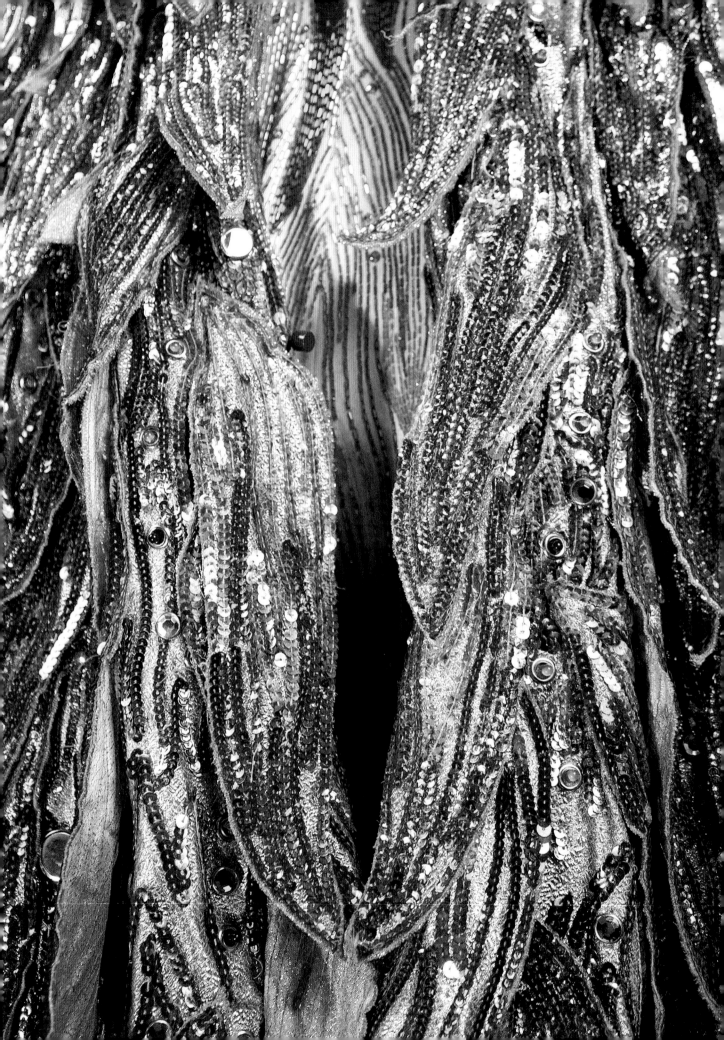

Flame • 1979

Costume design by Michael Travis

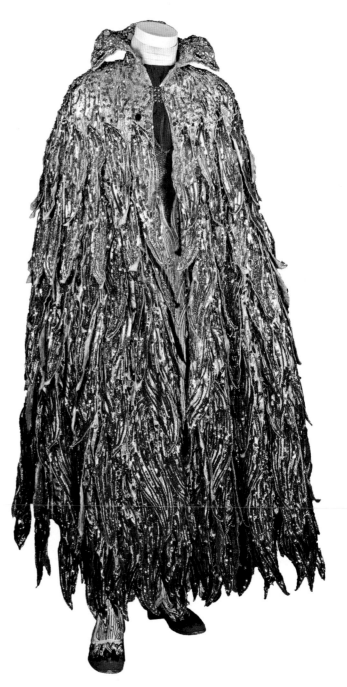

This costume is covered inside and outside with flames in gold, orange, and red sequins and is lit up by battery-powered lights. Constructed in 1979 for Liberace's show at the Las Vegas Hilton, Michael Travis recalled that it was one of the most challenging costumes:

We had to sew individual petals in metallic fabric shaded from silver to gold to copper to orange to magenta. Small mirrors had to be sewn to the entire cape and holes had to be sewn inside and outside the cape for sixteen-hundred lights. When the cape came back from Dallas with the wiring installed, it looked like something from NASA. The wiring is so detailed that Lee can practically spell out his entire name in lights with rheostats. We had to interline the cape so that the inside wires didn't touch the outside wires. The wiring, which was too thin for the intricate lighting, was replaced by heavier wires on the road.[67]

When Liberace was questioned about his fantastic cape, he replied: "As I flew around, some of the wires would break. At first we would fly a technician in from Dallas every time this happened, but we decided to go with the heavier wiring and eliminated the problem."[68]

Travis said: "The cape, when first designed, weighed one hundred and fifty pounds, with the wiring contributing just twenty-five to thirty pounds. The bulk of the weight, with which Lee seems to fly around the stage with little effort, is the embroidery on the petals."

The base fabric for the cape is heavy silver lamé with extensive Cornelli silver and gold sequining, crystal and topaz rim-set rhinestones, and rim-set mirrors. On top of this are twelve rows of flames. Each flame is cut from the same silver lamé and has gold, orange, and red Cornelli sequining. The color mixture creates an ombre effect.

The top six rows of flames are backed with silver lamé; the bottom six rows are lined with coordinating fabric colors. The cape closes at the neck with a large crystal rhinestone clasp.

The wide pointed yoke is silver lamé and extends across and over the shoulders in front and back. It is embellished with rim-set mirrors, crystal and topaz rhinestones, and silver sequins.

The wide stand-up collar is silver lamé and worked in gold sequins around its top edge. It is also embellished with rim-set mirrors, crystal and topaz rhinestones, and silver sequins.

Small clear bulbs are scattered all over the cape's exterior. At center back there are two zippers that allow access to the wiring and electronics. The lights could be operated from a red button on the inside right of the cape.

Beneath the cape, the jumpsuit's base fabric is a heavy light-gold gabardine covered with orange, gold, and red flames created from fabric appliqués with rows of bugle beads.

The flames point downward from a deep V-neckline, extend up the arms from the cuffs, and go from center front to center back and up to mid-calf on the pants. The remaining body of the jumpsuit is beaded in a loose overall pattern of gold bugle beads, silver bugle beads, and topaz crystal lochrosens.

Additional costume pieces include a red satin dickey, banded collar, lace cuffs, and matching boots by Di Fabrizio.

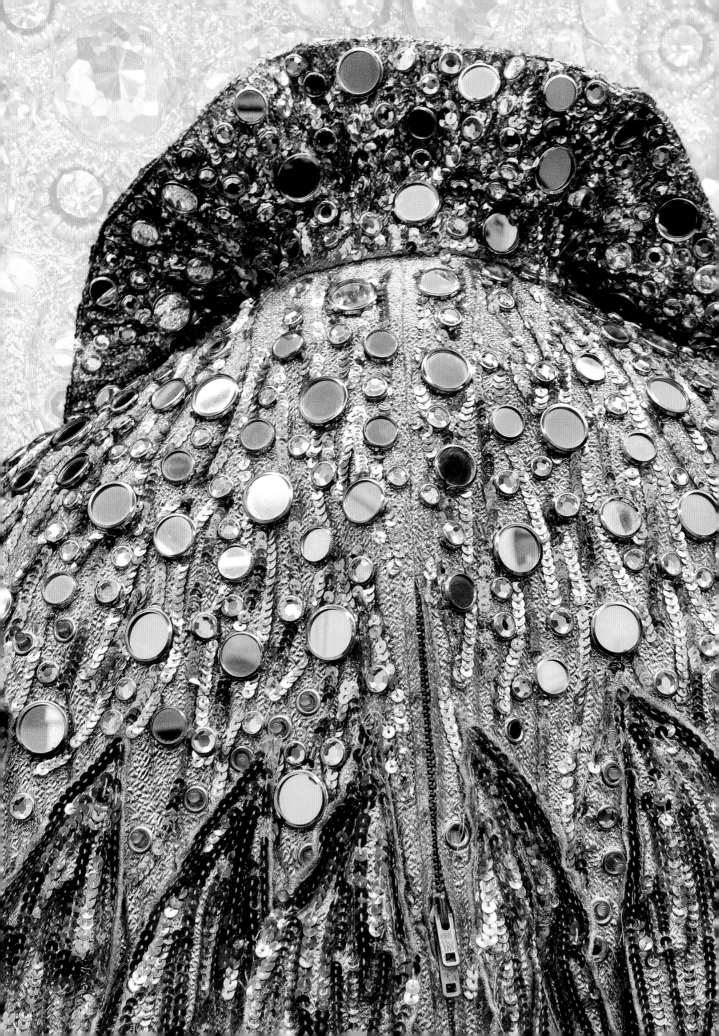

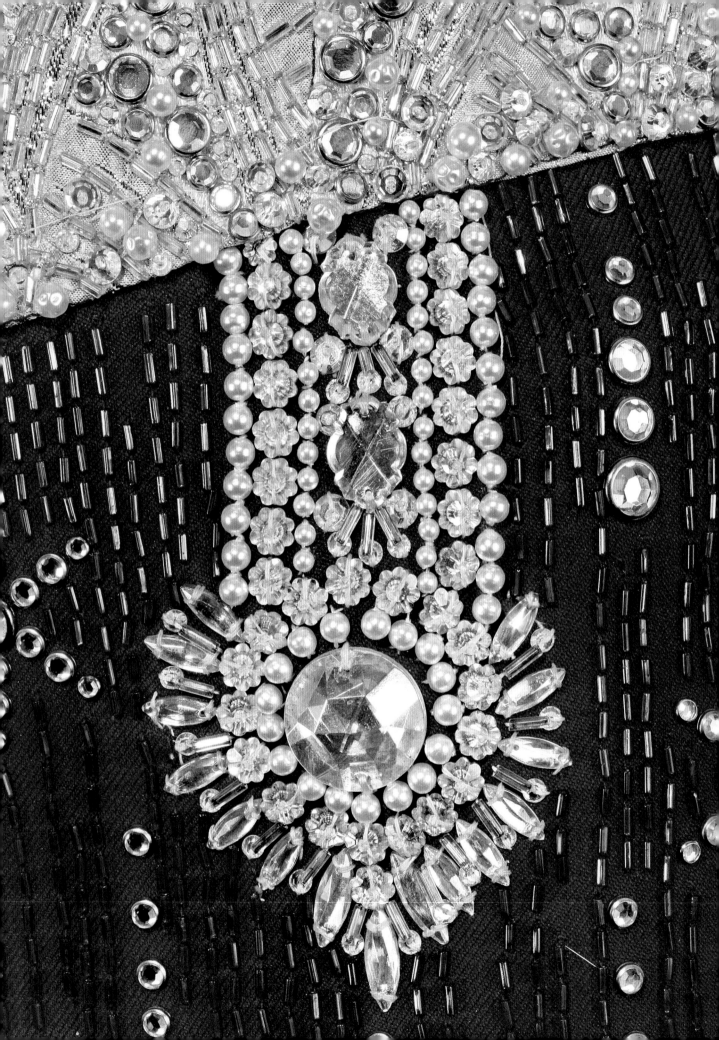

Red, White, and Blue "Hot Pants" Costume • 1980

Costume design by Michael Travis

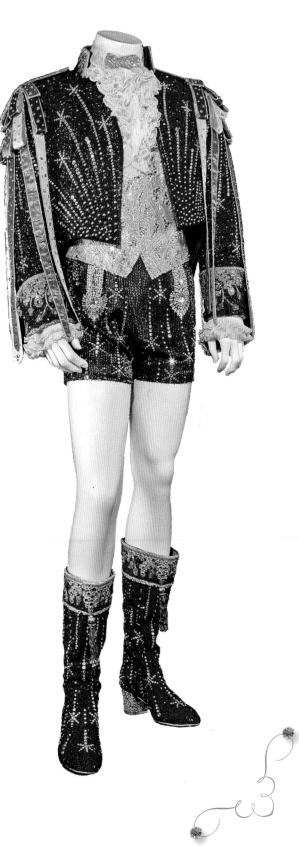

In *The Wonderful Private World of Liberace*, Liberace wrote, "As a gag, I once bought a red-white-and-blue leather hot-pants outfit, which I thought would be fun to wear to a Halloween party. That night, I put the outfit on under a coat and came back-stage for a performance, thinking it would get a laugh out of the musicians and crew. They flipped over the outfit. It wasn't expen-sive, it wasn't glamorous, but it was funny, extremely funny. They told me, 'You've got to wear that onstage.'" Liberace replied, "First, I come out in jewels and fabulous costumes, and then you want me to walk out wearing these ridiculous-looking hot pants? No Way!" [69] However, Liberace was not one to turn down a dare; he and his stage manager, Ray Arnett, decided to do a number that had a patriotic theme—it was 1971 at Caesar's Palace. They knew the act would get either the biggest applause or the biggest jeer of Liberace's career. Liberace said that he "marched down the aisle of the theatre wearing the hot pants and twirling a baton like a drum major. It was a show stopper. The audience rose to a standing ovation." [70] As was his custom, Liberace gave the audience a big wink. The audience erupted in laughter.

The hot-pants became such a popular part of the show that when appearing in Australia the contract stipulated that Liberace wear them. Unfortunately that specific outfit no longer exists; however, due to the popularity of the hot pants, Liberace directed Travis to design him another costume using them.

This costume, designed for the one-hundredth anniversary of the Statue of Liberty, was worn by Liberace at his 1986 Radio City Music Hall performance. For the finale of the show, he saluted a replica Lady Liberty, who held a candelabra instead of a torch.

Ask designer Michael Travis which costume is his least favorite and he'll quickly tell you "the red, white, and blue hot pants." But the costume always a hit with audiences.

The costume consists of a cutaway coat, vest, and hot-pants jumpsuit with cuffs, jabot, banded collar, bow tie, cape, and matching boots; a cane accessorizes it.

The vest is silver lamé and worked in silver-lined crystal bugle beads and rim-set crystal and AB crystal rhinestones. Pearls are scattered throughout and around the edges.

The hot pants are royal-blue polyester gabardine with straight split lines of royal-blue bugle beads. Center front on each leg, extending from the vest edge, are arrow-like shapes made from rows of pearls and margaritas, and centered with crystal and AB crystal sewn-on jewels. The motifs are finished with sewn-on AB crystal navettes. Rim-set crystal rhinestones in firework-inspired designs complete the embellishment.

The coat is red polyester gabardine and worked in a vermicelli pattern of red bugle beads. Its edges are finished with three rows of red bugle beads. The front, back, and sleeves feature a "shooting fireworks" pattern created from rim-set crystal rhinestones. Siam rhinestones in Tiffany mountings are scattered throughout. Epaulets and sleeve trim are strips of red, white, and mauve fabric with silver cording around the edges and a symmetrical pattern of crystal rhinestones. At the shoulders are two rows made from five loops of fabric in each, and an unlooped row extending to the end of the sleeve.

The stand-up collar and cuffs have a vermicelli pattern made from red seed beads and gold appliqué leaf and vine patterns with rim-set topaz rhinestones. They are outlined with crystal seed beads worked circularly over cording at the edges. Silver-lined crystal bugle beads, gold rocaille beads, and crystal seed beads form vines and small buds. Siam rhinestones in Tiffany mountings are scattered throughout.

The jabot and cuffs are pleated and ruffled organza with each layer merrowed. A crystal sequin bow tie and banded collar accessorize the costume.

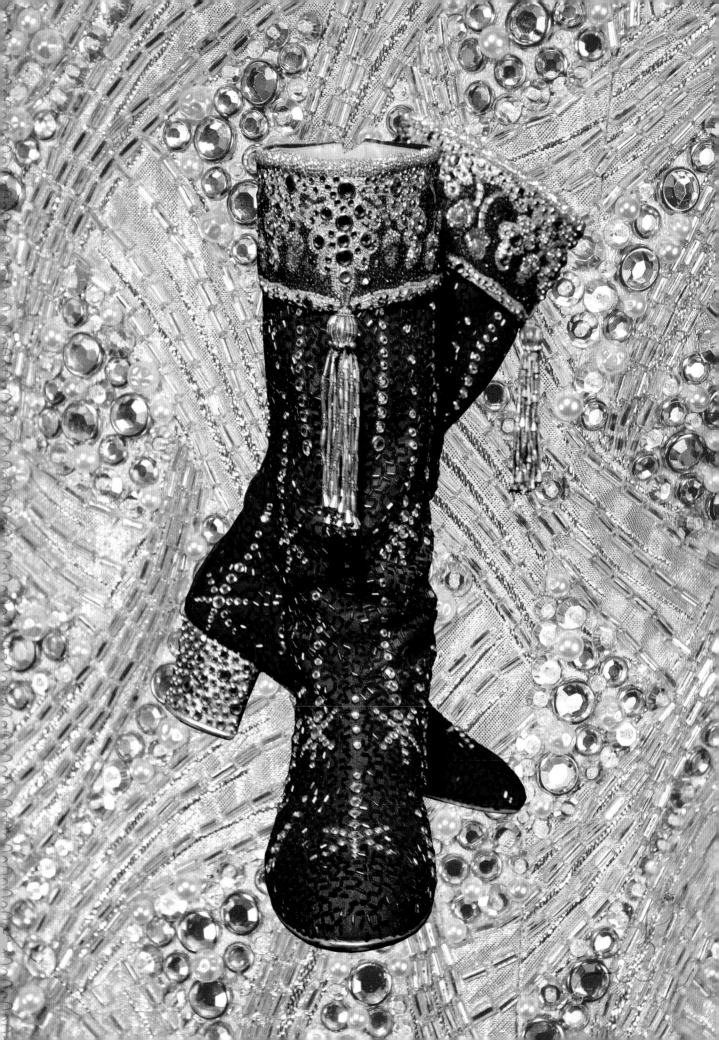

Red, White, and Blue "Hot Pants" Cape • 1980

Costume design by Michael Travis

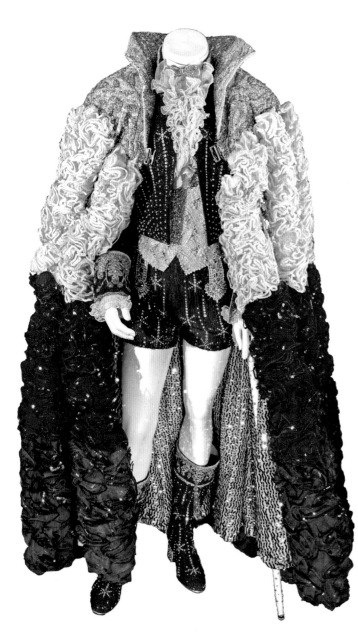

The cape features nine large red, white, and blue boas constructed from netting joined together and edged in matching sequins. They also have rhinestoned godets. The boas form the cape by being joined together with silver and white brocade godets. Each godet is appliquéd in a gold leaf and vine pattern and enhanced with rim-set topaz and crystal rhinestones, and silver sequins.

The front and back of the yoke and stand-up collar use the silver-and-white brocade fabric that is also the background for the gold appliqués of leaves, vines, and flowers. Each is outlined in gold bugle beads and set with topaz rhinestones. Around the gold patterns are crystal rhinestones, silver sequins, and large sewn-on crystal jewels.

The lining of the cape is light-gray silk with a shallow zigzag pattern of sequins. The sequin colors alternate every other sequin with royal blue and gray.

A white cane completes the costume. Crystal rhinestones are glued onto the cane, covering the ball.

Matching calf-high boots by Di Fabrizio are the same red gabardine as the coat. Their cuffs are defined by rows of crystal seed beads and gold rocaille beads and have gold appliqués accented with topaz rhinestones and a gold bugle beaded tassel. The heels are covered in rim-set crystal rhinestones.

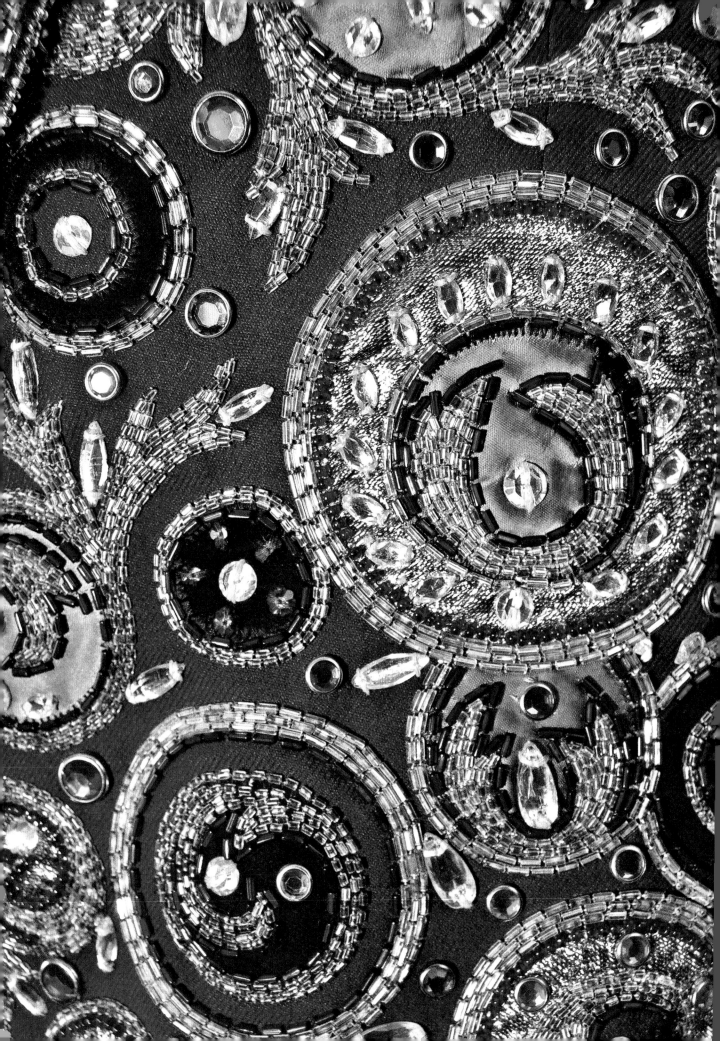

Purple and Silver Costume · 1983–84

Costume design by Michael Travis

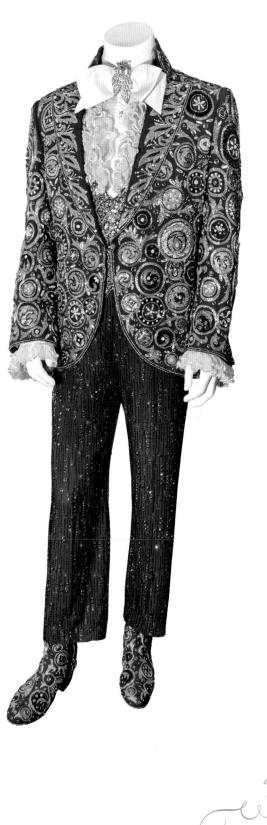

This purple, pink, and silver costume patterned in circular designs was worn by Liberace during his 1985 Radio City Music Hall performances. It comes with a matching floor-length cape trimmed with rare Empress Chinchilla fur.

The tailcoat was constructed from purple gabardine and the closely spaced circular motifs embellish the fabric. Pink and purple satin and pink lamé are appliquéd on many of the circles. Silver and pink rhinestones, AB-finished dark purple bugle beads, silver sequins, and sewn-on crystal navette-shaped jewels adorn them. Rim-set rose and sapphire rhinestones and crystal lochrosens are

at the center of most of them. Rim-set rose and sapphire crystal rhinestones are also sprinkled throughout.

The fold-over collar and lapels are embroidered in a leaf-like pattern using silver and dark-purple bugle beads, crystal lochrosens, white pearls, and sewn-on sapphire jewels. The lapels, cuffs, and tails, as well as the bottom and front edges of the collar, are finished with rows of silver bugle beads, dark-purple bugle beads, and crystal seed beads.

The vest is purple gabardine overlaid with a heavy metallic silver lace. It is outlined with a row of dark-purple bugle beads and a row of crystal seed beads. At center front, rim-set rhinestones are clustered using crystal, pink, light-pink, fuchsia, light-amethyst, and amethyst stones, and dark-purple bugle beads. Diamond patterns atop the silver lace are formed by silver and AB dark-purple bugle beads. The diamonds contain AB-finished amethyst margaritas and are centered with rim-set light amethyst rhinestones. Around the diamond are sewn-on crystal jewels in navette shapes, AB dark-purple bugle beads, and rim-set pink, light-pink, fuchsia, amethyst, and light-amethyst rhinestones.

The purple gabardine pants are stitched with broken rows of purple bugle beads set end to end and in zigzag lines. The dickey has crystal rhinestone buttons, a banded collar, a jabot and cuffs made from white pleated and ruffled chiffon edged with pale pink sequins, and a large white bow tie centered with a crystal rhinestone broach.

Matching Di Fabrizio boots are made from purple gabardine with circular and vine motifs matching the ones on the jacket. Their shaft and silver heels are decorated with light-rose and sapphire rhinestones.

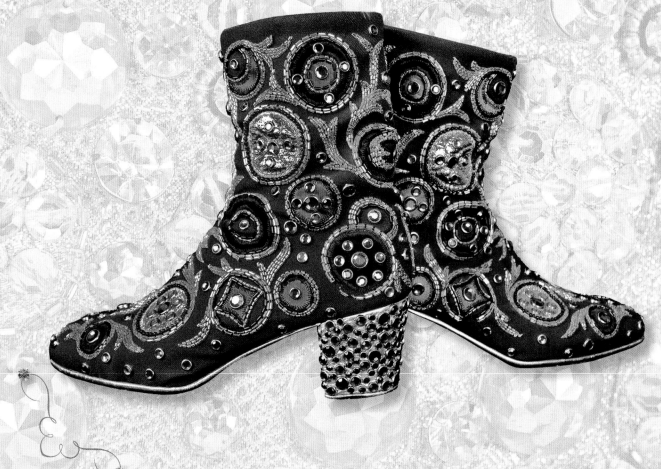

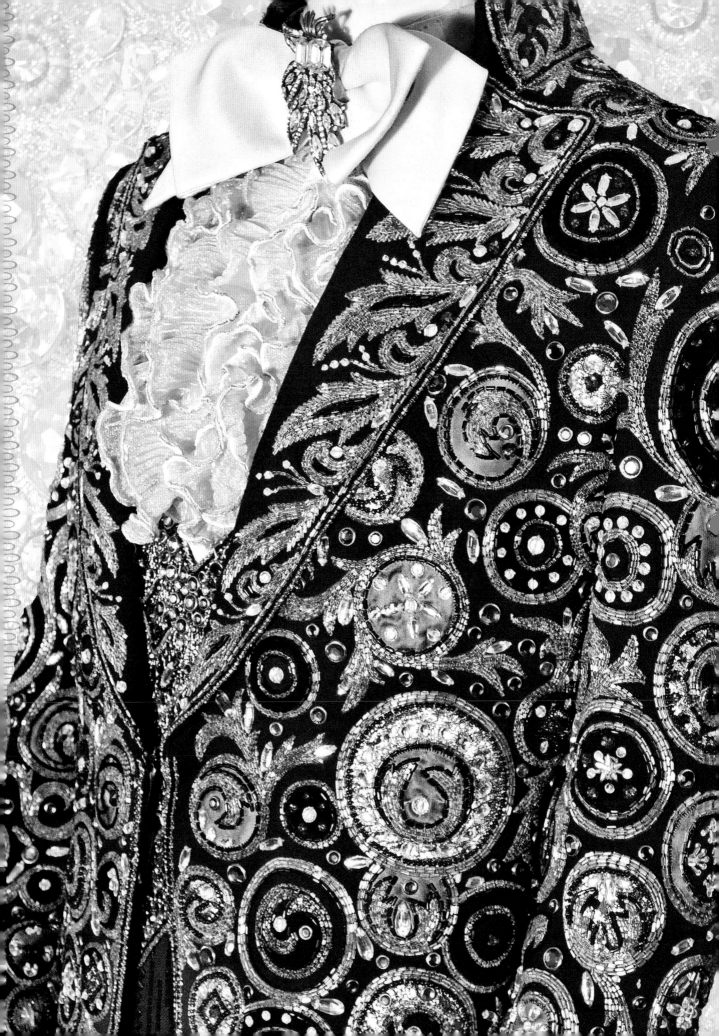

Purple and Silver Cape with Rare Empress Chinchilla Fur • 1986

Costume design by Michael Travis, fur made by Anna Nateece

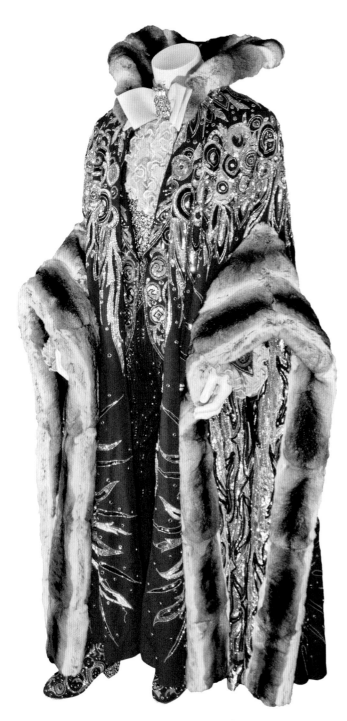

*T*he cape's base is purple polyester gabardine. Circular motifs on the upper third create a yoke-like effect; this embellishment pattern and appliqués echo those of the cape by using the same motifs and trimming.

Below the motifs, additional patterning cascades to approximately waist level. Elongated leaf-like designs are created using pink lamé and dark-purple satin appliqués; the designs are finished with silver and dark-purple AB-finished bugle beads and flat silver sequins. Crystal navette jewels and rose and sapphire rhinestones are scattered over most of the cape.

At center front, mirror images on each side feature the round and elongated leaf-like patterns. The round shapes are centered in the middle of the pattern, slightly over-lapping each other, and the leaf-like forms extend around them on all sides. Additional leaf-like sprays, unconnected to the large motif, flare out around the large motif. On the back of the cape, these patterns are repeated three times. There is one on each side placed under the yoke area and behind the arm opening. The third and largest covers the majority of the center back, from approximately the waist to the hemline.

Leaf-like patterns lie across the shoulders, extend around the back forming a yoke area, and cover the underside of the collar. They are also created from pink lamé and dark-purple satin appliqués, and finished with silver and dark-purple, AB-finished bugle beads and flat silver sequins. The large

stand-up collar is lined on the front with chinchilla fur, which also encircles each arm opening and is open at the bottom.

The inside of the cape is lined with pink lamé that is Cornelli-machine stitched in an abstract leaf pattern using silver, pink, and purple sequins. The cape closes with a silver metal clasp.

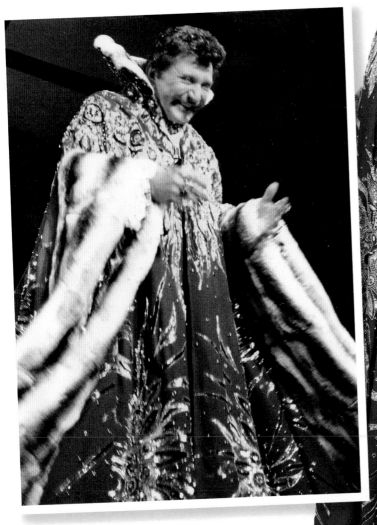

Above: Liberace greeting an audience.

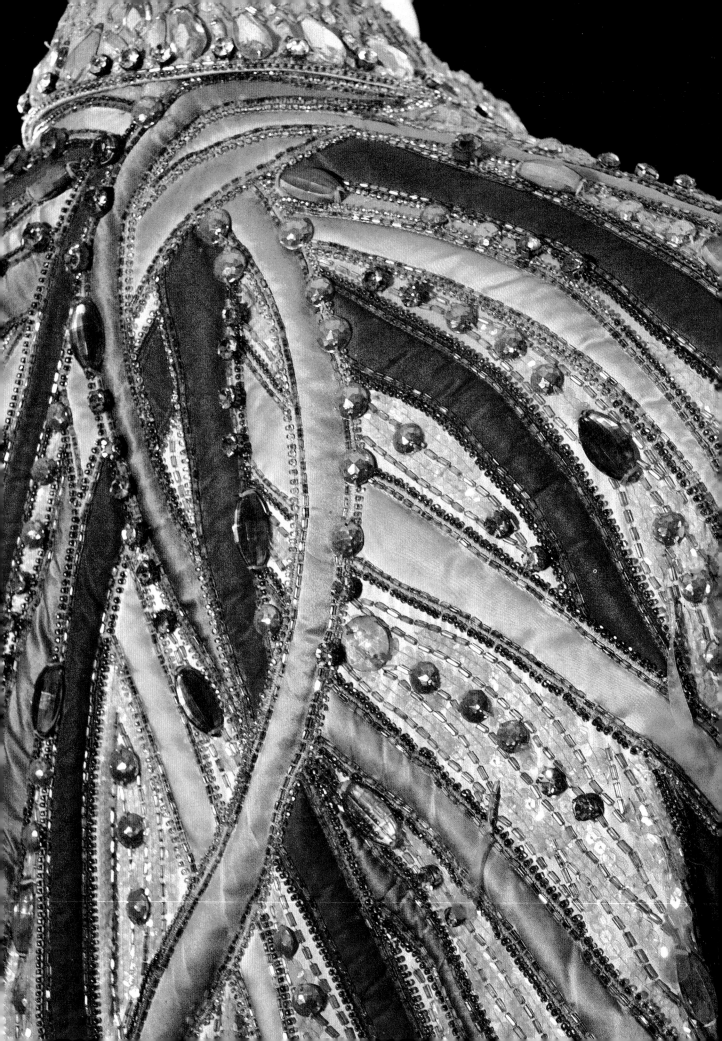

Suit of Glass • 1983

Costume design by Michael Travis

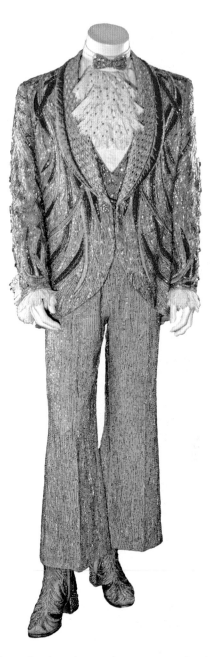

This costume's tailcoat, jumpsuit and cape are pale-pink polyester gabardine with pink appliqués. The whole costume is covered with Cornelli-machine sequins and clear AB-finished sequins to make it highly reflective; thus it was named the "Suit of Glass."

The tailcoat features bugle beads in closely spaced rows. Crystal lochrosens and navette-shaped rhinestone jewels are sprinkled between them. Pink trapunto appliqués are darker than the pale-pink base fabric, and are on the coat's front, sleeves, and shoulders, and in a large pattern across the back. They are edged in silver-lined, clear rocaille beads and silver bugle beads. Their tips are accented with crystal lochrosens and navettes.

The wide lapels are worked in silver bugle beads, forming gently rounded diamond-shaped rows. At the center of each diamond is a crystal navette. They are outlined in a thick trapunto band of medium-pink satin, tapering to a small point at center front.

The coat is lined in medium-pink silk satin. It is closed with a hook and eye and two crystal rhinestone buttons.

A rosy pink polyester gabardine creates the vest. It has two rows of silver bugle beads, a row of crystal rocaille beads, crystal lochrosens, as well as navette and teardrop-shaped crystal jewels. Completing the jumpsuit, the pants are worked in the same silver bugle bead and crystal lochrosen and jewel pattern as the tailcoat.

Also worn with the costume are a dickey, a light-pink banded collar, a tiered and gathered white lace jabot accented with rim-set crystal rhinestones, gathered white lace cuffs, and a bow tie with silver bugle beads and Tiffany-mounted crystal rhinestones.

The Di Fabrizio boots are also light-pink gabardine with pink satin appliqués, silver bugle beads, and crystal lochrosens. Rim-set crystal rhinestones cover the silver heels.

Suit of Glass Cape • 1983

Costume design by Michael Travis

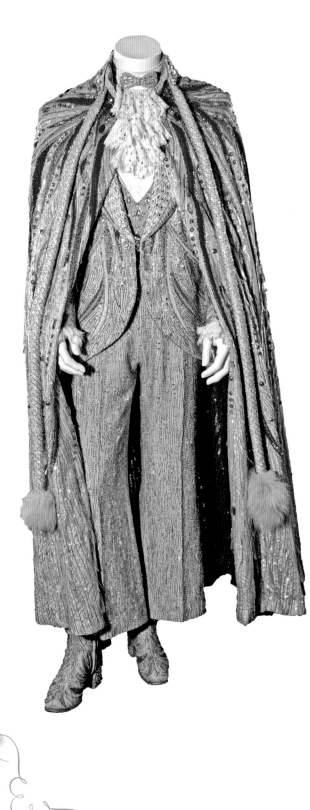

The cape has overall sequining in gently curving rows of clear AB-finished sequins. Each row is outlined with silver bugle beads and silver-lined crystal seed beads. Beginning at the shoulders, on both the front and back of the cape, intertwining rows of silk satin trapunto appliqués range in color from light pink to bright rosy pink. Short rows of pink rocaille beads, Tiffany-mounted crystal-rose rhinestones, light-rose sewn-on navettes, light-rose and rose crystal jewels, and crystal-rose lochrosens are scattered among the appliqués and around the body of the cape. Each appliqué is edged with silver bugle beads and pink rocaille beads. Their lowest points extend almost to the knee.

The fold-over collar is pale pink gabardine and worked vertically with silver bugle beads stitched in a zigzag pattern and centered with crystal lochrosens. Tiffany-mounted crystal rhinestones and large, teardrop-shaped, sewn-on jewels edge the collar directly above a row of small silver seed beads. The cape is closed with a silver clasp.

Attached under the collar at center front are two forty-inch pale-pink gabardine ropes. The ropes are embroidered with a row of AB clear sequins and zigzag rows of silver bugle beads set at their centers with crystal lochrosens. The pattern continues down and around the ropes and ends with a fox fur pom-pom dyed light pink.

The pink silk chiffon lining is Cornelli-machine sequined with hundreds of rows of pink sequins stitched in a chevron pattern.

Christmas • 1970s

Costume design by Michael Travis

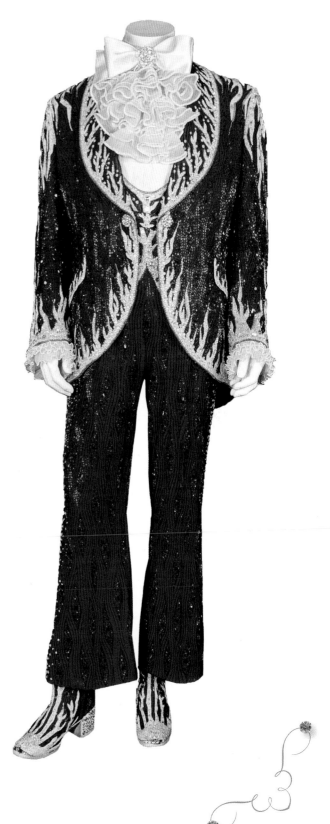

Liberace first wore this festive red-and-white costume in 1980 at the Las Vegas Hilton during Christmas season. It was worn again during his performances in 1985 at Radio City Music Hall and his last performance ever, which was in 1986 at Radio City Music Hall. The costume can also be seen on his 1981 Christmas card.

Constructed from red polyester gabardine, the costume consists of cape, tailcoat, and jumpsuit, white shirt and collar, gathered cuffs, and a bow tie.

Utilizing a moiré-style pattern, the tailcoat is beaded overall with red bugle beads, Siam crystal lochrosens, and Siam crystal, navette-shaped sewn-on jewels. The coat edges, lapels, cuffs, collar, pocket flaps, shoulders, and back yoke have flame-like motifs that are compatible with the tree limb patterning found on the cape. These are worked solid in milk-white and silver bugle beads, creating an appliqué effect.

On top of the flames are crystal lochrosens and sewn-on jewels. Several crystal lochrosens are also scattered among the flames. The coat's outermost edges are finished with a row of silver bugle beads and a row of silver seed beads. The jacket is closed with two crystal rhinestone buttons and a red beaded-and-stoned tab located between them. The center back of the tailcoat is finished with two crystal rhinestone buttons at the waist.

The matching pants and vested jumpsuit receives the same red bugle bead and Siam crystal jewel and lochrosen patterning as the

coat. The vest is defined by outlines of milk-white and silver bugle beads and crystal lochrosens. Extending down the outside of each leg is a wide band of Tiffany-mounted crystal rhinestones.

The densely ruffled jabot and detachable cuffs are pleated chiffon edged in clear sequins. A white shirt with a banded collar and a large satin bow tie, which is accented with a rhinestone brooch, are also worn with the costume.

Matching boots by Di Fabrizio repeat the use of red bugle beads. Flames extend up from the toes, using the same white bugle beads, crystal lochrosens, and sewn-on jewels as are found elsewhere on the costume. The heels are set solid with rim-set crystal rhinestones.

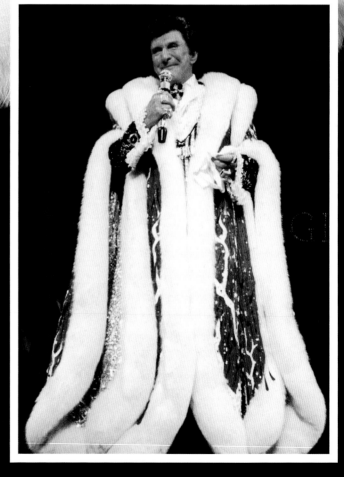

Above: Liberace singing.

Christmas Cape • 1970s

Costume and fur design by Michael Travis and Anna Nateece

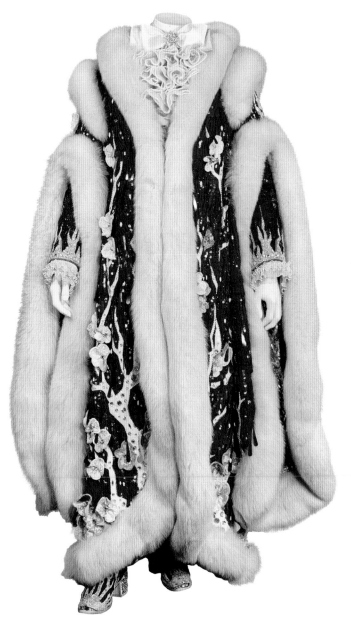

The massive red-and-white gabardine cape has a small train in back. It is extensively beaded and appliquéd and features lavish amounts of white fox fur. The entire cape is lined with Cornelli-stitched silver sequins.

The base fabric is embellished with rows of red bugle beads, flat red sequins, cupped red sequins, crystal and Siam lochrosens, and Siam crystal sewn-on jewels. Elongated teardrop-shaped red paillettes and crystal or milk-white, jewel-tipped dangling strands of red bugle beads provide swing and movement.

On the back and sides of the cape, an appliquéd white multi-limbed tree is made from Cornelli-machine sequining with milk-white sequins. This is outlined in milk-white and silver bugle beads, and finished with crystal lochrosens and crystal jewels sewn-on top of the sequins.

Five or six petal flowers are Cornelli-stitched using clear, white, cream, and light rosy-pink sequins. All petal edges are finished with a row of white sequins, and stiffened and stitched to be slightly cup-shaped. A rim-set crystal AB rhinestone is set at the center of each.

Fox fur boa trim goes around the center front, up both sides, around the stand-up collar, and across each shoulder. It is applied around the entire arm opening from shoulder to hem and extends around the hem.

175

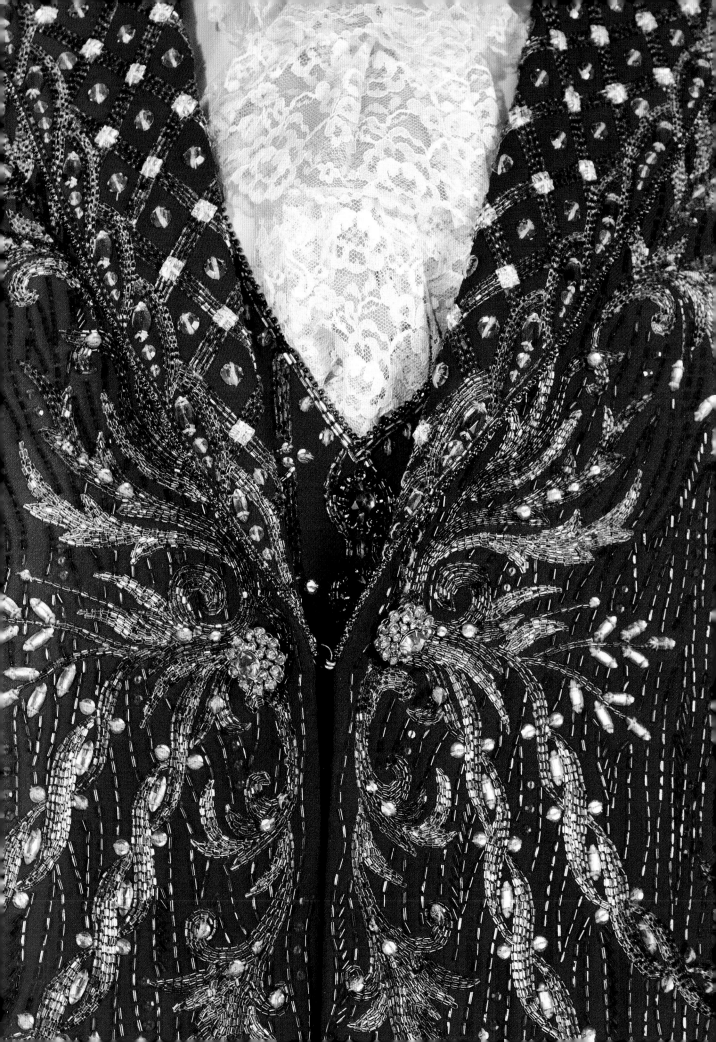

"Lasagna" · 1979

Costume and fur design by Michael Travis and Anna Nateece

Liberace joked that he wore this costume when he made lasagna because it "didn't show the stains." In fact, it made many appearances onstage from 1982 through 1984, and the audience loved it. When Liberace danced and spun in it, pieces of its unique sectional cape would fan out.

With red polyester gabardine as the base fabric, the entire coat body and sleeves are embellished. Wide flowing bands of silver and gold bugle beads are heavily accented with gold seed beads, topaz navettes, crystal and topaz lochrosens, and crystal Siam jewels. Self-fabric cording completes the edge of the coat.

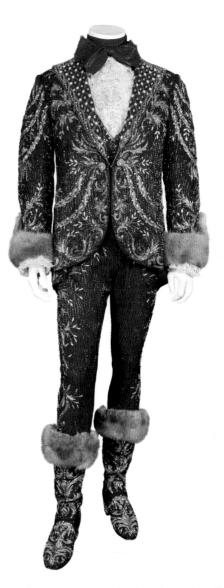

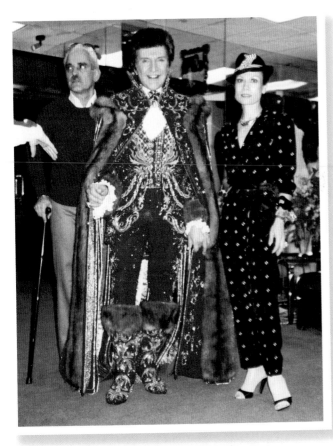

The pattern on the lapels and collar is created by diamonds formed from three solid rows of gold bugle beads. At the cross point of each diamond is a rim-set crystal rhinestone and in the center of each diamond is a topaz crystal lochrosen. The edges of

Left: Liberace, Michael Travis, and Anna Nateece.

the lapels are adorned with rows of silver bugle beads, topaz lochrosens, and gold seed beads. Filling in between and around the silver, topaz, and gold beading are broken rows of red bugle beads. The coat is closed in front with a large hook and eye, and set with two crystal topaz buttons. The slit cuffs are trimmed with a wide band of golden sable fur.

The vest portion of the jumpsuit is sprinkled with topaz lochrosens and edged and embroidered with gold bugle beads. It has three topaz and crystal rhinestone buttons.

Embroidered down the outside of each leg and using the same materials as the coat, there is a wide band of silver, gold, and topaz. The remainder of the fabric of the pants is worked in a loose moiré-style pattern using only red bugle beads.

A white shirt, ruffled lace jabot and cuffs, red satin banded collar and bow tie, and boots complete the costume. The beading pattern found on the coat is replicated on the Di Fabrizio boots. Their heels are rim-set with topaz and light-topaz crystal rhinestones. Golden sable fur tops the boots and pulls the whole look together.

Lasagna Cape • 1979

Costume and fur design by Michael Travis and Anna Nateece

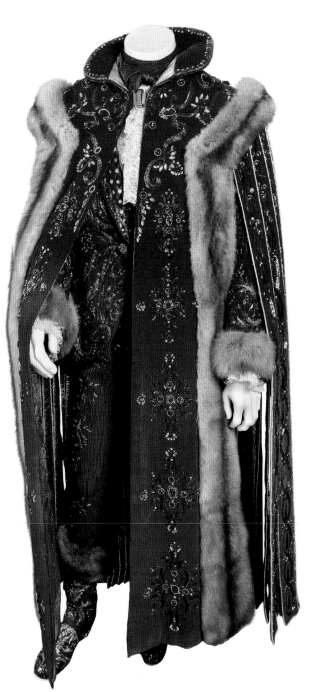

*T*he red cape has two embellished golden Russian sable fur trimmed panels that are sewn-on to thirty-three-inch-wide strips of fabric. The fur outlines the coat's two front panels, wraps at an angle across the shoulder, and forms a deep V-shaped yoke in the back, to which the strips are connected.

The front panels of the cape are beaded using silver and gold bugle and seed beads, topaz navettes, crystal and topaz lochrosens, and crystal Siam jewels. Each strip is embroidered in a repeating oval pattern of solid red using red bugle beads and rim-set Siam rhinestones. In the center of each oval dangles elongated, red pear-shaped paillettes, which add movement to the cape.

The front panels and strips are lined with an antiqued gold-and-silver lamé and gold cording. The shoulder areas, the collar, and the deep V-shaped back yoke are worked in a pattern that uses the same jewels, beads, and stones as are on the front panels and strips. Edging the stand-up collar are two rows of gold seed beads. The cape is closed at the neck with a silver clasp.

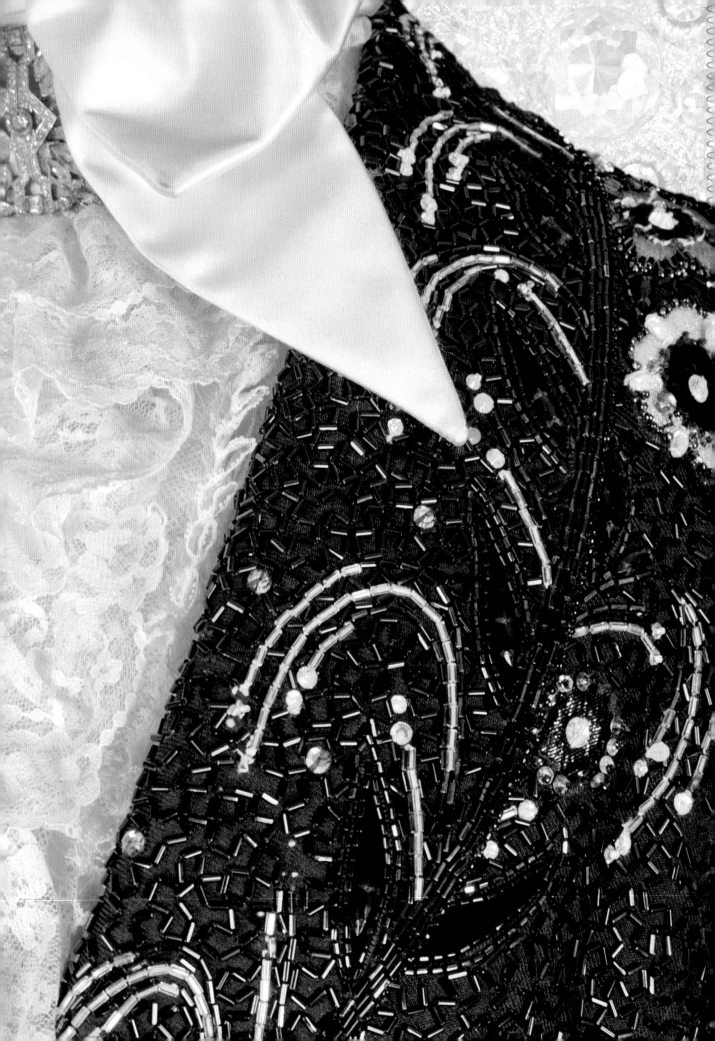

Art Deco Costume • 1982

Costume design by Michael Travis

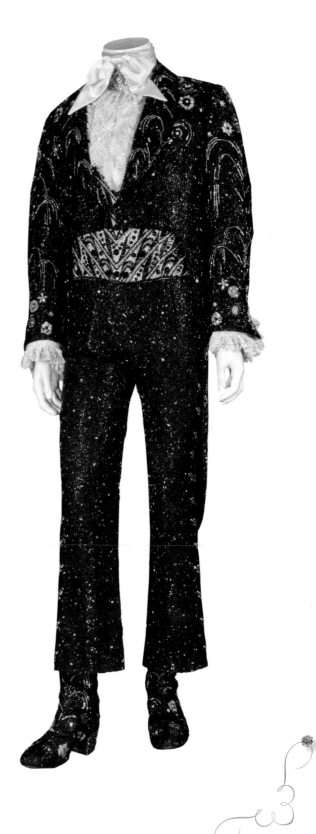

This art deco costume was first worn by Liberace during his 1983 cross-country tour, and then again at his 1985 Radio City Music Hall performances. Liberace can also be seen wearing it in the 1985 *Liberace Live* video.

The stoned, beaded, and appliquéd cape, tailcoat, and jumpsuit have a black polyester gabardine base, and are executed in silver, black, and pewter with gold accents.

The tailcoat is beaded in its entirety with jet-black bugle beads in a vermicelli pattern, and scattered crystal lochrosens. Its sleeves, shoulders, cuffs, and lapels have fountain-like sprays of silver bugle beads and crystal lochrosens. They and the front panels are enhanced with appliquéd silver and black flowers made in trapunto, and rim-set crystal rhinestones and jewels. The lapels are outlined in four rows of jet-black bugle beads. The jacket is closed at center front with a large black hook and eye.

The back shoulders have the same sprays and flowers. At center back, extending up from the waist, and on both sides of the back slit extending into the tails, are more silver sprays; there are also multiple silver, gray, and black appliquéd trapunto flowers with rhinestone accents. The back collar is treated to silver bugle bead and lochrosen sprays, and edged with three rows of jet-black bugle beads.

The vest is silver lamé and primarily worked in angular and vertical stripes of clear rocaille beads. They are accented with

Tiffany-mounted, jet-black rhinestones, crystal and jet-black lochrosens, and jet-black and silver bugle beads. Additional stripes are created using silver rocaille beads outlined with black bugle beads.

The pants are embroidered solid with jet-black bugle beads in a vermicelli pattern. Sprays of silver bugle beads and crystal lochrosens form a stripe down the length of the legs.

A white sleeveless shirt with ruffled lace front and a banded collar, ruffled lace cuffs, and a large, floppy white satin bow tie accented with a crystal rhinestone broach are worn with the costume.

Matching boots by Di Fabrizio continue the beading patterns. Appliquéd flowers with bugle beading and rhinestone centers decorate the toes. The silver heels are rim-set with crystal rhinestones.

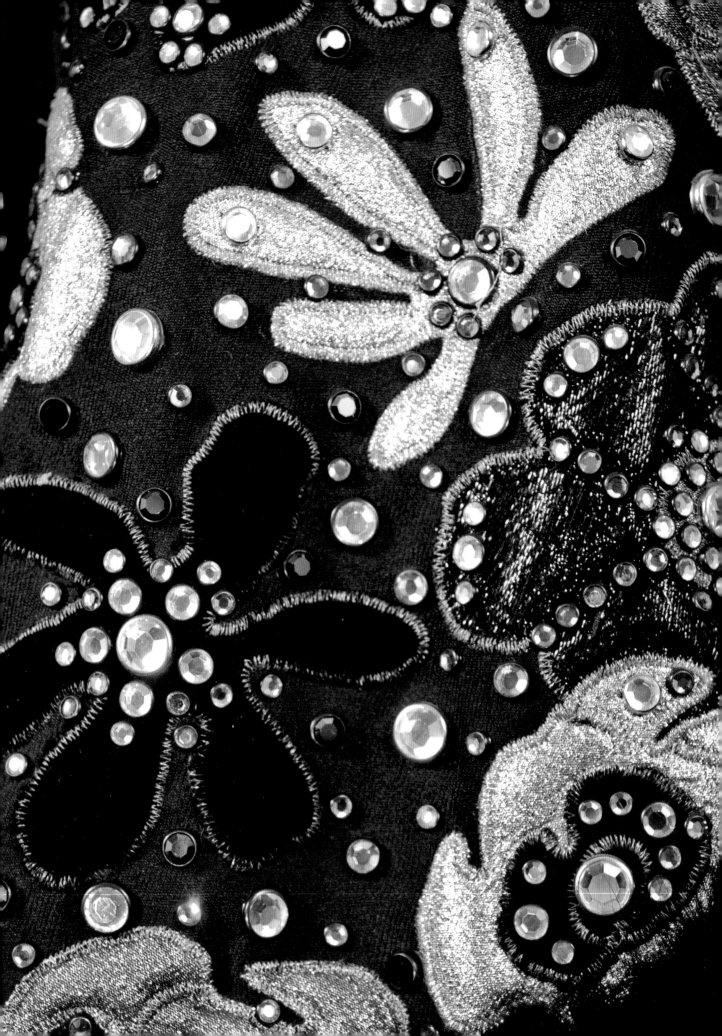

Art Deco Cape · 1979

Costume design by Michael Travis, fur made by Anna Nateece

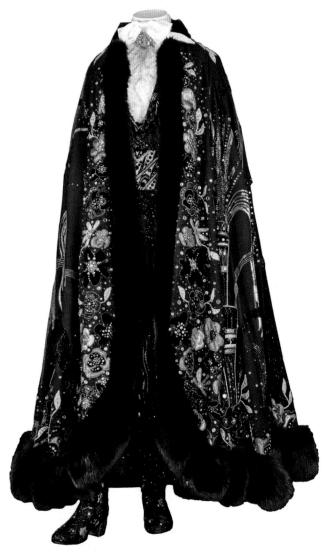

The cape has silver, pewter, and black lamé flower and leaf shapes appliquéd with a satin stitch in matching and contrasting threads. Each flower is accented with rim-set crystal rhinestones. The three-dimensional look of the flowers is achieved with trapunto stitching.

Scattered among the flowers and leaves and extending up into the body of the cape are rim-set mirrors and jet-black and crystal rhinestones. Wide bands of dense black fox fur edge the front of the cape and encircle the hem. Just above the fur hem, the floral and rhinestone pattern extends around the cape, doubling in width at center back. The collar is outlined and accentuated with rows of rim-set crystal rhinestones.

The pattern on the back of the cape is reminiscent of a fountain, with arcing bands of bugle beads, sequins, and rhinestones. The center appliqué has light and dark shades of silver lamé and black velvet. It is outlined with silver bugle beads and accented with rim-set crystal rhinestones and oval crystal and jet-black sewn-on jewels. Black, silver, and pewter bugle beads and crystal lochrosens form the wide trails emanating from the appliqué. As a final color highlight, Cornelli-machine-worked gold sequins spray from the top of the appliqué to near the bottom of the cape. There are eight rows of them on each side.

The interior of the cape is as glorious as the outside. It is self-lined and covered with hundreds of appliquéd flower shapes accented with rim-set crystal rhinestones. Each motif is constructed from shades of silver, pewter, and black lamé, and black velvet. They are appliquéd with matching and contrasting satin stitch edges, and worked in trapunto. Surrounding the flowers are rim-set mirrors and jet-black and crystal rhinestones.

Black fur edges the cape. It begins at the neck and extends down both sides of the front and around the hemline. The fur is double-faced on the inside of the cape and provides a rich accent.

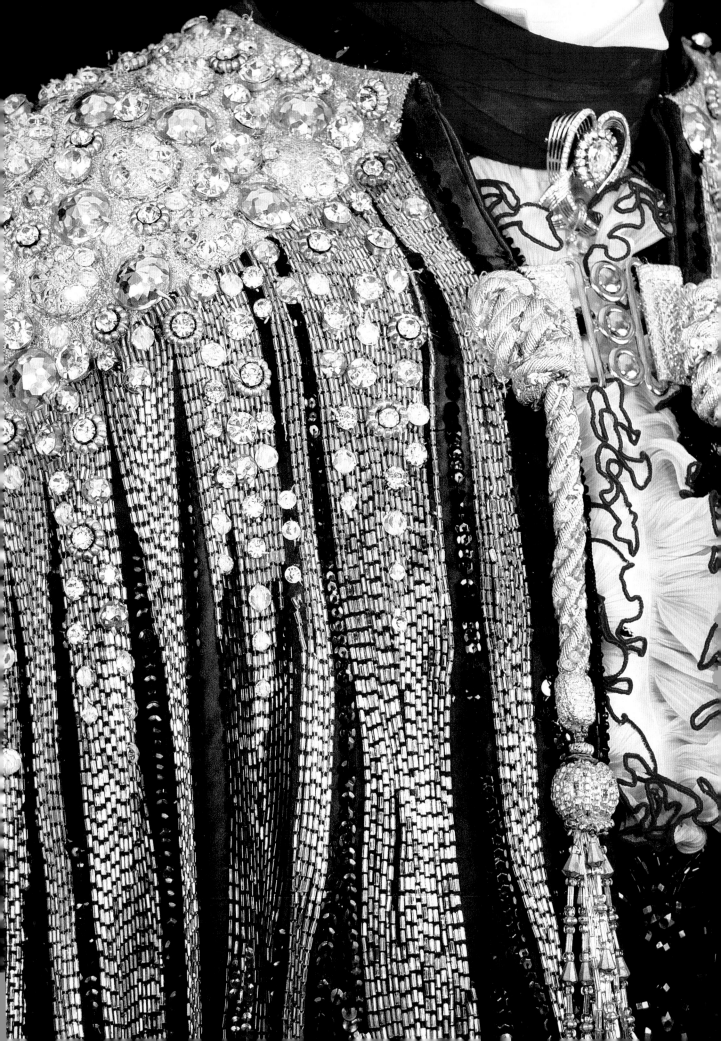

Mexican Matador Costume • 1979

Costume design by Michael Travis

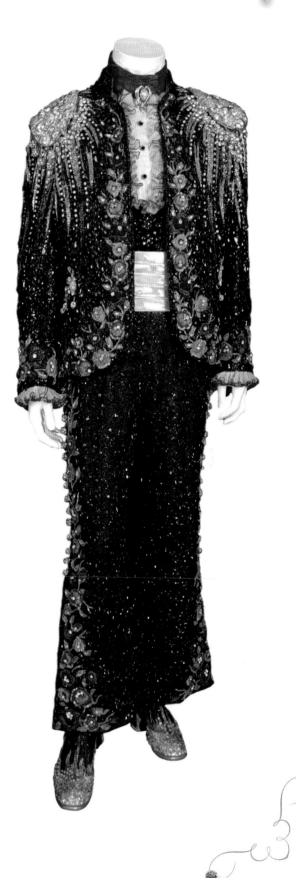

The Mexican matador costume was worn by Liberace in the late 1970s and early 1980s, notably on stage at the Las Vegas Hilton and during his 1981 tour of Mexico City.

The black gabardine coat is stitched in a vermicelli pattern with black bugle beads and jet-black jewels, some dangling from black seed beads, and scattered jet-black lochrosens. At the shoulders and yoke, there are thick-padded silver lamé epaulets. At the edge of the epaulets are silver rocaille beads holding a crystal rhinestone bauble and a row of crystal lochrosens.

Narrow flames of silver, red, pink, and fuchsia bugle beads radiate from the epaulets and run down the coat's front, back, and sleeves. These flames are interspersed with rows of crystal lochrosens and navette jewels. The flames are also at center back, under the collar.

Extending from the collar down the coat and repeating around the cuffs are pink and red satin floral appliqués. Each appliqué has silver and red bugle and seed beads, light Siam and fuchsia lochrosens, and Tiffany-mounted crystal rhinestones. The flowers' connecting stems consist of two rows of silver bugle beads. The leaves are crystal navette jewels surrounded by a single or double row of silver bugle beads.

The look of a pocket line is created from crystal lochrosens, crystal navette jewels, and silver bugle beads. The short stand-up collar is piped in black cording and embroidered

with black bugle beads and crystal jet-black jewels and lochrosens. The edges of the coat and cuffs have a row of black seed beads.

The black velvet vest has black bugle beads and crystal and jet-black jewels and lochrosens. The black gabardine pants are stitched in a vermicelli pattern using black bugle beads and jet-black jewels and lochrosens. Down the side of each leg and widening near the hem are the same embellishments that run down the coat. The pattern runs in two vertical strips. Also on the sides, from waistline to knee, are ten silver seed beads with hanging rhinestone baubles. From the knee down, the space between the floral appliqués creates a pleat. A strip of velvet and gabardine at the waist was left unbeaded to slim the waistline.

The costume was worn with a white dickey with an attached jabot made from gathered and pleated chiffon edged in red merrowing, red rhinestone studs, and cuffs, a wide red-banded collar, a white wingtip collar, a white satin cummerbund, and a rhinestone brooch.

Di Fabrizio boots feature toes encrusted with crystal lochrosens on white twill. Silver and red bugle beads form flames extending up the fronts and sides. Black bugle beads in a vermicelli pattern and jet-black faceted jewels cover the black twill upper and back portions of the boots. Red heels rim-set with light Siam rhinestones finish them.

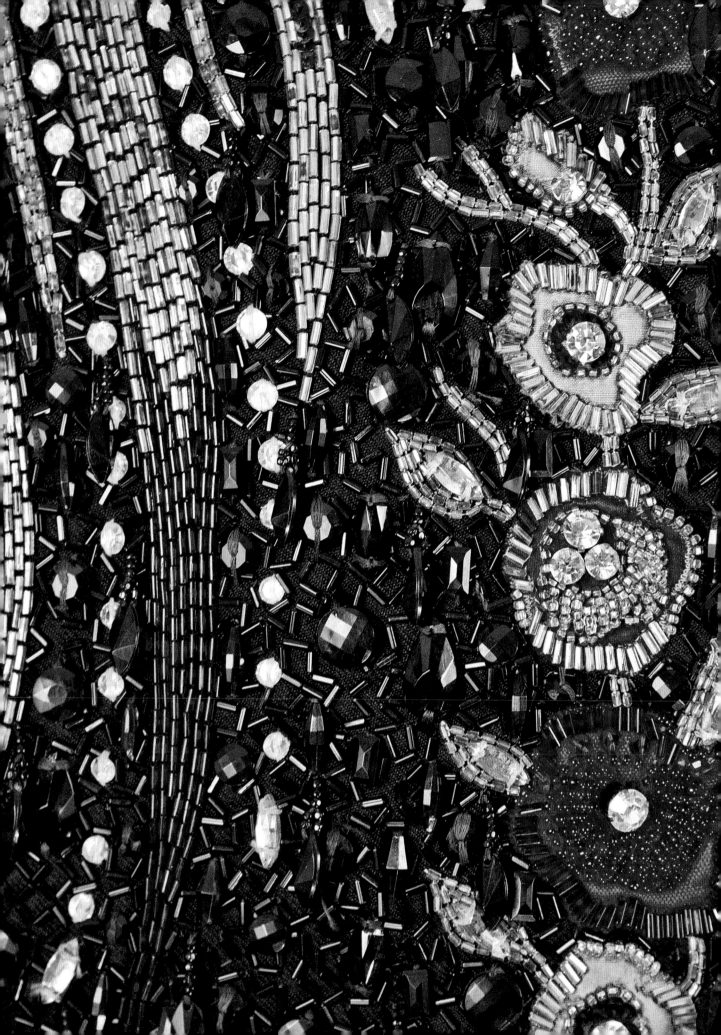

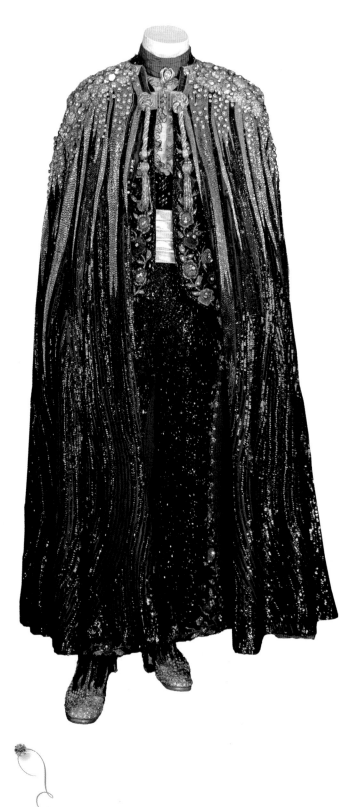

The body of this collarless, ankle-length cape is black polyester gabardine lined in red gabardine. The lower portion is Cornelli-machine-stitched in swirling vertical rows of black cupped and flat sequins.

The padded shoulder pieces and the back of the rounded yoke sit atop the cape, unattached to it. They are composed primarily of silver lamé motifs textured with crystal jewels, rhinestones, and lochrosens and encircled with silver bugle beads. They also have rows of faceted half-round silver-colored metal dome shapes. The rhinestones are Tiffany mounted and surrounded by a silver-colored metal beaded rim.

Extending down from the shoulders and yoke are long thin flames that are stitched with silver, red, pink, and fuchsia bugle beads. They are separated from each other by rows of black sequins. Tiffany-mounted crystal rhinestones and lochrosens run down the flame shapes.

A silver clasp is attached to the cape with two tabs of silver lamé and closes the cape below the neckline. Attached to the tabs are twisted silver ropes accented with crystal lochrosens. At the end of each rope are two beaded balls, one covered with silver seed beads and the other with clear, silver-lined rocaille beads. Silver-faceted bugle and rocaille beads strands form a tassel. Red self-fabric cording finishes the top edge of the cape.

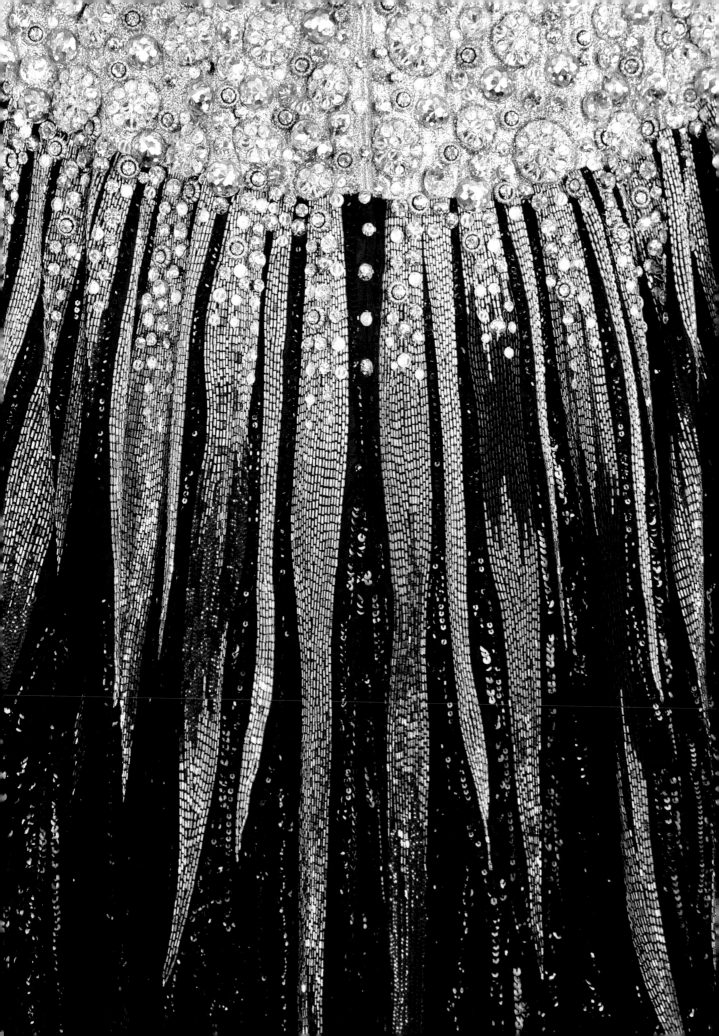

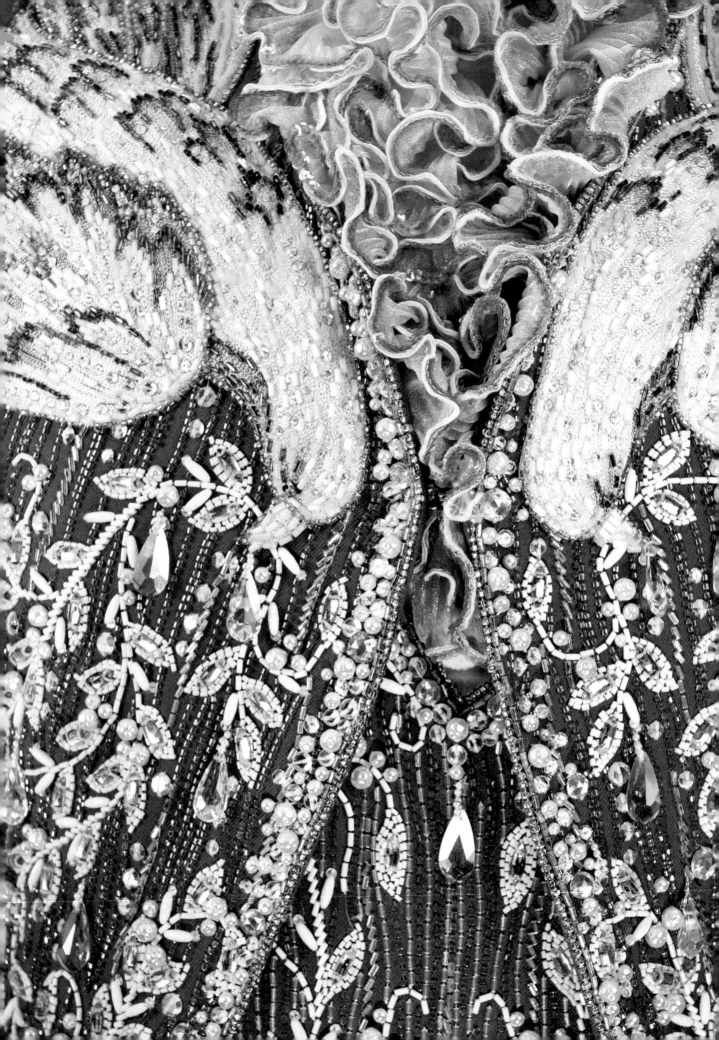

Purple and Pink Phoenix Costume with Ostrich Feathers · 1979

Costume design by Michael Travis

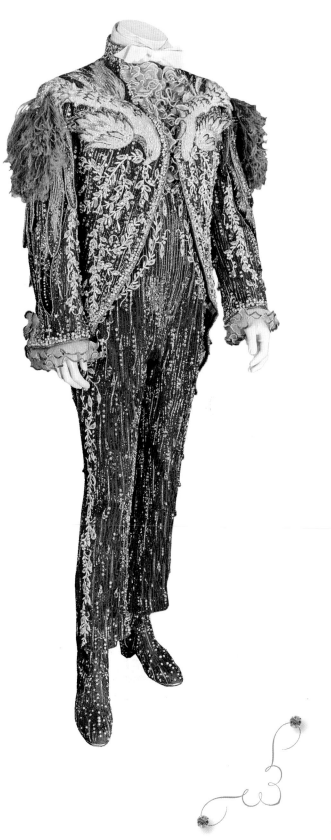

"Look me over," says Liberace, unleashed from his wire, twirling slowly in a purple feather and silver sequin ensemble. His hair is glittering with fairy dust. "I don't dress this way to go unnoticed. Do you like it?"[71]

Some of Liberace's greatest stage entrances were in this purple and pink phoenix costume with ostrich feathers. It was created for the 1986 season at Radio City Music Hall. Wearing it, Liberace would circle down to the stage from a twenty-five-foot wire. As Liberace swung his arms, the cape became shining wings, as if he were flying.

The tailcoat's base fabric is purple polyester gabardine. It has an underlining beading of broken, slightly curving, purple AB-finished bugle beads and clear bugle beads. Crystal lochrosens are stitched in short rows between bugle bead rows. Crystal teardrop-shaped jewels dangle from white pearl loops.

Glittering phoenix appliqués adorn the shoulders and front of the jacket. They have chain-stitch embroidery in white, dark-purple, and gray thread and are outlined in crystal seed beads. Each bird is enhanced with white, silver, AB-purple, and pink bugle beads, and crystal lochrosens. The tails culminate in pink French-curled ostrich feather fringes.

Leaf and vine sprays cover the lower two-thirds of the coat's front. They are fashioned from white bugle beads, pearls, and glass beads. Sewn-on crystal navettes

...e at the center of each leaf. Large AB crystal, teardrop-shaped jewels dangle from loops of white seed pearls and are scattered throughout the vine and leaf motifs.

Edging the coat, tails, and cuffs is a band of crystal lochrosens, white pearls, AB crystal jewels, and two rows of silver bugle beads and crystal seed beads. Continuing around the tails is a row of white leaves and vines.

Curving around the sleeves are staggered rows of long, loose feather appliqués extending from the top of the costume to the slit in the cuffs. Each appliqué is created from a base of purple, dark-purple, or pink threads. They are embellished with pink, silver, AB purple, and dark-eggplant AB-finished bugle beads, and crystal lochrosens. The edges are finished with crystal seed beads. The feathers would radiate outward as Liberace spun around. As he did this, he smiled brightly at the audience. "I hope you like this," he would say, "because you paid for it!"

On the back of the coat, the phoenix appliqués continue across the shoulders. Here they are sewn with pink, purple, dark-purple, white, and gray threads and outlined with crystal rocaille beads. The feathers are detailed with pink, silver, AB purple, and dark-eggplant AB-finished bugle beads, and crystal lochrosens. The coat is lined in pink silk satin.

The stand-up collar is embellished with dark-purple bugle beads, crystal lochrosens, white pearls, crystal seed beads, and AB crystal jewels.

The jumpsuit is purple polyester gabardine. Its beading consists of broken, slightly curving rows of

purple AB-finished bugle beads, clear bugle beads, and crystal lochrosens. Crystal teardrop-shaped jewels dangling from white pearl loops are scattered.

The upper edge of the V-neck has white pearls, crystal lochrosens, clear rocaille beads, and AB crystal teardrop-shaped jewels, which dangle from white seed pearls. Near where the coat's edge falls are vine and leaf motifs created from white bugle beads, pearls, and glass beads. Crystal navettes are at the center of each leaf. AB crystal teardrop-shaped jewels dangle from loops of white seed pearls and are

scattered throughout the vine and leaf motifs, as well as over the entire jumpsuit. On the outside of each leg, the vine and leaf pattern trails from waist to hem.

A white banded-collar dickey, with attached pleated, ruffled chiffon jabot and cuffs, is edged with pink sequins. A bow tie completes the costume.

Matching boots by Di Fabrizio are also purple gabardine. Their beading echoes the decoration on the pants. The silver heels are rim-set closely with AB crystal rhinestones.

Purple and Pink Phoenix Costume with Ostrich Feathers Cape · 1979

Costume design by Michael Travis

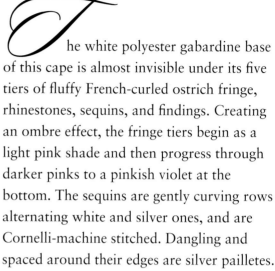

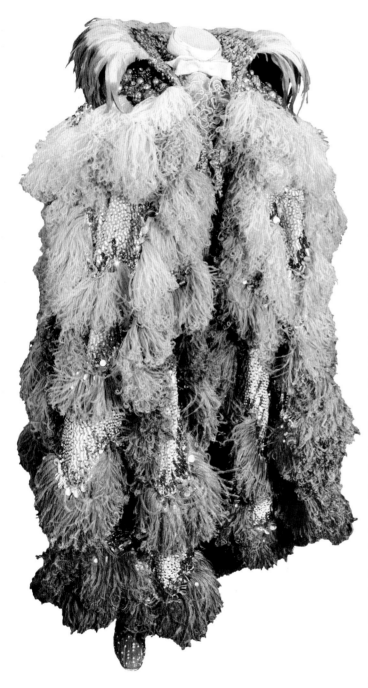

The white polyester gabardine base of this cape is almost invisible under its five tiers of fluffy French-curled ostrich fringe, rhinestones, sequins, and findings. Creating an ombre effect, the fringe tiers begin as a light pink shade and then progress through darker pinks to a pinkish violet at the bottom. The sequins are gently curving rows alternating white and silver ones, and are Cornelli-machine stitched. Dangling and spaced around their edges are silver pailletes.

The cape's upper tier has a standing collar heavily decorated with sequins and rhinestones and topped by a row of snowy white sprouting coque feathers. The feathers nearest to the front are tipped in a bright pink dye. As they continue around the collar, the tip color graduates to a medium violet. The inside and outside of the collar are machine-stitched silver sequins and rim-set AB crystal rhinestones. Atop the collar and near its edges, silver and pink sequins are glued onto the feathers.

The back of the cape is encrusted using white pearls, rim-set AB crystal rhinestones, Tiffany-mounted crystal rhinestones framed with gold metal rim and sewn-on beading, and half-round, faceted silver-colored metal findings. Additional color is added with machine-stitched silver, pink, and fuchsia sequins.

The cape is lined with silver lamé and the same sequin pattern that is on the front of the cape: sprays of lavender sequins on a field of white and silver sequins. Vine patterns are stitched on top and use violet-cupped sequins.

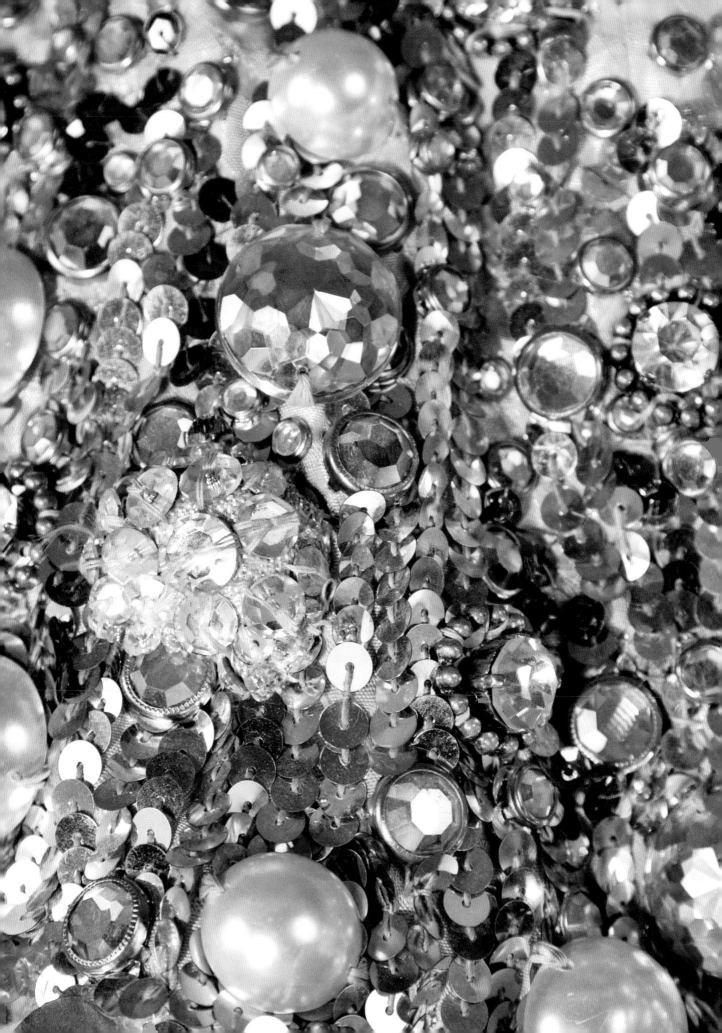

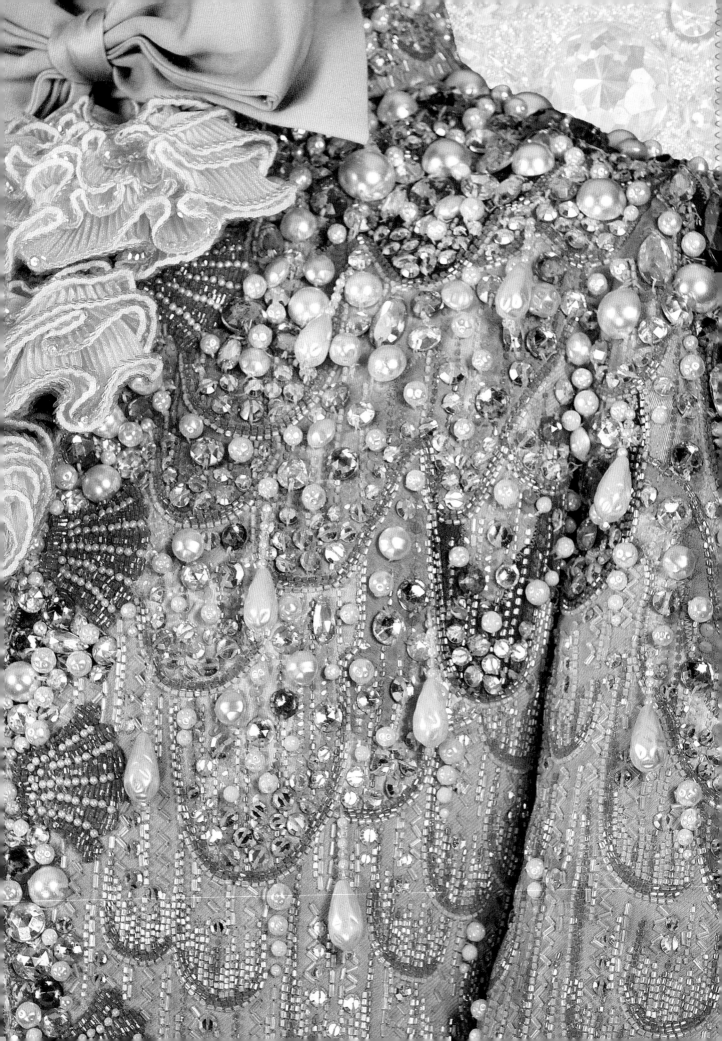

King Neptune · 1983

Costume design by Michael Travis

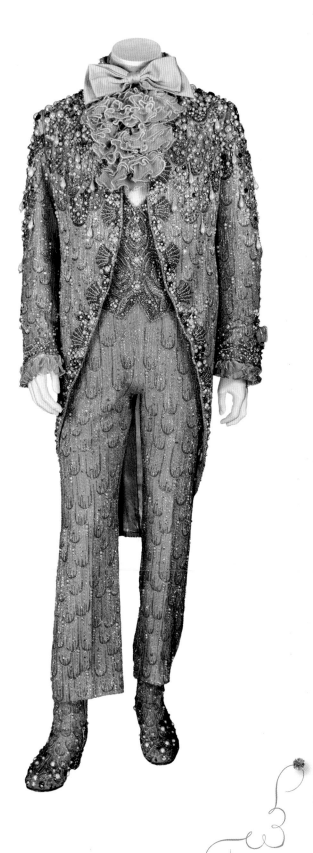

One of the most detailed and encrusted of Liberace's suit, the King Neptune suit was created for Liberace's appearance at the 1984 World's Fair in New Orleans. Later that year, Liberace wore this costume for his performances at Radio City Music Hall. He also wore it in 1985 in Atlantic City and at Caesars Palace in some of his final performances in 1986.

The King Neptune costume measures twenty-six feet around the outside of the cape and is the heaviest of all the non-fur costumes, weighing more than two hundred pounds. The great weight of the costume results from the sheer volume of rhinestones, jewels, pearls, and sequins that completely encrust it. The audience oohed and aahed when Liberace—wearing the King Neptune costume—arrived onstage in a chauffeured limousine. The chauffeur removed the heavy cape to allow Liberace the freedom to continue the performance.

The tailcoat is a light-coral polyester gabardine with an underlying pattern created from clear and coral bugle beads, white pearls, and crystal lochrosens. The clear bugle beads are set both in zigzag and straight lines. The coral beads are set in straight and hook-shaped patterns. The pearls are set in lines of four or five, in graduating sizes. The lochrosens are liberally scattered.

Scallop-shaped pink and dark-coral appliqués create a front and back yoke and extend down the sleeves. Each appliqué is outlined with rows of crystal bugle beads, and the entire area is encrusted

with light-peach and crystal lochrosens, AB crystal and light-peach sewn-on jewels, and white pearls. Large teardrop-shaped white baroque pearls dangle from short chains of seed-size pearls.

The beading on the stand-up collar matches that of the coat body with the top edge worked with round and half pearls, light-peach and crystal lochrosens, and AB crystal and light-peach jewels. Pearls and crystal lochrosens are scattered.

At center front and around the knees are clusters of light-rose and crystal lochrosens, white pearls, and AB crystal jewels. These clusters alternate with shell motifs created from AB coral bugle beads and seed-size white pearls. AB crystal lochrosens finish the edge.

The only additional color on the coat is on the cuffs. There, sea-foam green bugle beads and lilac seed beads fill the bottom. They are topped with crystal lochrosens and white pearls. A coral and pearl shell tops the motif.

At the split in the cuffs, large sprays extend upward and partially around the sleeves, evoking sea coral. These were created with dark-coral and pink underlain appliqués, white pearls, light-peach and crystal lochrosens, and AB crystal jewels. Crystal lochrosens edge the cuffs.

The vest has a fabric base of rosy pink gabardine. An overall swirling pattern is worked in alternating rows of silver bugle beads and crystal rocaille beads. Interspersed among the beading are white baroque pearls and crystal lochrosens. The edges of the vest are outlined in two rows of silver bugle beads, ending with a final row of crystal lochrosens stitched end to end. At center front, three sewn-on crystal jewels are placed at the top and immediately under the edging row of lochrosens. To finish, three buttons are formed from stitched-on, white half-pearls that are encircled with crystal lochrosens.

The pants use the same coral gabardine as the coat. The beading on the pants repeats the decoration on the coat. A white banded collar, sleeveless shirt, ruffled and pleated organza jabot, cuffs edged in pink sequins, and a large pink bow tie complete the costume.

Di Fabrizio used all of the costume embellishments to create matching boots. The heels are silver and rim-set with crystal AB rhinestones.

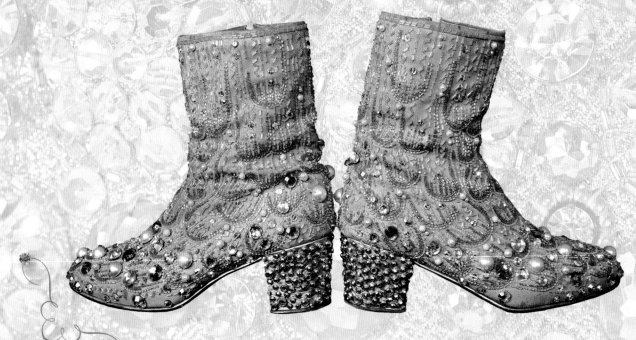

200

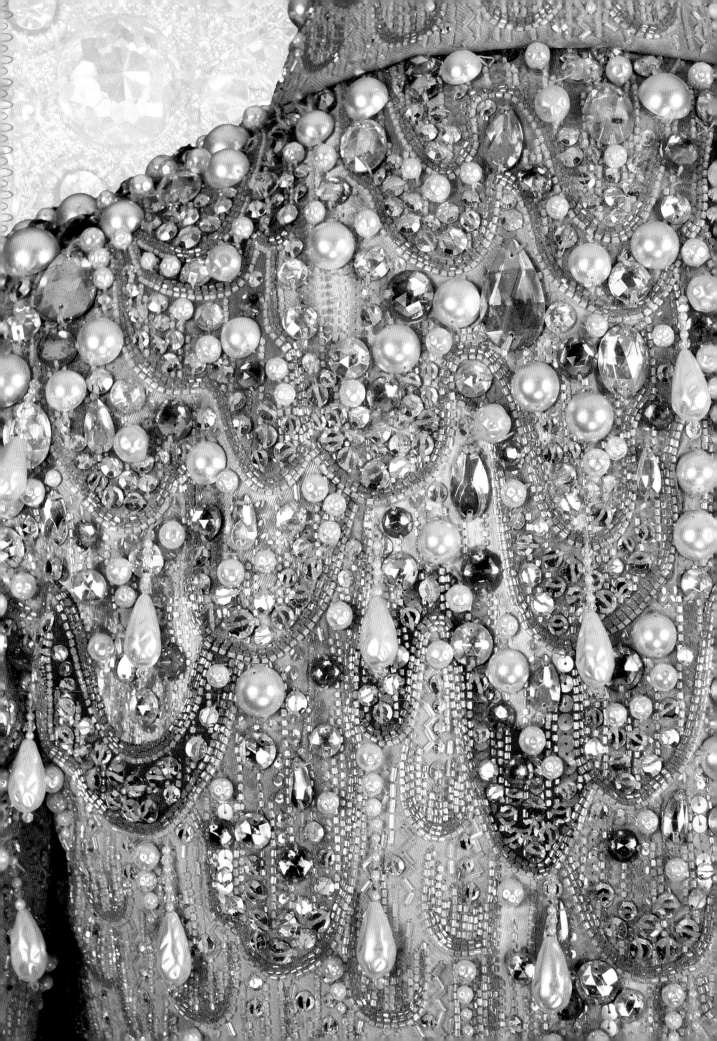

King Neptune Cape • 1983

Costume design by Michael Travis

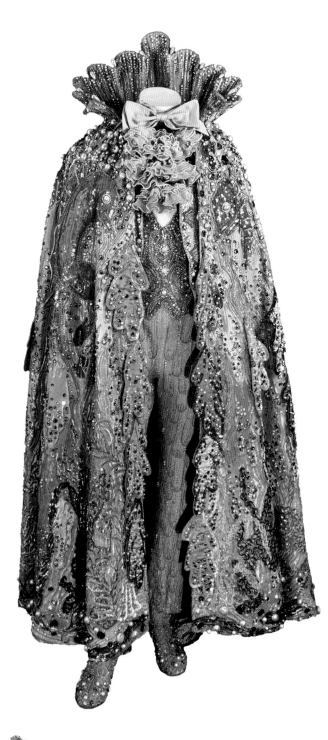

The cape evokes a coral reef. The outer portion has coral polyester gabardine as the base fabric and is appliquéd with coral, pink, and red.

Down both sides of the front of the cape and scattered on the front and back are free-form, coral-like shapes in pink and coral colors. Each appliqué is outlined and formed in contrasting darker shades of machine-stitched sequins. They are embellished with rim-set rhinestones in rose, light rose, and crystal, as well as white pearls. The appliqués are attached to the cape at their tops.

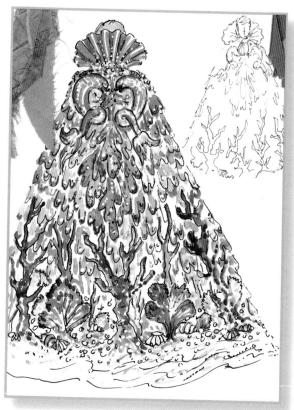

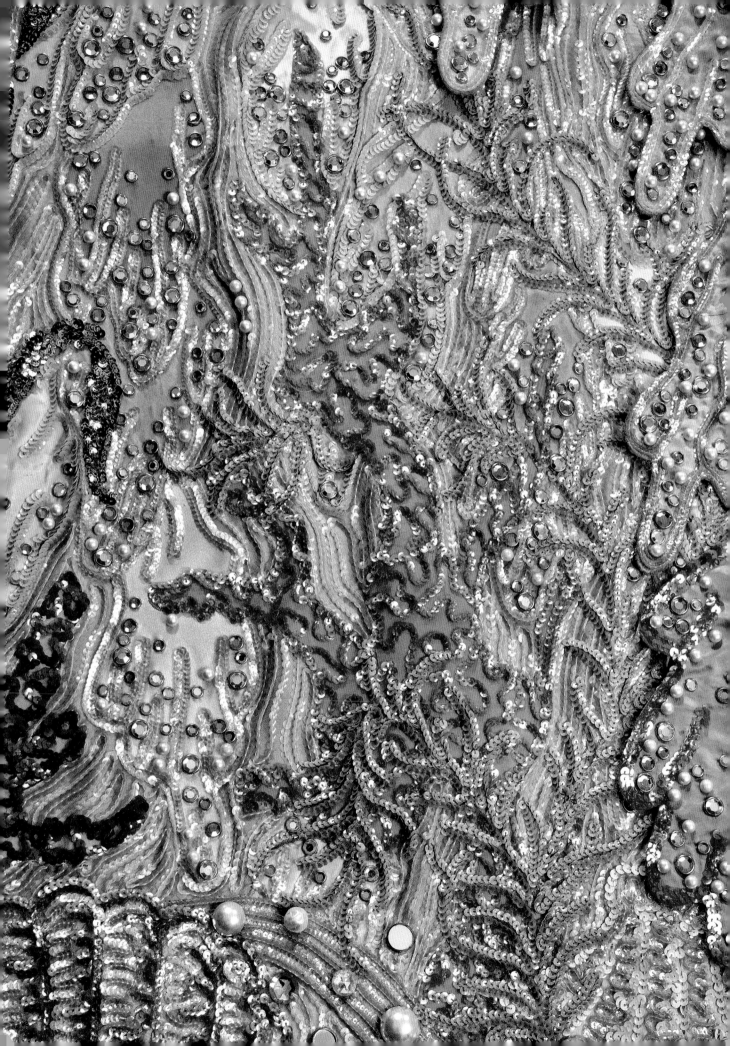

Featured on the front are two trapunto sea horses with looped tails. They were created with Cornelli-machine stitching using coral and pink sequins. Their bodies and faces are outlined with crystal lochrosens, and the fins are created using white seed pearls. The eyes are white, half-round pearls circled with white seed pearls.

On the back of the cape, beneath a heavily embellished and appliquéd yoke area, are two more trapunto sea horses. These are identical to the two on the front, but larger.

At the bottom of the cape is the magnificent coral reef itself, worked all the way around and extending at its highest to more than three feet. Constructed entirely from machine-stitched sequins, the corals are depicted with pink, red, coral, fuchsia, turquoise, blue, green, lilac, and purple sequins. At the bottommost edge, horizontal undulating rows of purple, teal, blue, turquoise, and green sequins suggest water and anchor the coral reef. Finishing the bottom edge are shell shapes worked in pink sequins.

The cape is covered in embellishments: rim-set mirrors, rim-set rose, light-rose, and crystal AB rhinestones, white pearls, and light-peach crystal and AB crystal sewn-on jewels. Cornelli-machine cupped and flat sequining in coral, pink, and clear—many with AB finishes—fill the areas around the appliqués, sequin corals, beads, pearls, and jewels.

The cape closes at center front with a large silver clasp. The large, rippling shell-shaped collar stands almost two feet tall at its highest point. It is detachable and has a thick wired edge. Vertical rows of various shades of clear, cream, pink, and coral sequins are stitched on the inside of the collar. Short rows of rim-set AB crystal rhinestones run over the sequins.

Contrasting with the lighter shades of fabric used on the front, darker shades of pink and peach fabric are used on the back. These are clear, pink, and coral, and they are also machine-sequined vertically. Along with short rows of pearls and rim-set AB crystal rhinestones, pearls, rim-set fuchsia rhinestones, Tiffany-mounted crystal AB rhinestones, and peach and crystal AB sewn-on jewels complete this beading. On the top edge, between the scallops, are teardrop-shaped pearls.

"Too much of a good thing is wonderful!" Liberace often said. Never one to stop at excess, Liberace ensured that the inside of this cape be nearly as stunning as the outside. With a light silver lamé fabric as the base, the inside has a second reef of Cornelli-machine sequined corals. Starting at the bottom of the cape, the corals extend upward and use flat and cupped sequins in pink, green, teal, red, and purple. Snails and shells are stitched with pink and tan sequins, and starfish are formed with teal sequins. Between the corals and sea life are curving, closely spaced rows of cupped and flat sequins in various shades of silver, brass, light purple, and green, many with an AB finish.

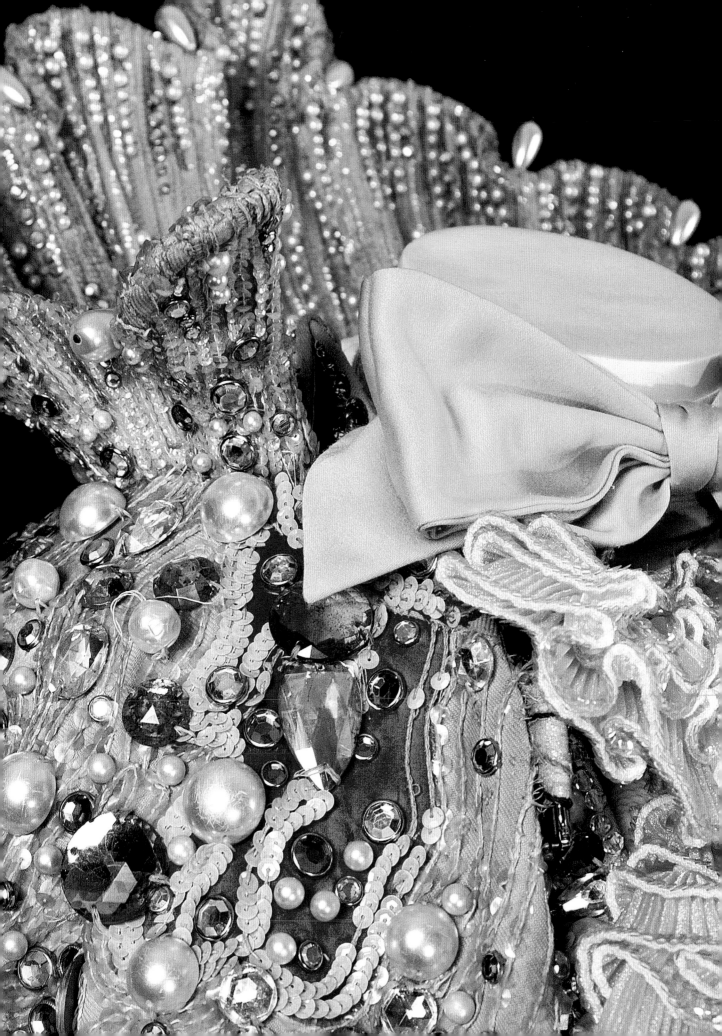

Liberace's Legacy

Liberace died of pneumonia on February 4, 1987; his body had been weakened by AIDS. He was sixty-seven years old. In measuring the influence of his style, one only has to look at Elvis, Lady Gaga, Little Richard, Elton John, Michael Jackson, Cee Lo Green. Liberace's display of excess and opulence in his extreme costuming paved the way for future superstars.

Liberace and Elvis Presley met twice, both times in 1956. The first time was during Elvis's two-week run at the Frontier Hotel in Las Vegas; the second time was six months later, at Liberace's show at the Riviera. At the Riviera show, Liberace noticed Elvis in the audience and decided it'd be fun to serenade him. Afterward, they met in Liberace's dressing room. The Riviera's press agent, there to photograph the meeting of the two musical idols, suggested that they exchange jackets—Liberace's gold lamé tuxedo jacket for Elvis's sport coat. Musical instruments were also exchanged, with Liberace playing a guitar and Elvis on the piano. The ensuing jam session lasted almost a half hour.

Four months later, Elvis wore a full gold lamé suit for his spring tour. Liberace had influenced Elvis's style and would continue to influence it throughout his career. Elvis would soon be known for his jewel and rhinestone jumpsuits and capes.

Lady Gaga has often been called the female Liberace—his performances have been a great influence on her costuming, props, and exaggerated style. In her song "Dance in the Dark," she uses his name. Little Richard called himself the "Bronze Liberace." Elton John gives Liberace credit for influencing the flashy costumes John

donned in the seventies, which were highly adorned with rhinestones, feathers, and fur. Michael Jackson was a personal friend of Liberace's and it is easy to see Liberace's influence on Jackson's late seventies and early eighties costumes. Cee Lo Green's grandiose Las Vegas show, "Loberace," was given its name in tribute to Green's biggest influence.

Through the sparkle of the jewels and rhinestones, the legacy that Liberace left to the world shines the brightest. He'll forever be remembered as one of the world's most outlandish, flamboyant performers. He experienced hard times, a rough childhood, a career crash, a million-dollar lawsuit filed by his former lover, and tough critics, but he always overcame the challenges. In prevailing, he single-handedly reshaped the entertainment industry. He paved the way for a new art of performance—one which embraced showmanship as well as artistry—and today's stars follow in his footprints.

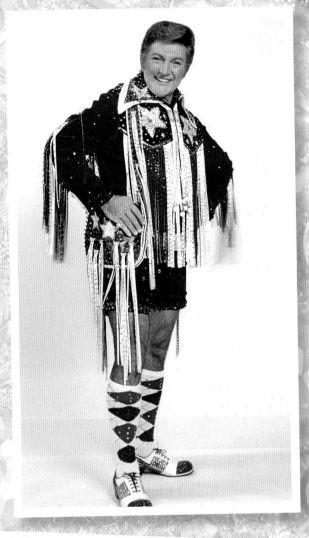

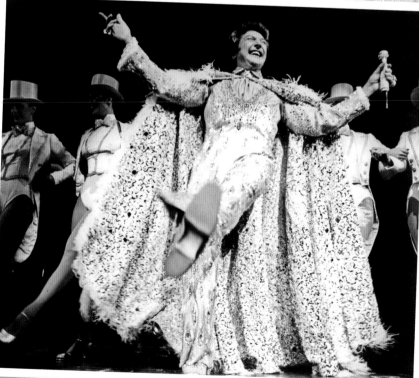

Top: Liberace in a hot pants Americana costume. *Right*: Liberace in a fully embellished suit and cape.

Glossary

BEADS AND BEADING TECHNIQUE

Bugle beads are small tubes with holes running down their centers and often silver-lined. They are graded by size one to five, which translates to their lengths in millimeters.

Glass beads: Among the oldest art forms is the making of glass beads, which dates back more than thirty thousand years. The most common modern glass bead is the seed bead. Seed beads are an example of mechanically drawn glass beads and are extruded by machine. Seed beads are usually round and come in a number of sizes, beginning at less than five millimeters, with a tiny hole for stringing or sewing. A beading needle must be used for seed beads. Seed beads are often used in costuming as a way to attach lochrosens and paillettes.

Rocaille beads are very similar to seed beads, although larger and often silver-lined.

Tambour beading is a technique that takes its name from the French word for "drum," because the fabric is tightly stretched. The beading technique originated in 1770 to create designs for the French court. It is done by hand and performed with a hook in a wooden holder, which holds a shortened French Cornelli needle and is used to bead onto fabric that is stretched over a frame. This style of beading flourished in the 1920s and 1930s, an era that began with the flapper dress, which was heavily beaded. Popular for its time, tambour beading is now a dying art form. The technique survives because of its use in European couture ateliers. Today in the United States, this work is done almost exclusively in New York and Los Angeles by beaders who are now in their seventies for design houses such as Halston and Bob Mackie.

EMBROIDERY

Cornelli-style embroidery is created using a Cornely machine—a special industrial machine—and the embroidery is known commonly as Cornelli embroidery. The machine was developed in the late 1800s by the French inventor Emile Bonnaz and first manufactured by the French Cornely Company. A Cornely machine is a chain-stitch machine that allows the operator to embroider fabric with sequins, beads, cording, braids, heavy metallic threads, and ribbons in delicate or closely worked designs. The machine manufacturer's name is spelled "Cornely." The embroidery style is referred to as "Cornelli," or sometimes "Corneli."

Goldwork is embroidery done with metal threads. Up to the thirteenth century, goldwork was reserved for ecclesiastical purposes. Later it was used on the clothing of royalty and eventually also on military clothing. It has always been reserved for special use because of the cost of the materials and the length of time the technique requires. The threads have never come from solid gold but are composed of thin sheets of gold cut into strips and wound around thin cotton strands. Thread is sold by weight, and the cost depends on the quantity of gold used. A technique called "couching" holds the gold thread in a pattern on the surface of the fabric. A stiletto tool is used to make small holes in the fabric. This technique pushes the ends of the gold thread through the fabric and holds them in place.

Jacobean style became popular in the early part of the English Renaissance. The style is known for its ornamental patterning of scrolls and its paisley designs. It is often used for patterning clothing.

Trapunto in Italian means to "embroider." Trapunto is a type of quilting in which the design is raised from the background with a cord or yarn filler. This is done by stitching through the

quilt front, the batting, and the backing in parallel rows, creating channels. These channels are then threaded with cord or yarn, thus raising the design from the background. Commercially, trapunto is done with a small machine that inserts the cord between the layers. Often the background is stippled—an effect achieved by placing small, random stitches very close together. This causes the background to lie flatter than it otherwise would, emphasizing the raised part of the design.

FABRICS

Bengaline silk: A woven fabric made with lesser amounts of silk than cotton.

Boiled wool: Wool that has been heated to make it softer than regular wool.

Brocade: A heavy, exquisite jacquard fabric with an allover raised pattern or floral design.

Chiffon: A plain woven, lightweight, sheer, and airy fabric made from silk or synthetics.

Cotton: A natural fiber that grows in the seed pod of the cotton plant.

Crepe-back satin: A two-faced fabric in which one side is satin and the other, crepe.

Damask: A reversible figured fabric with a pattern formed by weaving.

Eyelash lamé: Woven from the same materials as traditional lamé, but with long strands of the metallic fibers woven into the fabric to create a three-dimensional effect.

Lamé: A shimmering material that is created by combining metallic fibers and natural or synthetic fibers into a woven or knit fabric with a high gloss.

Matelassé: Matelassé is French for "quilted" or "padded." A matelassé fabric is a luxury fabric made in a double-cloth construction to create a blistered or quilted surface that appears padded.

Nylon: First produced in 1938, nylon was the first completely synthetic fiber. It is known for its strength and resilience.

Organza: A crisp, sheer, lightweight, plain-weave fabric with a medium to high yarn count. It is made of silk, rayon, nylon, or polyester.

Polyester gabardine: A synthetic fabric that is smooth, strong, tightly woven, and resilient. Polyester gabardine resists wrinkling and is fire retardant. The durability and strength of many of Liberace's most elaborately beaded costumes, their retention of true color, and the successful preservation of many of these costumes is due in large part to the choice of fabric—polyester gabardine. Never thought of as a showy fabric like silk, satin, brocade, or lamé, polyester gabardine is a perfect working fabric for elaborately beaded and fully embellished costumes.

Silk: A natural filament fiber produced by the silkworm in the construction of its cocoon.

Velvet: A constructed fabric in which the cut pile stands up straight. Velvet is commonly made with a filament fiber for high luster and smoothness.

Wool: Fabric made from the fleece of sheep, cashmere from goats, or the specialty fibers of the camel, alpaca, llama, or vicuna.

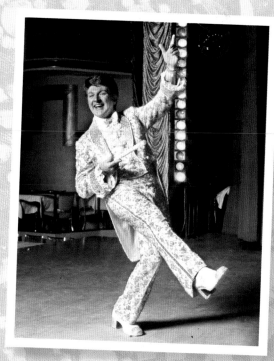

Above: Liberace in his cream and silver electric jacket with matching pants.

FUR

There is great controversy over the killing of animals for their fur. The use of fur for clothing, however, has a long history.

Chinchilla: The chinchilla is a rodent native to the high Andes of South America. The fur is very soft, silky, and dense, and it mainly ranges from gray to slate blue. Chinchilla fur has the highest hair density of any fur, with more than twenty thousand hairs per square centimeter.

Ermine: The winter phase of the weasel, ermine is a silky white fur with black tips. Ermine was once the fur of royalty, for whom it was reserved as a symbol of virtue and purity.

Fox fur is found all over the world. Clarity of color is important in fox fur, as are the fullness and density of the underfur and soft sleekness of the guard hairs. Red fox is the least expensive fur, platina and white the most expensive. Blue fox colors range from a blue-brown to a real blue, as well as white with blue highlights.

Lynx is characterized by white fur with subtle beige markings. The whiter the fur, the greater its value.

Mink: Soft and lightweight with lustrous guard hair and dense, soft underfur, mink are primarily farm-raised. Mink fur is available in a wide range of natural colors.

Sable are a kind of marten—a weasel-like mammal. Russian sable is the most prized fur in the world, renowned for its legendary silky quality, rarity, and light weight. Prime sable is deeply furred with even, silvery-tipped guard hairs. The color is a rich brown with a blue cast. Golden sable has a reddish or amber color.

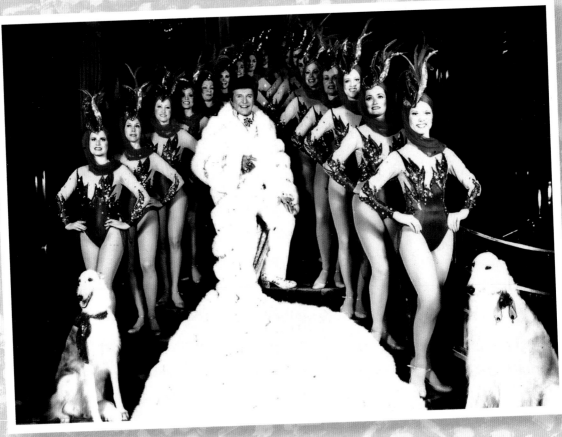

Above: Liberace at Radio City Music Hall.

"Upside-down" Monkey Fur: Made from the pelt of the black-and-white colobus of central Africa, this fur is very long (reaching lengths of five inches), sleek, and shiny. It looks and feels eerily like human hair. Monkey fur was popular from the mid-nineteenth century through the 1940s. It was used upside down, resulting in a curl to the hair. Monkey fur is now illegal under the Convention of International Trade in Endangered Species of Wild Fauna and Flora (CITES).

MAKING THE FUR GARMENT

Constructing a fur coat takes more than fifty hours of skilled work. A completed fur may have up to ten thousand seams when finished. The creation of a fur requires meticulous workmanship and a number of steps:

Every coat starts out as a design on paper. From this pattern, the number of skins needed is calculated, pelts are then chosen, and the furrier matches the alignment.

During the "letting out" process, a pelt can be lengthened. Each pelt is cut into narrow, diagonal strips that are sewn into a longer and thinner shape, retaining the color and markings of the original pelt. This process is one of the secrets of making a supple, flowing garment.

The pattern is then traced onto the hide and the pelts are then joined together. Next the furrier passes the coat under clippers to ensure that every hair is cut to the same length.

After the coat is cleaned, the finishing stage begins. The lining is inserted into the garment and the final tailoring touches are completed.

FEATHERS

Coque is the French word for "rooster," and the term "coque feather" refers to the rooster's tail feather. Coque feathers are available in white and "natural." If dyed, white coque feathers produce a bright and rich color. The feathers are long and sturdy and retain a soft, delicate look. They are available loose or in strands stitched to matching ribbon.

Ostrich Feathers: The ostrich is a large, flightless bird native to Africa but farmed around the world. Ostriches are raised primarily for their feathers. The ostrich feather is unique in its durability, softness, and flexibility. The feathers can be bleached or dyed any color. Ostrich feather fringe is created by stitching the herls, or hairs, from wing feathers onto matching colored ribbons. They are generally one- or two-ply and measure four-and-a-half to six-inches long from tip to tip. There are approximately thirty to thirty-five feathers per inch. French curling of the ostrich feather is an extremely time-consuming method that is almost obsolete. It is done on fringe and complete wing feathers. The herls of the feather are drawn singly over the edge of a knife, which functions much like a curling ribbon. The result is a small curl, which makes a much fluffier feather.

Turkey Feather Boas: Turkey boas are made from quality turkey feathers with wide tips. The feathers can be bleached or dyed any color and are sewn onto a cotton-covered wire.

PAILLETTE

Paillettes are available in a myriad of colors, including metallic, with one hole for attachment.

PEARLS

Imitation pearls are manufactured from glass, ceramic, shell, or plastic. Plastic pearls are most commonly used for costuming. Plastic pearls can be dyed with fabric dye.

Flat-back pearls are a whole round pearl split in half.

Baroque pearls are pearls that have an irregular shape.

RHINESTONES

Named after the Rhine River on the German–Austrian border, the rhinestone is made from glass, paste, or quartz. Production of rhinestones began in 1892 when Daniel Swarovski received a patent for a machine that automatically cut the stones.

In 1895, Swarovski set up a factory in Wattens, Austria, and began producing rhinestones of superior quality. Swarovski rhinestones are genuine lead crystal and are the rhinestone of choice, offering high reflectiveness and brilliance. They are available in a wide range of vibrant colors.

The appeal of a crystal rhinestone is the stone's ability to catch and hold the light. Only Swarovski stones were used on Liberace's costumes. In 1982, to show their appreciation to Liberace, the Swarovski family presented Liberace with a massive lead crystal rhinestone of 115,000 carets and 134 facets. It weighed more than fifty pounds and was the world's largest rhinestone at the time.

Colors

Rhinestones come in a wide variety of bright sparkling colors, but the most popular rhinestone by far is the crystal rhinestone, which looks like a diamond, colorless and clear.

The second most popular rhinestone is referred to as "crystal AB." The color, inspired by the northern lights (aurora borealis), was created in 1965 when Swarovski collaborated with French designer Christian Dior on the first color "effect" for rhinestones. A special coating is applied to the stone to create an iridescent effect, so that it reflects different colors as it moves. When AB coating is applied over a colored stone, the result is the same multicolor prismatic effect, enhanced by the original color of the stone.

Cutting

Tin cutting is a high-precision method for cutting a stone that creates the depth and brilliance of the stone. This method is superior to "fire polished." Fire polished only molds the glass so its facet edges are not overly sharp.

Foils

Foil refers to the backing applied to a stone. A stone back can be foiled in silver, gold, or with no backing at all. Foiling the stones reflects radiance and color from the stone.

Rhinestone Banding

Rhinestone banding is a connected row of stones with each stone set in a plastic cup. Available in single rows as well as multiple rows, the stones have pointed backs, but they are set into the banding so they lie flat. Stones are connected to one another and rows are connected to others with either solid or elastic thread. Liberace's black diamond mink cape is lined from top to bottom with rhinestone banding.

Settings

There are two types of settings: rim set and Tiffany style. The first is used for flat-back stones and the second for pointed-back stones. Most settings are available in a silver or brass finish and come in a variety of lengths and sizes.

Rim-set mountings enclose the stone on the front side with a solid bezel, a band of metal that holds it in place. Prongs are pushed through the fabric to the back and folded over against the fabric.

Tiffany-style mountings attach the stone from the back of the fabric. Most of the setting is on the back and only the small prongs that hold the stone in place can be seen. The setting is inserted through the fabric from the back and crimped over the stone's edge.

All rhinestones on Liberace's costumes are either rim set, Tiffany set, or sewn-on.

Sizing

Rhinestone sizes are specified using a universal jewelry trade nomenclature, "stone size" (ss) scale, which correlates to a millimeter diameter ranging in size from ss5 (1.7 to 1.9 millimeters in diameter) to ss48 (10.9 to 11.3 millimeters).

Originally, sizing was based on a centuries-old method of pearl sizing. Pearls were placed on plates with holes punched in them, and the pearls that fell through the holes were sized according to the hole they fell through. This is where the "pp" designation of sizing comes from, with "pp" standing for pearl plate. Pearl sizes range from 3pp up to 35pp.

Today, both sizing methods continue to be in use. Typically, smaller stones will be sized in "pp" and the larger stones in "ss."

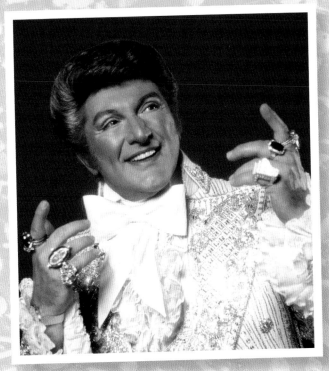

Above: Liberace promotional photograph.

Styles

Although rhinestones are available in a wide variety of shapes, sizes, styles, and colors, there are only two basic types of rhinestones: point back (or chaton) and flat back (or chaton rose).

Chaton rhinestones are round with pointed backs. They are the most brilliant and fiery of all rhinestones. Chatons are set in Tiffany-style mounts.

Flat-back rhinestones are the most frequently used in costuming. They are faceted on the front surface, and the flat backs are foiled to produce an extraordinary brilliancy.

Jewels are large rhinestones of various sizes and shapes. They are available in flat back or pointed back, with holes for stitching, and as drop jewels with a hole in the top used to attach them to the fabric or to additional beads for a longer drop. Other shapes are teardrop, pear, navette, and oval. Three-dimensional shapes are called "pendants."

Chaton roses are round, flat-back rhinestones with a mirror coating on their backs. These stones can be heat set, glued, rim set, or Tiffany mounted. They are the most popular style of rhinestone.

Flat-back, sewn-on rhinestones come in a variety of shapes and sizes, from round to teardrop.

Lochrosen are round, flat-back rhinestones with a hole in the center for sewing to the material. The center hole allows a bead to be attached to the center of the stone.

Margaritas are the same as lochrosens, except with flower-shaped edges.

SEQUINS

Sequins are available flat or cupped. Spanish sequins are the highest quality sequin, manufactured in color and not dyed. Commercial grade sequins greatly vary in quality. They are often dyed and will lose color over time.

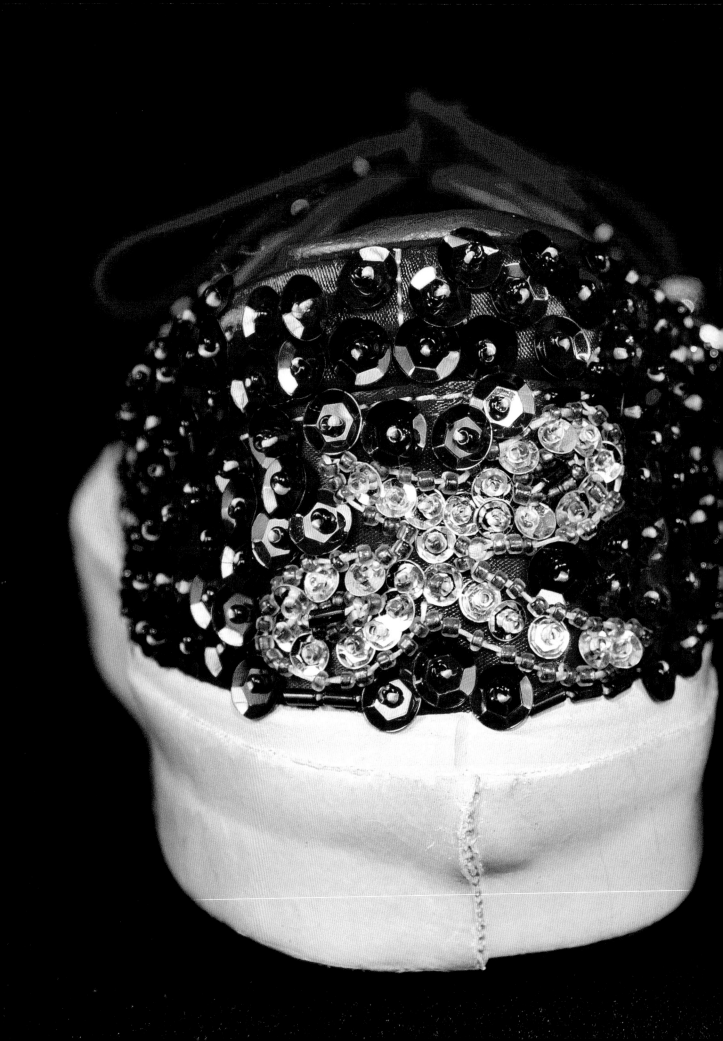

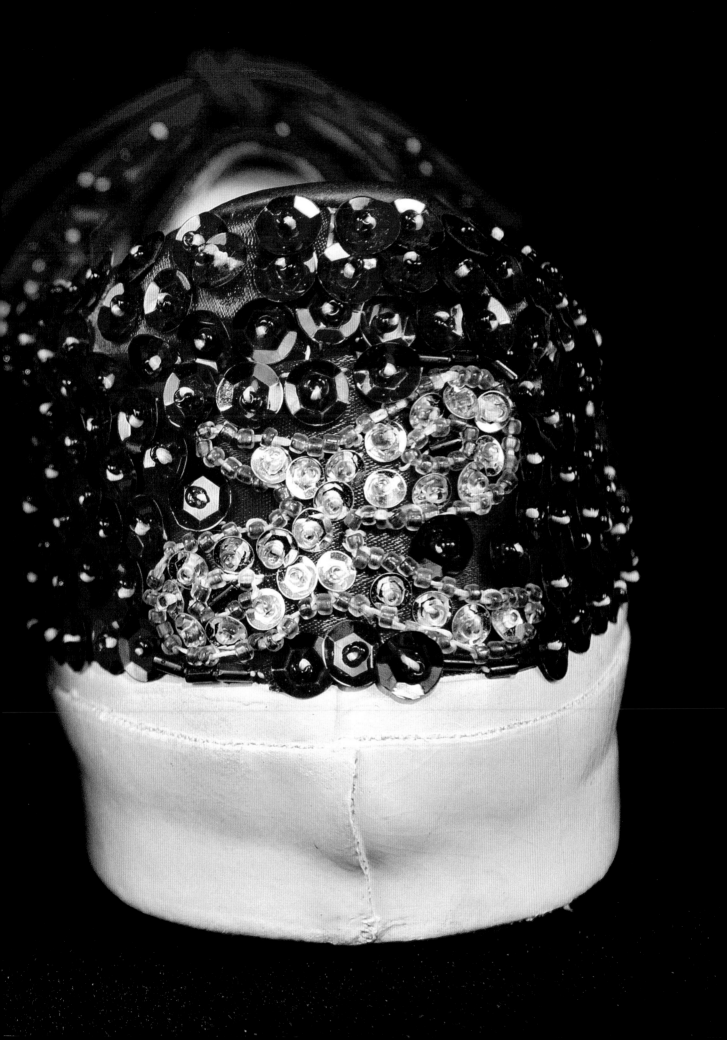

Bibliography

Faris, Jocelyn. *Liberace: A Bio-Bibliography*, Westport: Greenwood Press, 1995.

Liberace. *Liberace: An Autobiography*, New York: G.P. Putnam's Sons, 1973.

Pyron, Darden Asbury. *Liberace: An American Boy*, Chicago: Chicago Press, 2000.

Thomas, Bob. *Liberace*, New York: St. Martin's Press, 1986.

Thorson, Scott. *Behind the Candelabra: My Life with Liberace*, Los Angeles: Knightsbridge Publishing Co. Mass, 1990.

Zamoyski, Adam. *Paderewski*, New York: Atheneum, 1982.

About the Liberace Foundation

At age seven, Liberace received a scholarship to the Wisconsin Conservatory of Music in Milwaukee. There, he received classical training on the piano and was encouraged to pursue his dream of being an entertainer.

When Liberace established the Liberace Foundation, formally, the Liberace Foundation for the Creative and Performing Arts, in 1976, he wanted to give young musicians the same opportunity that he had been given. In his book, *The Things I Love*, he wrote: "A lot of good things have happened to me in show business and I want to do what I can to give others just starting out a career boost. I hope The Foundation projects will continue into the future to offer gifted newcomers financial help, and in many cases, artistic exposure as well."

Today, the Liberace Foundation's Liberace Scholarship for the Creative and Performing Arts has awarded more than five million dollars in scholarships to more than 2,700 students at 112 colleges and universities.

About the Liberace Museum

Liberace opened the Liberace Museum in Las Vegas on April 15, 1979; its profits went toward supporting the Liberace Foundation. Overseen by he and his brother, George, the museum had two buildings: one housing the majority of his stage costumes and jewelry, the other for his pianos and cars.

In 2010, in the midst of a difficult economy, the Liberace Museum closed its doors. The Foundation is now entirely funded by private donations, while the museum's Board of Directors continues to seek a new home.

On its final day, hundreds of Liberace's fans flocked to the museum, lining up well before its opening, to get one more look at the performer's fabulous costumes. It is said that at the end of the day, fans and employees stood together, some crying, others simply hugging one another. Then, just as the gates shut for the final time, the thunderstorm that had been raging all day eased. The clouds retreated and a double rainbow colored the sky.

Opposite, left: Liberace and his mother.
Opposite, right: An early publicity still.
Above: Liberace outside the Liberace Museum.

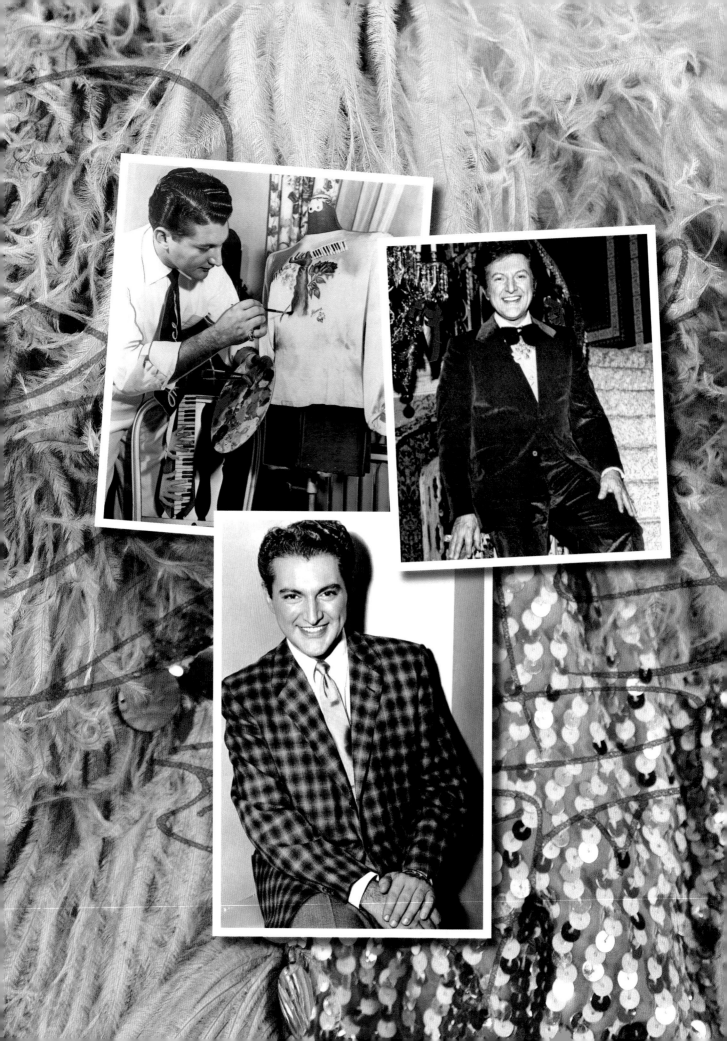

Notes

Introduction

1. Eric Felton, "Lady Gaga and Liberace: Separated at Birth?" *The Wall Street Journal* (September 17, 2010).
2. Adam Nagourney, "Mr. Showmanship's Show Is Closing," *The New York Times* (September 18, 2010).

Chapter 1: The Beginnings

3. Darden Asbury Pyron, *Liberace: An American Boy* (Chicago: The University of Chicago Press, 2001), 39 (Pyron's source is "50 N.t., n.d., Liberace File #7, Milwaukee Public Library").
4. Liberace, *Liberace: An Autobiography* (New York: G.P. Putnam's Sons, 1973), 54–55.
5. Ibid., 66.
6. Pyron, *Liberace: An American Boy*, 43 (Pyron's endnote is "*Wisconsin College of Music Bulletin*, season of 1930–31, Milwaukee Public Library").
7. Ibid., 51 (Pyron's endnote is "N.t., n.d., Liberace File #7, Milwaukee Public Library; 'Liberace Coming Home,' March 29, 1951, Liberace File #2, Milwaukee Public Library, confirms").
8. Liberace, *Liberace: An Autobiography*, 73.
9. Pyron, *Liberace: An American Boy*, 57 (Pyron's endnote is "N.t., n.d., Liberace File #7, Milwaukee Public Library").
10. Pyron, *Liberace: An American Boy*, 56 (Pyron's endnote is " 'Liberace Whips Up Music, Muffins at His Old School,' n.d., File #3, Milwaukee Public Library").
11. Bob Thomas, *Liberace: The True Story* (New York: St. Martin's Press, 1987), 29–30.
12. Liberace, *Liberace: An Autobiography*, 89.
13. Ibid., 172.

Chapter 2: The 1950s

14. Bob Thomas, *Liberace: The True Story*, 60.
15. Ibid., 62.
16. James Bacon, "Liberace First Pianist Since Paderewski to Need Hall Like Madison Square Garden," *News and Courier* (May 23, 1954).
17. Jocelyn Faris, *Liberace: A Bio-Bibliography* (Westport, CT: Greenwood Press, 1995), 111.
18. Ibid., 57.
19. Liberace, *Liberace: An Autobiography*, 90.
20. Faris, *Liberace: A Bio-Bibliography*, 54 (Pyron's endnote attributes this to Faris with " 'Strain Put on Fuses at Liberace Concert,' *Los Angeles Times*, Sept. 6, 1954").
21. Ibid., 56.
22. *NY Sunday News* (July 13, 1969) [title and author unknown].
23. Pyron, *Liberace: An American Boy*, 265 (Pyron's endnote is " 'Fresh Flowers from Friend Elvis,' n.d., Liberace File #83, Milwaukee Public Library").
24. Thomas, *Liberace: The True Story*, 117.
25. Pyron, *Liberace: An American Boy*, 265 (Pyron's endnote is " 'Fresh Flowers from Friend Elvis,' n.d., Liberace File #83, Milwaukee Public Library").
26. Pyron, *Liberace: An American Boy*, 201 (Pyron's endnote is " 'Liberace Puts Punchline First,' n.d., Liberace File #16, Milwaukee Public Library").
27. *Variety* (Oct. 15, 1958) [title and author unknown].
28. Marian Christy, "Liberace: Super Showman Has Known Hard Times," *The Ledger* (September 12, 1974).
29. Faris, *Liberace: A Bio-Bibliography*, 63.
30. *The Phil Donahue Show* (featured in the Liberace Museum; air date not available).
31. Aline Mosby, "Meet the Man Who Made Liberace Glitter," *Binghamton Press* (January 6, 1956).

Opposite, left: Liberace hand-painting a shirt. *Opposite, right*: Liberace at a 1950s Christmas party. *Opposite, bottom*: Liberace in a plaid sport coat.

Chapter 3: The 1960s and '70s

32. *New York Daily News* (July 13, 1969) [title and author unknown].

33. Ibid.

34. Maggie Sieger, "Seams like a dream," *Daily News* (November 27, 1994).

35. Ibid.

36. Christie Mitchell, "Island's Talented Thespians Should Perform in Summer," *Galveston News* (December 2, 1962).

37. Sieger, "Seams like a dream," *Daily News*.

38. "Liberace," *Saturday Evening Post* (December 3, 1978) [title and author unknown].

39. "Liberace," *Washington Star* (August 24, 1977) [title and author unknown].

40. "Liberace," *Saturday Evening Post* (December 3, 1978) [title and author unknown].

41. Liberace, *Liberace: An Autobiography,* 163.

42. Morton Moss, *Los Angeles Herald-Examiner* (June 16, 1969).

43. "Bugle, Bangles and Beads," (author unknown; August, 1973) [title and author unknown].

44. Morton Moss, *Los Angeles Herald Examiner* (further details unknown, 1969).

45. Forrest Duke, "Liberace Out-Dazzles Hilton Star Liberace," *Las Vegas Review-Journal* (June 5, 1974).

46. Emma, Trotter, "Glamorous Life," *Luxury Las Vegas* (March, 2010).

47. Ibid.

48. Ibid.

49. Ibid.

50. Athan Karras, "Michael Travis, Designer for the Superstars," *Greek American Review* (December, 2003).

51. Ibid.

52. Ibid.

53. Ibid.

54. Ibid.

55. Ibid.

56. Ibid.

57. Betty J. Ott, *Buffalo News* (title unknown; August 23, 1959).

Chapter 4: The 1980s

58. Liberace, Pianist," *Parade* (article title and author unknown; February 5, 1984).

59. Benjamin Epstein, "Blackwell Dubs Princess Worst-Dressed," *Los Angeles Times* (January 24, 1986).

60. Cheryl Lavin, "It's Mr. Showmanship: Liberace Continues to Bank on Self-Parody," *Chicago Tribune* (November 10, 1986).

61. Ibid.

62. Mike Hodgkinson and Naomi Greenaway, "Sole Trader," *Sunday Mirror*, London (January 26, 2003).

63. Ibid.

64. Ibid.

65. Cindy Cullen Chapman, "Designer Keeps Liberace under Lavish Wrap," *Gazette* (courtesy of The Liberace Foundation, n.d.).

66. Quote supplied by The Liberace Museum's tour guide.

67. Elliot Krane, "Michael Travi$, De$igner of Liberace'$ $pangled uit," *This Is Las Vegas* (April 20, 1979).

68. Ibid.

69. Liberace, *The Wonderful Private World of Liberace* (New York: Harper and Row, 1986), 174.

70. Ibid.

71. Lavin, "It's Mr. Showmanship: Liberace Continues To Bank on Self-Parody," *Chicago Tribune*.

Opposite: Liberace in a white fur coat made by Anna Nateece.

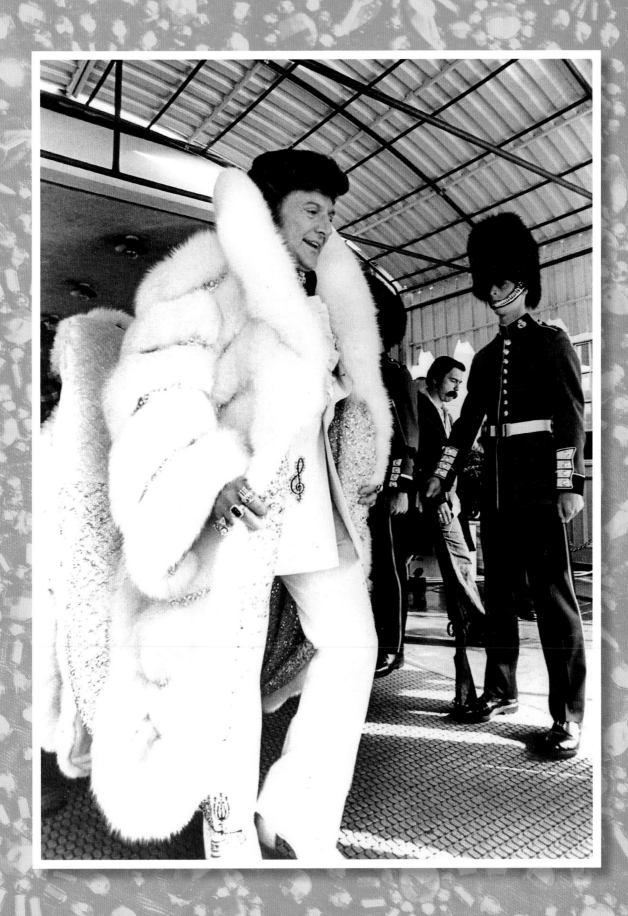

Index

Acknowledgments

It took an army to make this endeavor feasible. The authors would like to thank Arizona State University for granting a sabbatical for this project, the United States Institute of Theatre Technology for awarding us a grant, Michael Travis, Jim Lapidus, Anna Nateece, Ray Arnett, Gordon Young, Bob Croghan, David Rodgers, Dr. Andrew Hartley, Stacey Glick (our agent), Gene Ducette of the House of Embroidery, Linda Essig, David Furr, Kimb Williamson, Pauline LaChance, Darin Hollingsworth, Jerry Rutterbush, Jerry Goldberg, Robyn Gebhart, Deborah Bell, and Deborah Nadoolman Landis.

We could not have created this book without the unwavering support of the Liberace Foundation, Paco Alvarez, Melanie Coffee, Jeffrey Koep, and the wonderful volunteer staff of the Liberace Museum.

A special thanks goes out to Connie's spouse, Michael Soloman, and to our parents, Walter and Betty Jo Furr and Harry and Opal Brooks. Without their love and encouragement, this would not have been possible.

Art director Lynne Yeamans was a powerful force in fine-tuning the look of this book. Designer Tanya Ross-Hughes worked tirelessly on it. Julia Abramoff, our editor, deserves accolades for her patience and expertise in guiding us through this process.